PAINTING
PORTRAITS
and FIGURES
IN WATERCOLOR

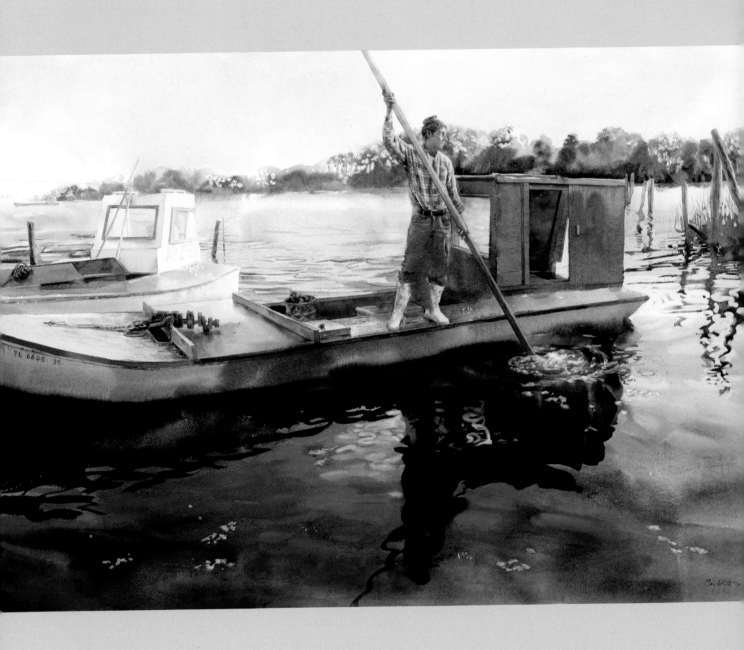

PAINTING PORTRAITS *and* FIGURES IN WATERCOLOR

MARY WHYTE

Watson-Guptill Publications | New York

Published in the United States by Watson-Guptill Publications, an imprint of the Crown Publishing Group, a division of Random House, Inc., New York.

www.crownpublishing.com

www.watsonguptill.com

WATSON-GUPTILL is a registered trademark and the WG and Horse designs are registered trademarks of Random House, Inc.

Library of Congress Cataloging-in-Publication Data

Whyte, Mary.

Painting portraits and figures in watercolor / Mary Whyte.

 p. cm.

 Includes index.

 ISBN 978-0-8230-2673-9

1. Watercolor painting—Technique. 2. Portrait painting—Technique. 3. Figure painting—Technique. I. Title.

 ND2200.W49 2011

 751.42'242—dc22

2010045653

Printed in China

Design by Karla Baker
Front cover design by Karla Baker
Front cover art by Mary Whyte

10 9 8 7 6 5 4 3 2 1

First Edition

TITLE PAGE *Tonger*
2009, watercolor on paper, 27 x 40½ in.

COVER *Explorer*
2008, watercolor on paper, 27 x 20 in.

OPPOSITE *Red*
2009, watercolor on paper, 22 x 18 in.

FOR MY STUDENTS, PAST AND FUTURE.

Acknowledgments

I am grateful to the many skilled professionals who helped create this book, especially Katie Lindler, who worked long evenings compiling and organizing the endless components of my paintings and writing. Thanks are also due to Marilynn McMillan and Croft Lane for always presenting my work in the best light. Most of all, my deepest gratitude goes to my friends and family, especially to my husband, Smith Coleman, for making mine a wonderful life.

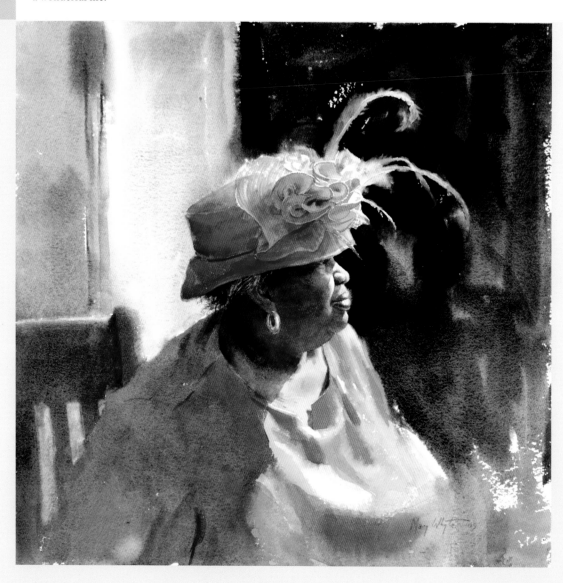

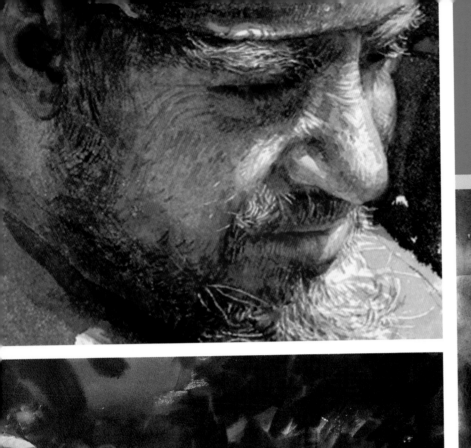

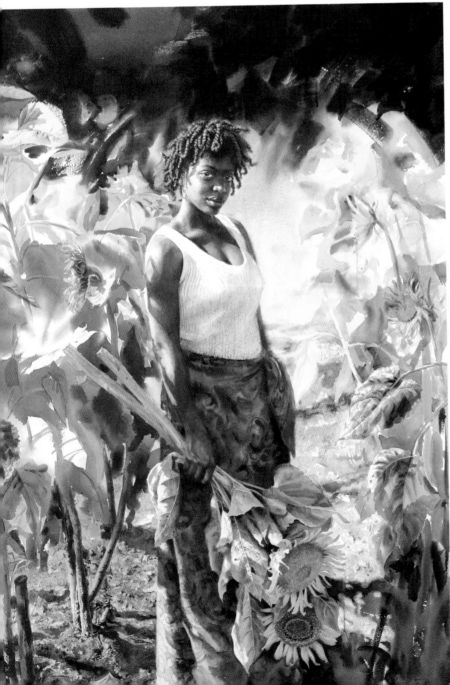

contents

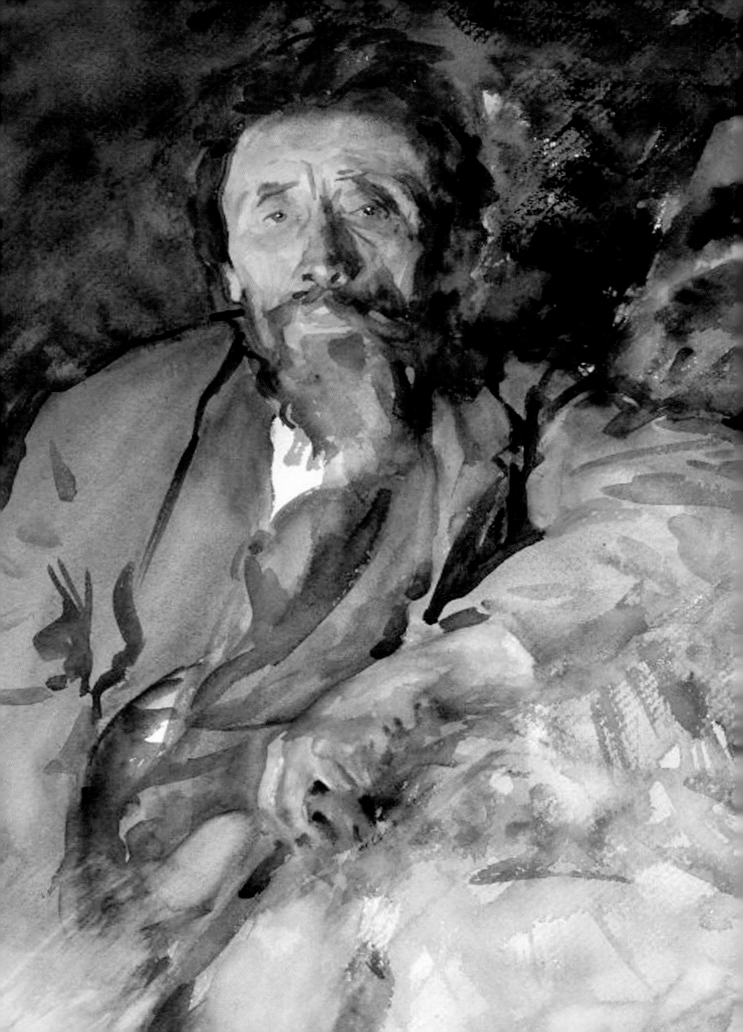

introduction

"Every portrait that is painted with feeling is a portrait of the artist, not of the sitter."

—OSCAR WILDE

PERSONAL PHILOSOPHY

Watercolor is the essence of the human spirit: It is lively, spontaneous, engaging, unpredictable, beguiling, and has a will of its own. It has so many of the same characteristics we humans do, why *shouldn't* it lend itself to painting portraits? Watercolor's natural luminosity can easily duplicate the fresh, translucent look of skin, as well as aptly render interesting textures of clothing, hair, backgrounds, and atmosphere. The lightweight and less cumbersome supplies needed for painting in watercolor make it much more practical for travel, outdoor studies, and quick, abbreviated sketches of the model. It is a medium perfectly suited for exploration, dreams, and discovery.

There is no "right" technique or style to painting people. The way I paint is only *one* way. With earnest effort and hard work, you will find *your* way. The information in these pages will offer an explanation to understanding color, light, techniques, composition, materials, and working with the model. Most of the chapters include a demonstration that will show you the methods I use in my own work and how I resolved certain challenges and problems. After each section I have included a few suggested exercises to help you with your exploration of the medium and to further develop your personal vision as an artist. There are no recipes, shortcuts, or rules. There are only the guidelines and encouragement that I have been offering students over my thirty years of teaching.

I started painting people in watercolor when I was in high school. My first attempts were predictably muddy and overworked, but I was enthralled with both the power and the delicacy of the medium. At the time I had no intention of being a portrait painter, but after I graduated from art school folks began asking me for paintings of their families. I soon discovered that I truly loved painting people, and if someone was actually going to *pay* me to paint them, what could be better? It was like being paid to go to the amusement park. Since then, a great deal of what I have learned about painting in watercolor has been through experimentation and what I have garnered from studying the works of artists I admire.

Painting portraits is a special breed of art. It requires sound drawing skills and a general understanding of human anatomy and how it works. It also requires that you have empathy and respect for your subject and are able to see the unique physical and emotional qualities of the one person you are painting. In watercolor portraiture, having surefooted drawing skills is imperative, as making corrections can jeopardize the freshness of a painting. Nonetheless, it is not enough to be a portrait painter. First and foremost you must be an artist, a maker of images that appeal to the senses.

This is largely a book about seeing—how to see values, weigh color, select backgrounds, get a likeness, and draw more accurately. It is also a book about thinking. As an artist it is not enough to know what you are seeing and painting; it is important to know *why* you have chosen to paint something and how you *feel* about it. In my studio I have a small hand-lettered sign that reads, "A man who works with his hands is a laborer, a man who works with his hands and brain is a craftsman, but a man who works with his hands, his brain, and his heart is an artist." I have kept the quote tacked to my wall for over thirty years as a reminder that painting not only requires hard work and intellect, but that it also requires passion and emotion. Being an artist requires that we not only feel what it is that we are

OPPOSITE John Singer Sargent, *The Tramp*
1904, watercolor on paper, 20 x 14 in.
Brooklyn Museum of Fine Art

Sargent's expressive use of a variety of techniques such as washes, scraping and opaques shows the unlimited possibilities of the watercolor medium.

painting but that we have the tools to describe these feelings to others.

Whether your goal is to be a professional portrait artist or to derive pleasure from painting on weekends, this book will guide you in the fundamentals of making a sound expression in watercolor. And if all you do is read this book and never pick up a paintbrush, my hope is that you will forever derive a greater understanding and happiness from viewing art and the extraordinary world around us.

Most of all, my desire is to encourage and inspire you to paint like *you*. Since the day you were born you have been given a unique set of family members, experiences, preferences, geographic familiarities, educational opportunities, challenges, influential people, and physical characteristics. No one else can claim this exact mix of personal data except you. It is what can make your work wholly original and provide you with endless lifelong discoveries as a painter. As an artist, you possess the amazing ability to exclaim with feeling the very essence of the people and circumstances of your own lifetime.

Mary Whyte

LEARNING FROM THE MASTERS

John Singer Sargent described watercolor as "making the best of an emergency." The artist aptly referred to a medium that is at once elemental in its simplicity, illusive in its control, yet able to capture the vagaries of the artist's temperament and world around us. Our most valuable education in art will come from the accomplished artists who have gone before us. By studying their works, we can glean methods of technique as well as what they viewed as essential in portraying their subject matter.

Some of the earliest watercolors may be those of Raphael in the early sixteenth century, when he sent designs for his Vatican tapestries to the Flemish weavers in Brussels. The full-scale cartoons were done in color, with the hues fixed in a form of animal glue and mixed with white, much like today's gouache. At the same time, Albrecht Dürer was using a similar-bodied pigment for his well-known studies of animals and micro-landscapes. Other beginnings in watercolor painting were evident in the illuminated manuscript, or book decorations, and then later in the miniature portrait.

The first works of art in the Western tradition to be produced in this country were watercolor. Artists such as Jacque Le Moyne in the sixteenth century, and later Edwin Whitefield and John James Audubon, made use of the water-based medium during expeditions to record images of the newly discovered western territories and their birds and animals. The compact portability of watercolor made it ideal to record accurate renderings for botany and zoology and also to describe the effects of the landscape's changing light and atmosphere.

Most of the works being done in America at the time were portraits painted in the European Baroque tradition. Miniature portraits became fashionable in the nineteenth century with the rising middle class, partly because the small likenesses were durable and could be easily transported. Henry Benbridge (1722–1789) was a southern artist whose portraits on small ovals of ivory were meticulously done using a stippling effect. The miniscule brush marks Benbridge used were painted with just the few hairs of a pointed brush to achieve his convincing textures of skin, hair, and clothing. Other well-known artists of the period, such as Benjamin West, admired the look of the medium and did numerous "watercolors," which were later discovered to be not watercolor at all but oils thinned out to mimic the luminous effect.

Most artists of the time regarded watercolor as a mere sketching tool for working out preparatory drawing ideas for future oils and not as a predominant mode of expression. One such artist was Thomas Sully (1783–1872), who reportedly did over two thousand portraits in his lifetime. In his early years, Sully produced mostly miniature portraits, and at the age of nineteen he produced his first oil painting. He was hugely successful, with clients from Boston to Charleston, as well as having done a portrait of Queen Victoria. As a mature artist, Sully increasingly turned to watercolor to flesh out drawings for future paintings, often filling entire sketchbooks with studies that evoked a sentimental narrative. A page from his sketchbook titled *Sheet of Figure Studies* depicts several

Henry Benbridge,
Portrait of William Gibbes
1743, watercolor on ivory, 1¼ x 1⅛ in.
From the collection of the Gibbes Museum of Art, Charleston, South Carolina

Early American artists made use of ivory's white, durable surface to show off the luminous qualities of watercolor.

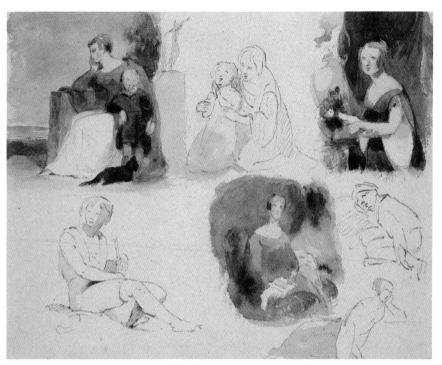

Thomas Sully, *Sheet of Figure Studies*
Circa 1830–1839, pen and brown ink on watercolor paper, 8¾ x 11½ in.
From the M. and M. Karolik Collection, Museum of Fine Arts, Boston

Many of the watercolor sketches, such as the ones shown, were submitted to clients for consideration and can be linked directly to finished oil portraits.

BELOW Winslow Homer, *Girls on a Cliff* 1881, watercolor on paper, 19½ x 12½ in. Bequest of David Kimball, Museum of Fine Arts, Boston

Homer's use of figures in the windblown landscape would become one of his trademark motifs.

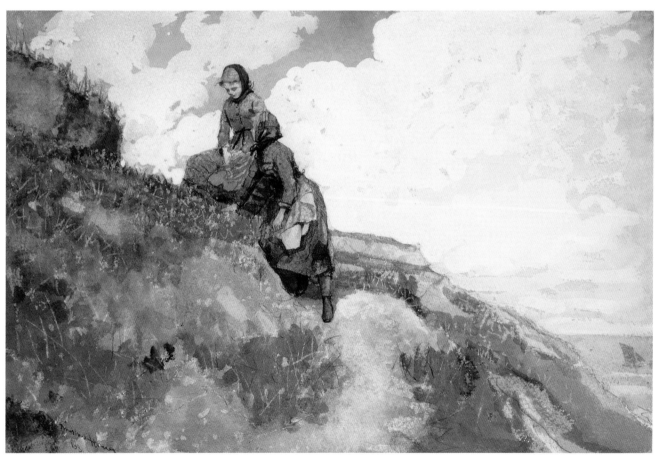

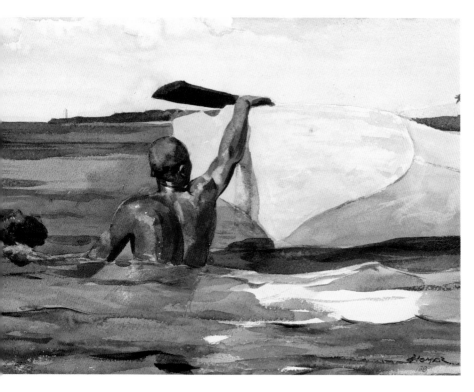

Winslow Homer, *Sponge Diver*
1898, watercolor on paper, 15 x 21 in.
Collection of the Museum of Fine Arts,
Boston

Homer's grasp of watercolor enabled him to
paint almost any subject matter with seem-
ingly few details. Here, the essence of water,
sky, and the muscularity of the diver are
rendered with clarity and feeling.

careful renderings of people in different poses. Sully often ex-
tolled the virtues of using watercolor sketches to his students
and included the advice in his book *Hints to Young Artists*,
which was published the year after his death.

Up until this period, watercolor was still considered as a
medium for amateurs. Its genteel qualities appealed to women,
and before long watercolor had taken the place of embroi-
dery as a cultivated, leisure occupation, particularly in the
eighteenth and nineteenth centuries. Classes for women were
available in many large cities, with the favored subject matter
usually flowers.

It wasn't until the late 1800s that watercolors were
deemed by the public to be worthy of collecting. America
went from a mirroring of what was being painted in Europe to
a having a dominant position with the newly adopted medium
of watercolor. Several artists, such as Winslow Homer (1836–
1910) and his lifelong friend John LaFarge, enjoyed great
success at this time, with Homer's first one-man show of just
watercolors exhibited in 1880. Homer's work was especially
well received in Boston, where New Englanders' avoidance of
anything too ostentatious made watercolor, as opposed to oils,
the perfect, more modest collectable. By then the American
Watercolor Society had been started (with Homer as a found-
ing member), and America had embraced its new medium.

Homer was the first artist to show true technical bravura
and carry the potential of watercolor to its furthest limits.
A self-taught artist, he began as an illustrator for *Harper's
Bazaar* and later would revolutionize the medium and be
the first to produce watercolors on paper of epic scale and
meaning. Many of Homer's watercolors were executed based
on his knowledge of oil technique, with clearly demarcated
areas. Highlighted areas were often painted using thick, white
opaque paint.

Many of Homer's works were painted in the Adirondacks
or near his studio in Prout's Neck, Maine, where he lived
an isolated life. He was a devoted *plein air* artist and wrote
that he preferred painting outdoors to get the true essence of
the subject. Although he did many of his paintings indoors,
Homer lamented that in the studio "You get composition, but
you lose freshness: you miss the subtle and, to the artist, the
finer characteristics of the scene itself."

In 1881, Homer sailed to England, where he stayed for a
year and a half. His painting *Girls on a Cliff* shows two young
girls picking flowers on a cliff high above the sea. His use of
opaque white is evident in the depiction of billowing clouds,
as well as his use of blotting, lifting, and scraping techniques
to enliven the ground and vegetation.

Several years later, Homer would paint his most mature

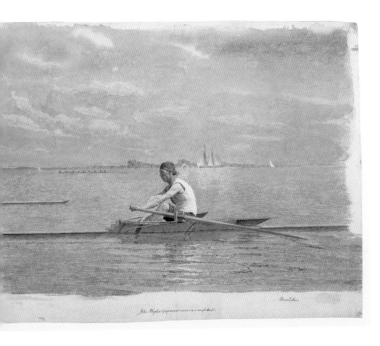

Thomas Eakins,
John Biglen in a Single Scull
Circa 1873–1874, watercolor on paper,
19⅝ x 24⅞ in.
The Metropolitan Museum of Art

Thomas Eakins frequently used friends as models. His careful attention to perspective and proportion gives his paintings volume and depth.

OPPOSITE Mary Cassatt, *Self Portrait*
1878, watercolor on paper, 23⅝ x 16³⁄₁₆ in.
National Portrait Gallery, Washington, DC

Though best known for her oil and pastel paintings of figures, Cassatt was equally adept with the medium of watercolor.

watercolors in the Bahamas and Bermuda, which he said were "as good work as I ever did." His painting *The Sponge Diver* depicts a half-submerged diver seen from the back clinging to the stern of a boat with one hand and grasping a sponge in his other hand. Homer's bold, wet brushstrokes are masterfully done, depicting the man's glistening back as well as the jewel-like expanse of water. It is believed that the painting was later reworked in the studio, scraping away the upper part of the landmass at the right to suggest greater recession into the distance. To bring more focus to the diver and boat, Homer marked the image for cropping, nearly an inch in on both sides of the painting.

Thomas Eakins (1844–1916) was an instructor for many years at the esteemed Pennsylvania Academy of the Fine Arts in Philadelphia, where he maintained a highly influential presence in the art world. Eakins's renderings with watercolor had a more polished finish, as he imbued his watercolors with the same attention to detail as his oils. Though Eakins was known best for his oils, the artist sometimes did oil paintings as studies for future watercolors, such as *John Biglen in a Single Scull*. For this painting, he worked out the convincing sense of depth by drawing a mathematical diagram, a method he learned from his father, who was a calligrapher. Eakins would employ the method of using a precise grid as an aid for drawing perspective for most of his career.

The artist's first works upon returning from Europe fea-

tured a large group of rowing scenes, which included oils and watercolors. Breaking from the traditional scenes and motifs of his contemporaries, Eakins's theme of men sculling on the river in Philadelphia had never before been depicted in art. *The Sculler* (1874) was the artist's first known watercolor to be sold.

Mary Cassatt (1844–1923) was an American painter and printmaker who lived most of her adult life in France. It was there that she befriended Edgar Degas and showed her works with the innovative Impressionists. Cassatt began her formal art training at the Pennsylvania Academy of the Fine Arts at the age of fifteen and would continue her studies through the Civil War. Although she came from a wealthy family, her father was not supportive of her desire to be a professional artist and insisted she pay for her own art supplies.

Although she was proficient in oils, pastels, and printmaking, Cassatt was also comfortable working in watercolor, as seen in her *Self Portrait*. The image shows the artist dressed in the fashionable style of the time, with an elegant hat casting a shadow over her face, and looking past her easel toward the mirror (and viewer). Her style is confident yet explorative, done in abbreviated washes and brushstrokes of broken color that would become her signature style. Cassatt was intrigued for most of her career with the shapes and textures of current attire and often used socialites as figures in her paintings. However, many of her most recognizable images

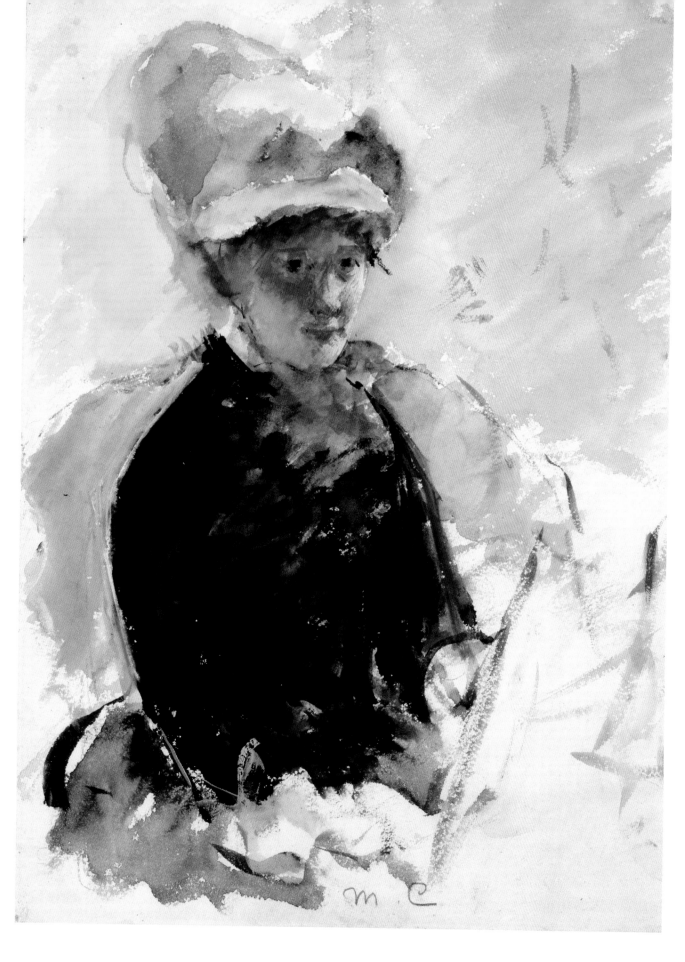

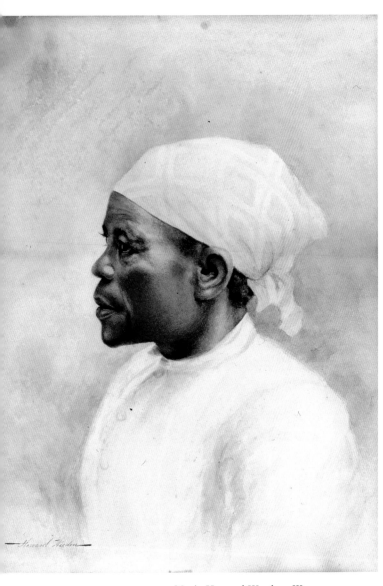

Maria Howard Weeden, *Woman*
1895, watercolor on paper, 14½ x 10½ in.
Collection of the Greenville County Museum of Art, Greenville, South Carolina

Weeden's portraits were often devoid of background, and though generally the subjects were models with little means, they were given a sense of formality and dignity, as seen in her painting *Woman*.

and legacy would be depictions of everyday mothers tending to their children in intimate settings.

Another woman artist of the same period, Maria Howard Weeden (1847–1905), lived a more modest lifestyle. As a Southerner, the Civil War left Weeden impoverished and reclusive, with little opportunities for training. In the South, materials were particularly scarce, as were clients with the money to buy art. Accomplished at drawing, Weeden resorted to doing portraits of her cooks, gardeners, and nannies in sepia-toned washes. Many of the artist's simple portraits were reminiscent of the newly emerging black-and-white photographs of the period, which may well have prompted her fascination with using a monochromatic palette.

John Singer Sargent (1856–1925) worked in watercolor throughout his career, but it wasn't until he was in his forties that his interest in the medium accelerated. Many of Sargent's watercolors were done during vacations to Venice and Spain as a welcome diversion from the pressures of his portrait commissions. Sargent worked quite rapidly on damp paper, often with a limited palette, spreading the washes to the edges and then adding a few final highlights and accents in gouache. Inventive in the techniques he used, the artist often employed methods such as scratching out and lifting, and he used different resists—including wax crayons, as seen in his painting *The Cashmere Shawl*. In the painting of his sensuously posed woman, Sargent scribbled on the background wall with the wax crayon, suggesting texture and achieving a pleasing contrast to the soft-looking fabrics worn by the model.

Sargent frequently traveled with an entourage and engaged them as models. The subject for *The Tramp* may well be landscape painter Ambrogio Raffele, who became a frequent sketching companion of Sargent in the Italian Alps. The watercolor showcases the wide range of brushwork Sargent was known for: sculptural strokes, soft masses, ethereal washes, and dry brush. The convincing form is rendered freely and without a trace of pencil.

Maurice Prendergast (1858–1924), like Winslow Homer, spent several years studying in Europe. It was presumably there that Prendergast first saw the watercolors of Cézanne, which would change the course of the artist's future work. Prendergast greatly admired the way Cézanne left everything to the viewer's imagination: distilling objects to their most intrinsic shapes and colors, leaving areas of white paper, and creating passages with active, abstracted notes. Prendergast's charming watercolor *Handkerchief Point* shows dozens of

figures in the landscape, each depicted in jewel tones and rounded shapes. Prendergast's career was buoyed by several enthusiastic collectors who not only purchased his work but funded his efforts. Sarah Choate Sears, a wealthy socialite, began purchasing watercolors and monotypes by Prendergast in the mid-1890s and is believed to have financed his 1898–1899 trip to Italy. There is little doubt that such a powerful endorsement influenced the successful career of the artist and encouraged others to invest in his work as well.

In the 1920s, watercolor exploded in the United States. Many artists such as Edward Hopper concentrated on watercolor as a response to the market, as previously he had been unable to sell any of his works. Other artists like Frank Benson (1862–1951) were equally popular and enjoyed great achievement and prosperity. Benson turned increasingly to the depiction of landscapes featuring wildlife, which was an outgrowth of his and the public's interest in hunting and fishing. Benson sold to clamoring collectors, with ten one-man shows of his watercolors and etchings in 1923 alone. His watercolor of *Old Tom* depicts his longtime caretaker, Tom Nickerson, with his masculine hunting attire, a gun, and a dead goose.

Henri Matisse (1869–1954) would take watercolor in a new direction with his determination to simplify the illusion of three-dimensional space and the human figure. Known for his flattened, cut-out shapes, Matisse approached watercolor with an equally simplistic interpretation, giving free rein to the medium. Matisse's *Nude*, dated about 1905, would set the course for a more innovative approach to the new American medium by allowing the watercolor to flow across the paper without restraints. For his 1908 New York debut, and subsequent exhibition in 1910, Mattise's work consisted largely of watercolor and works on paper, giving new status to the medium.

By the 1920s, the standards of the traditional ateliers had been swept away by the more forward-thinking avant-garde. Since watercolor wasn't being taught in the art schools, the opportunity for more freedom of personal expression created the perfect gateway for contemporary American artists to take the medium to new heights. Watercolor could now move away from the traditional highly representational look to paintings with more vigorous brushstrokes, white spaces, and areas of color breaking free from the original drawing with forms that were suggested rather than defined. Leaders of the modernist movement, such as Edward Hopper, Charles Burchfield, William Glackens, Charles Demuth, John Marin, and Georgia O'Keeffe (1887–1986), would adopt watercolor as a primary

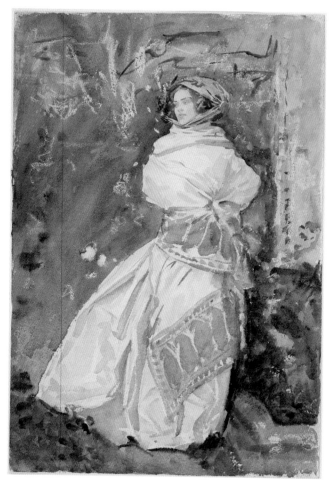

John Singer Sargent, *The Cashmere Shawl* 1911, watercolor on paper, 20 x 14 in. Hayden Collection, Museum of Fine Arts, Boston

The cashmere shawl was one of Sargent's most reoccurring props in his work and was painted with simplicity, yet with a convincing sense of form.

medium for part or all of their careers. O'Keeffe's painting *Seated Nude XI* is an example of the artist's exploration of form through the medium.

Since then, watercolor has made even further strides with noted twenty-first-century figure painters such as Andrew Wyeth, Jamie Wyeth, Stephen Scott Young, Dean Mitchell, and Henry Casselli. From these artists, as well as from the masters of the past, we have learned that there are no limits to the ways in which watercolor can be manipulated or to the subject matter and style in which it can be applied.

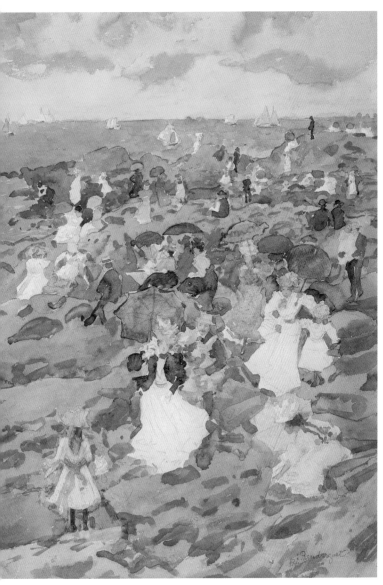

Maurice Prendergast, *Handkerchief Point*
1896–1897, watercolor on cream paper,
19⅝ x 13¾ in.
Museum of Fine Arts, Boston

Prendergast gives us a convincing sense of
a crowd of people enjoying a summer day,
with cheerful interlocking and overlapping
shapes, dotted by small sparkles of white
paper. It is a painting that does not pull the
eye to one specific area of literal narrative
but lets the viewer delight in the qualities of
the watercolor as a whole.

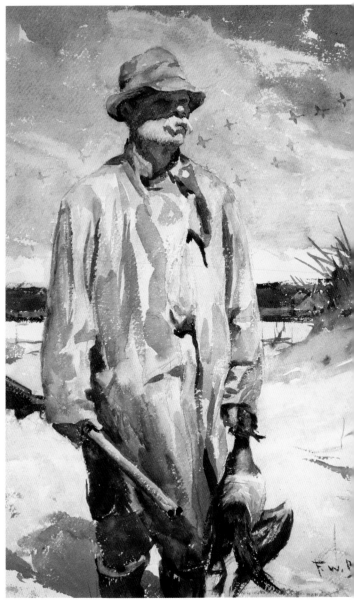

Frank Benson, *Old Tom*
1923, watercolor on paper, 20⅟16 x 17⅟16 in.
Museum of Fine Arts, Boston

With the popularity of sporting scenes
growing, many artists of the time, such as
Benson, focused on portraying men in hunt-
ing scenarios.

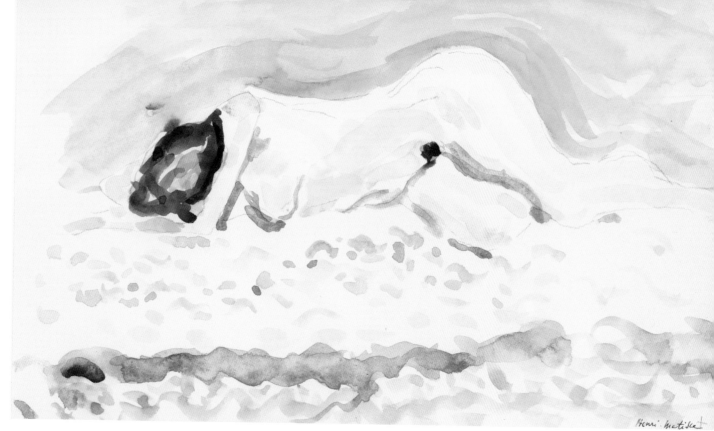

Henri Matisse, *Nude*
Circa 1905, watercolor on paper, 5¾ x 9⅝
x in. From the Alfred Stieglitz
Collection 1949, The Metropolitan
Museum of Art

Matisse set out to present qualities of the
human figure in a way that had never before
been done. Working in watercolor allowed
him to explore the shapes, colors, and mood
of the female nude.

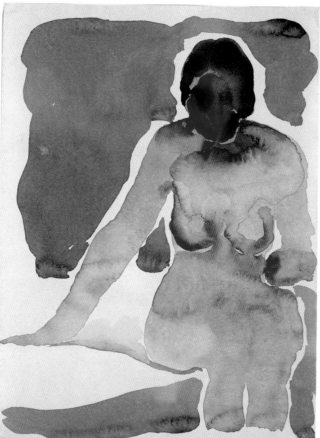

Georgia O'Keeffe, *Seated Nude XI*
1917, watercolor on paper, 11⅞ x 8⅞ in.
The Metropolitan Museum of Art

O'Keeffe experimented extensively in water-
color, often laying the loose sheet of paper
on the floor and working in a crouched posi-
tion. By working flat, fluid washes could be
puddled together on the paper, separated
by small areas of dry paper, creating pristine
outlines of white.

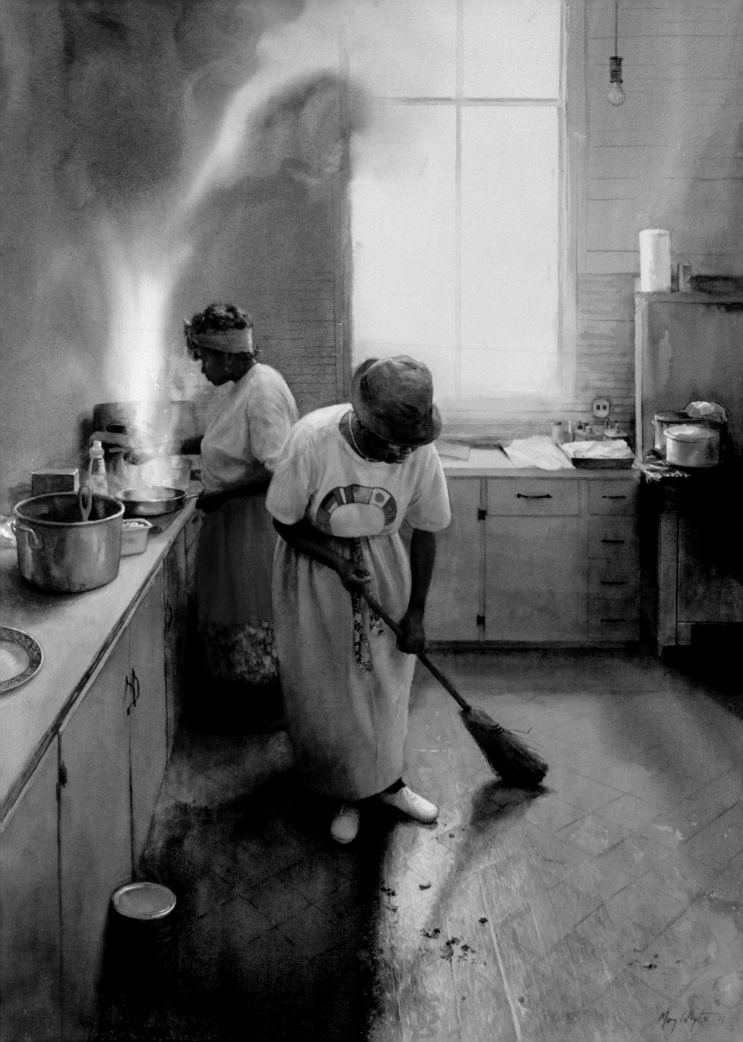

getting
started

"*Painting is easy when you don't know how,
but very difficult when you do.*"

—EDGAR DEGAS

Being an artist has to be one of the most gratifying ways there is to
make a life and a living. You have your own working hours, you make
your own decisions, you choose where you want to paint, and you
spend your days discovering and expressing in your own way what
you believe to be beautiful. As artists, we are constantly engaged in
using this special gift we have been given to translate the diverse world
around us into a readable image made of paint on paper or canvas. We
not only recognize what is truly beautiful, but we are given the tools to
share what we see and feel with others. It is an extraordinary privilege.

OPPOSITE *Wednesday Chores*
2004, watercolor on paper, 38 x 28½ in.

Painting people you know can add special meaning to your work.
This is a group of women whom I have been painting for over twenty
years near my home on Johns Island in South Carolina. Although
the painting is not meant to be a portrait of specific individuals, the
watercolor captures the essence of the women's character.

WHY PAINT PEOPLE?

Having an interest in painting people opens up an even greater world of possibilities and rewards. The human face is an endless landscape of shapes, textures, and nuances of color. Each person we look at presents a unique arrangement of interesting possibilities to consider. With each model there are a hundred different poses, color combinations, and lighting conditions that might be employed, each one resulting in a very different painting. One tiny change in the corner of a mouth or tip of the eyebrow can dramatically alter the mood of the painting. A different angle of lighting source can enhance certain features and characteristics. However, each portrait is more than settling on a suitable pose and copying the model's features. Each

portrait becomes the sum of humanity, along with everything we have come to know and recognize in ourselves.

Compared to that of an artist, few professions offer entrée into so many different ways of life and the chance to meet so many interesting people. As artists, we can spend the morning sketching and chatting with a hog farmer and the evening of the same day find ourselves discussing art with a bank president. Spending time painting the people around you not only offers a glimpse into how other people live and think, but it can give you the opportunity to experience the world in a way that is much more personal and fulfilling. Painting another human being with emotion and sensitivity not only clarifies

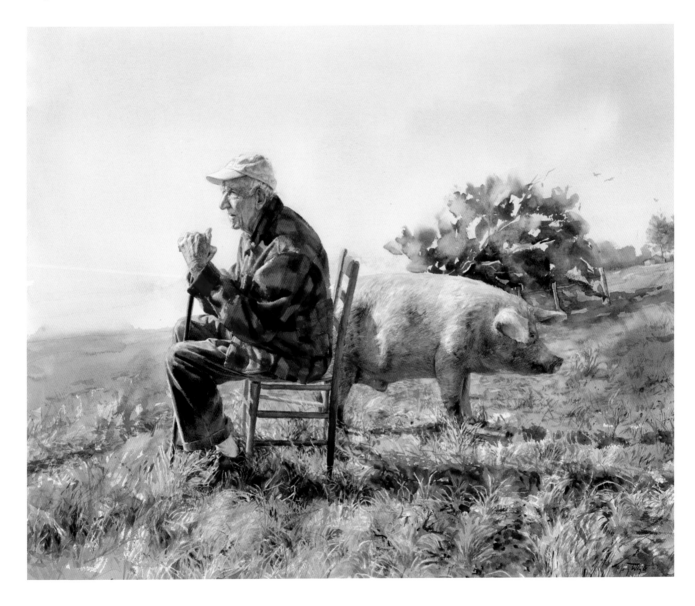

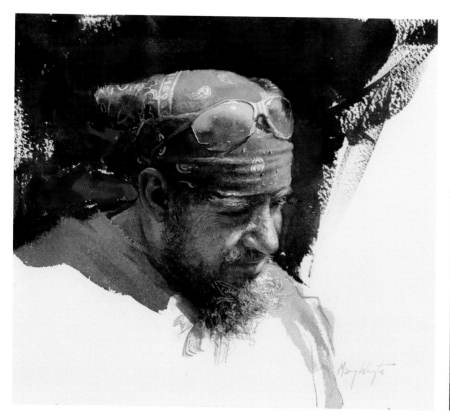

2009, watercolor on paper, 15⅞ x 17⅛ in.

The human head is endless in its array of interesting shapes, colors, and textures. People from all walks of life can make interesting models, with an infinite number of poses and possibilities for artistic expression.

ABOVE The details of the head and face can be great fun to paint. Textures such as beard stubble, wrinkles, clothing, and glasses all add visual interest and narrative to a painting.

what you know about living in today's world but also how you feel about it. Your finest paintings of people will end up being the ones that were done with the most empathy and sense of personal connection.

Whether your paintings hang in public places or are simply sketches of your grandchildren done for pleasure, you will be creating your own legacy. And more important, you will be leaving behind proof of having lived a full and engaging life.

OPPOSITE *Sentinel*
2010, watercolor on paper, 28½ x 34½ in.

Being a painter of people will give you the opportunity to meet many different folks in your lifetime. As an artist you will find that most people are encouraging of your efforts and often willing to model, even in unlikely places.

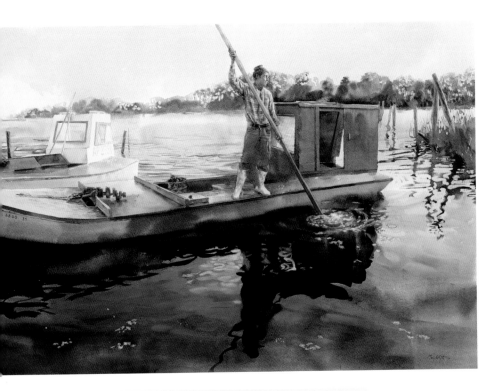

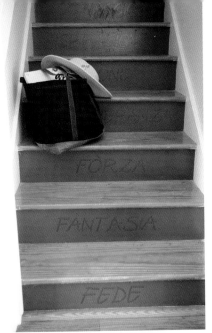

Becoming an accomplished artist takes years of practice, learning the skills of drawing and technique. Sincere effort will always go further than ability.

LEFT *Tonger*
2009, watercolor on paper, 27 x 40½ in.

For many artists, there is nothing more satisfying than painting the people around them. This is a painting I did of an oysterman from Florida. I spent a couple of days drawing and sketching him, and in the end I made a painting as well as a friend.

ABOVE The seven steps to my studio are each painted with a pertinent word in Italian as a daily reminder of what I need to be an artist. For me, the most important element for my work is faith.

TALENT

I am sometimes asked by students if I think they have the talent it takes to become an artist and whether they should bother investing the time needed to become a good painter. My reply is always the same: *How sincere are you, and how hard do you want to work?* Whether one is born with artistic talent is a topic that can be debated. Having the necessary abilities for making art, such as drawing well or mixing color, isn't something we are born with. What we are born with is the interest and desire to express the world around us. The skills come only with dedicated learning and years of practice. So don't worry about whether you think you were born with a bucket of talent or not. And above all, don't make your goal to be famous or to please everyone, as this will dictate and ruin every brushstroke you will ever do. If you already have the interest and strong desire to create art, the question is not about if you are talented but about what you are going to do about the abilities, motives, intelligence, curiosity, and sensitivity that you already possess.

There is no way to reassure someone that he or she has the makings of a successful artist, as it is impossible to predict if and when true mastery will occur. The requirements needed to become competent in painting are a complex mixture of education and work, with a pinch of luck, health, and timing undoubtedly thrown in. On the risers of the steps leading up to my studio I have seven words written in Italian. Translated into English, these seven words are the key ingredients of what I need every day when I am in my studio: *faith, imagination, strength, perseverance, vision, courage,* and *inspiration.* Talent isn't mentioned.

WHERE TO START

If your goal is to become an artist, then you will have to make a few decisions about how you spend your time and efforts. Learning to do anything well—flying a plane, playing a violin, riding a horse, speaking a foreign language—takes discipline and time. Painting is a skill that cannot be learned casually. Laziness never produced achievement. If you want to spend the afternoon seriously painting, you cannot spend the afternoon playing golf. To do one thing well, sacrificing other activities must happen. If the idea of sacrifice makes you uneasy, think of it as giving yourself the opportunity to do something you really love. When you are going after what you truly desire, getting up the learning curve can be the most interesting part of all.

There are many artists who claim to be self-taught. I'm not sure having a lack of schooling is something to brag about, but to some degree we are all self-taught. Painting is primarily a solitary business in which we are left to our own devices and imagination to solve artistic problems. Nonetheless, there are artists who unfortunately believe that a formal education will inhibit spontaneity and deplete the maker of any originality. It is a misguided opinion, since a full education allows the artist to choose from a complete repertory of personal expression. Fundamental instruction is worth its weight in gold, for it will set your sights higher and open the doors of possibilities wider than you could ever do for yourself.

Ultimately, you will be your own best teacher. Just your wanting to learn to paint will help to point you in the right direction, as you seek out the best instruction and examples to further your knowledge. Making the decision to commit some of your time to painting is the place to start. Whether it is done by setting aside one morning a week, planning to paint on weekends with fellow artists, enrolling in a class, or visiting a museum, any amount of time spent pursuing art will be beneficial, to both your mind and spirit.

And don't say you are too old. Painting is one of the few vocations where age is an asset. All of your life's experiences, passions, and dreams come into play every time you pick up the brush. Youth or physical prowess has no advantage in the studio. It doesn't matter what one's sex, age, height, size, or heritage is to become an accomplished artist. All it requires is a brain and eyes, the ability to hold a brush or pencil, and the desire to translate what you see and feel. The great statesman Sir Winston Churchill took up painting when he was forty

years old. In his book *Painting as a Pastime*, Churchill wrote that to find himself "plunged in the middle of a new intense form of interest and action with paints and palettes and canvases, and not to be discouraged by results, is an astonishing and enriching experience." To start painting at middle age, for him, required no less than a sense of adventure and a bit of audacity.

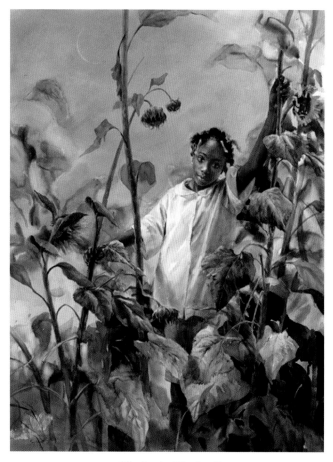

The Last of the Sunflowers
2009, watercolor on paper, 46½ x 34½ in.

Learning to paint in watercolor is an ongoing process. Knowing how to make soft and hard edges depends on timing, which takes practice. In this painting I incorporated the use of gouache in the background, to give a milky glow to the sky, and painted most of the background leaves wet-into-wet.

FAILURES

There are a lot of reasons people do not pursue something they really want to do. It can be time constraints, financial considerations, or health reasons. Often it is simply a fear of failing. Failures are a necessary part of learning. If we did the same successful painting over and over again, how would we get any better?

Don't be afraid of making bad works. Keep your disastrous paintings long enough so that you can study them and understand what went wrong. Each one is a lesson of what not to do next time. Don't just give up and say, "I'll never be a good painter." Instead, say, "I am becoming a better painter because I know not to make *that* mistake again." I like to think of every bad painting as a stepping-stone to the good ones. I have made hundreds of mistakes, some of which I tore up, some of which made it into a frame and shouldn't have. I look back and wish all my earlier paintings were better, but I know I did the best I could at the time. Fortunately, I was too enthralled with painting to know just how bad my early works were. I was determined to be a painter.

In talking to many accomplished artists over the years, I have discovered that almost all of them agree that painting never gets any easier. Most beginning artists are surprised when they hear this, as they mistakenly think that after a certain point in one's art career all the learning has been done and it is simply a matter of deciding what to paint, mixing the colors and spilling them out onto the paper or canvas. Nothing could be further from the truth. As artists, we relearn fundamentals every day and are challenged to pull together what we know to express new ideas and discoveries. Unless we are making wallpaper and are painting the exact same thing over and over again, each creation presents an entirely new set of challenges that we have never encountered before. It is what makes painting so engaging, beguiling, and sometimes frustrating.

Knowing Why a Painting Fails

When you make mistakes, it isn't that you aren't any good as an artist. In your artistic growth you will make many bad paintings, and if you are willing to take risks and consider new approaches and ideas, you will stumble now and then. No accomplished artist was brilliant right out of the chute. Every one of them had to pay his or her dues with hundreds of drawings and paintings. The key is to learn from your failed works and understand what went wrong.

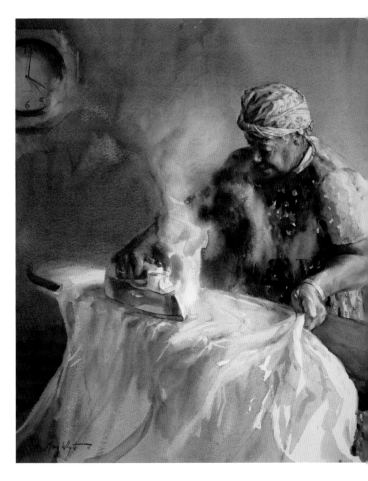

Over the years I have analyzed many failed paintings (most of which were my own) and have come to realize that there are generally two reasons why a painting fails. *Composition* and *drawing* are the two areas that seem to give most artists difficulties, and each can be the undoing of a work of art. A weak composition or a poorly executed drawing cannot save the most heroic efforts or skillful technique. It is especially critical to have a good drawing if you want to paint in watercolor, as it is a medium that will allow for very few corrections!

John Singer Sargent said the two most common mistakes he saw his students make were using a brush that was too small and too little paint. So load up that big brush and have at it!

RIGHT *Lovers*
2008, watercolor on paper, 26½ x 27⅛ in.

Painting the translucent quality of skin with its warm and cool tones is particularly conducive to the medium of watercolor. Wrinkles are simply small cylindrical forms that go from light to middle tone to dark.

OPPOSITE *Ironing*
2009, watercolor on paper, 21 x 27 in.

Becoming a good painter means you are willing to take risks that sometimes lead to failure. There are many paintings that I have done that I had to do over, such as this one. The first time I did this painting the background was muddy, and I painted the figure wearing a different-colored dress. By analyzing the painting and realizing my mistakes, I was able to make corrections and start again.

SUGGESTED EXERCISES

1 If you had the ability to paint anyone, whom would you paint? Describe in a journal how you might go about painting three people you know, their poses, and what the paintings would look like.

2 Commit to spending time each week painting. Decide if you are going to paint with a group, enroll in a class, or spend a few hours at a time working on your own.

3 Borrow or buy three books on watercolor artists, and study their work.

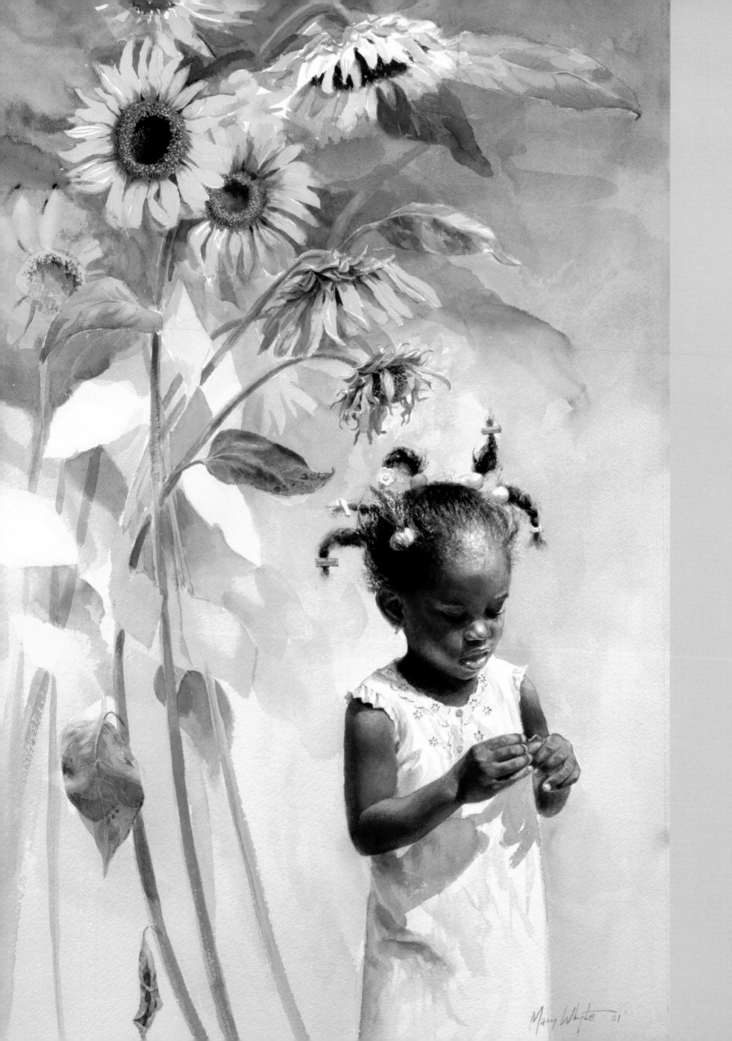

CHAPTER TWO

materials & tools

"A man paints with his brains and not with his hands."

—MICHELANGELO

OPPOSITE *Inchworm*
2001, watercolor on paper, 2⅞ x 19 in.

Having the right materials and tools will enable you to say what you want in watercolor. In this watercolor, a large brush was used to paint the background, while a small, round brush was employed to paint the details of the face and hair.

I remember a teacher saying, "Failing to prepare is preparing to fail." This admonition is worth remembering when painting with watercolor. By its fluid nature, watercolor is a spontaneous medium—and at the same time an unforgiving one. Every correction takes away from the intrinsic freshness of the medium, and if we make enough corrections we end up with mud! For the natural, effortless look of watercolor to appear, there must be an adequate amount of preparation before we start. Being a well-equipped painter takes some research as well as an initial investment in supplies. Good painting supplies can be expensive, and while most people adhere to a budget, scrimping on materials is generally not worth the trade-off. Invest in the best materials you can afford. With proper care, many supplies will last a long time—which often makes them more economical to use after all.

BRUSHES

The most important tool for the serious watercolorist is the brush. A sensitive extension of the hand and eye, this is the one tool that can most express what you want to say in many different ways. A good brush will do what you ask of it, just as if you were asking a violin to play a certain note. An inferior brush will fight against you and be unable to manipulate the paint in the way that you may want. Painting is difficult enough without having to blame a failed watercolor on an unsuitable brush.

There are limitless styles and sizes of brushes for the watercolor artist to choose from. Likewise, the prices of watercolor brushes can vary depending on the materials from which they are made, ranging from a few of dollars to a couple hundred per brush. Art supply catalogs are always promoting the "newest" brush, designed to do a specific trick. In truth, the serious watercolorist needs only a few brushes as long as they are good quality. What is important is in knowing how to *use* them. A few well-made brushes will offer the versatility and durability needed to create worthwhile paintings and last a long time.

Most fine watercolor brushes are made of kolinsky or red sable hair, because of their desired ability to hold a large quantity of paint, and you can release as much or as little as you wish. The kolinsky hair is arguably the very best there is, since it is fine, resilient, and flexible and allows both spontaneity and control. Both kolinsky and sable come from different families of the weasel, with the most prized kolinsky hair coming from the male Siberian and Manchurian marten in winter. Kolinsky hair is so valued for its performance and resilience that it can cost as much per ounce as gold. There are many brushes made with less expensive hair, such as *petit gris* (squirrel), ox, goat, badger, and pony. Several synthetic brushes are also made with very good results, and there are some good "blends," using both natural and synthetic hair.

The two most common watercolor brush styles are rounds and flats. Other types of brushes are wash, bright (short and flat), oval, mop, filbert (almond shaped), script or rigger, and cat's tongue, which is a blend of a round and flat. The numbering system for brushes goes from #000 (thin-

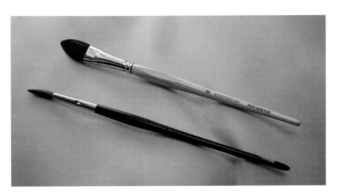

The two brushes I use the most are a #8 round brush made of kolinsky and a ¾-inch cat's-tongue brush made out of *petit gris*, which is squirrel hair.

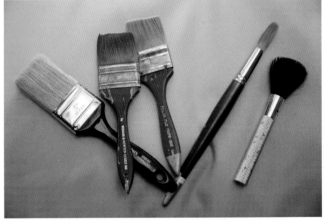

For areas of paintings that require large washes, I use 2-inch- or 3-inch-wide brushes, such as the Polar-Flo or the Winsor & Newton Series 965. The large round brush is a #36 made by Robert Simmons. The mop-shaped brush is a makeup brush and is useful for painting scratchy, textured strokes. The hair of most large brushes is synthetic for affordability.

nest) in some styles up to #40 (fattest), and wash brushes are numbered with their actual measurement—from 1 to several inches wide.

I do the majority of my painting with a #8 round kolinsky brush made especially for me by Artxpress. The brush comes to a perfect point and, depending on how I hold the brush, is made to paint a one-inch-wide stroke or an eyelash. The other brush I use is a #6 squirrel hair cat's-tongue brush, which is the perfect marriage of a flat wash brush and a more controllable round brush. With these two brushes I am able to do the majority of my paintings. Both brushes are available to the public for purchase by Artxpress. Other quality brushes for watercolor that I have used are made by Isabey and Winsor & Newton. Additionally, a wide range that combine synthetic and natural hair blends have proven most successful, such as the Winsor & Newton Sceptre series and the Isabey Syrus brush. Both are considerably less expensive than kolinsky brushes and perform well.

Stiff-haired brushes are needed for scrubbing and lifting. I use various inexpensive brushes, like the ones shown.

An old toothbrush is an excellent tool for spattering. By rubbing the toothbrush into the palette wash and then raking your thumbnail over the brush's bristles, you can create a fine, even spatter on your painting. Larger spatters can be created by flicking a loaded round brush of any size at the painting. Before you spatter, be sure to lay clean paper towels over areas that you want to remain spatter-free.

Caring for Your Brushes

Never leave your brushes standing in water. The brush hair will lose its shape, and the water will seep beneath the metal ferrule (collar), causing the wood to expand, which in turn will make the hair loosen and fall out.

Rinse your brushes by swishing them in water and then wipe them on a clean rag or paper towel. Never use soap. Wipe the brush by turning and pulling it against the towel, so that it always is returned to a proper point.

Avoid handling the brush hairs with your hands, as skin oils can eventually deteriorate the hair. Never clean a brush or form it into a point by putting it in your mouth, as some pigments are toxic.

Store brushes in a dry place such as in a brush carrier or standing upright in a container in a way so that they don't touch one another and so nothing touches against the hair. Following this routine will ensure that your brushes always maintain a perfect point.

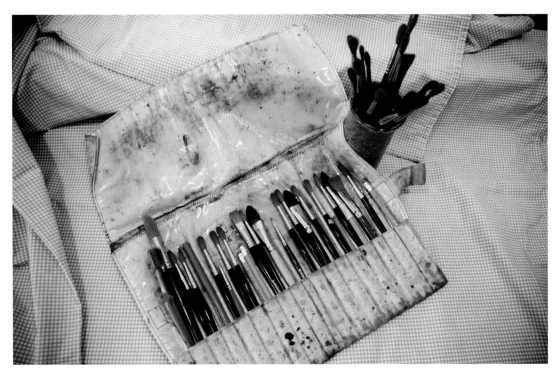

Watercolor brushes are easy to take care of. I keep mine standing in upright containers. For travel, I carry my brushes in a handmade carrier that keeps the brushes secure and prevents anything from pressing against the hairs. Many art suppliers make brush holders.

PAINTS

Although many paints are also available in the more economical student grade, my advice is to choose professional-quality paints. The higher-grade paints contain a greater proportion of pure pigment with less binder, producing a more intense, longer-lasting color. I prefer paints that come from the tube (.47 fl. oz. or 14 mL) as opposed to the small pans, because the color is richer and more saturated and the paint is easier to mix. I put out at least a gumdrop size of each color on my palette. If the color has dried overnight on the palette, I simply dribble a small amount of water on top of the paint to soak in and rewet the pigment.

When you purchase your paint you will note that the colors are priced differently. Like all paint, watercolor is made up of three components: pigment, binder, and vehicle. The pigment is what gives us the color and, depending on the availability of the pigment, determines the price. For example, some of the least expensive colors are the earth colors like burnt sienna and yellow ochre, generally because their pigments are more readily available. Certain blues and reds can be exorbitant in price, since their pigments are more difficult to obtain or manufacture. All tubes of paint will have lightfast ratings evaluated by the American Society for Testing and Materials (ASTM) printed on the tube. However, not all light fastness tests are created equal, with the ASTM standards revised or re-approved from time to time. Nonetheless, most manufacturers have improved the durability of their paints in recent years, promising greater longevity for the works of watercolorists. Still, it is worthwhile to note the lightfast ratings on the colors you buy, and choose hues with the highest ratings.

The binder, or what holds the paint together, is gum arabic, which formerly had a tendency to crack, until artists thought of adding honey or sugar to increase fluidity. Today glycerin is used in addition to gum arabic as a wetting agent, though some manufacturers such as M. Graham & Company and Sennelier still use honey in their watercolor paints.

The obvious vehicle in watercolor is water. I know of a few artists who use distilled water, though I have never seen it make any difference. The most important rule regarding water is that it must be kept clean. Dirty water will muddy any subsequent colors you mix.

You will soon discover that the different paint manufacturers differ on their opinion as to what certain colors should look like. For instance, not all cobalt blues look alike. I suggest that you try many different brands of paint so that you can decide which colors you prefer.

Paint Characteristics

Watercolor is generally thought of as a transparent medium, which is one of the reasons I find it so conducive for painting the translucent quality of skin in portraiture. However, not all hues are see-through. Each pigment has its own characteristics. Pigment colors fall into four categories: transparent, opaque, granulating, and staining. The list of colors on the following page identifies categories for each of the twelve colors that I most commonly use. I keep black and white on my palette mostly for value reference.

Several manufacturers make good-quality paints. My personal favorite watercolor paint is made by M. Graham & Company. Other good-quality paints are made by Sennelier, Winsor & Newton, Holbein, and Schmincke.

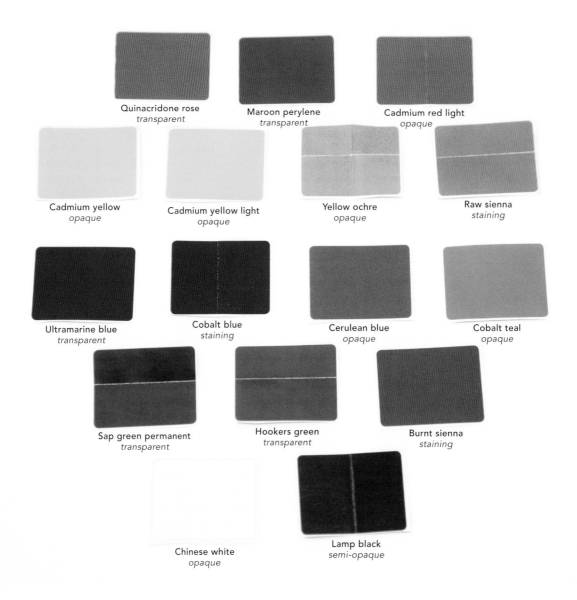

Quinacridone rose
transparent

Maroon perylene
transparent

Cadmium red light
opaque

Cadmium yellow
opaque

Cadmium yellow light
opaque

Yellow ochre
opaque

Raw sienna
staining

Ultramarine blue
transparent

Cobalt blue
staining

Cerulean blue
opaque

Cobalt teal
opaque

Sap green permanent
transparent

Hookers green
transparent

Burnt sienna
staining

Chinese white
opaque

Lamp black
semi-opaque

The colors I prefer to use are largely transparent and lend themselves to painting portraits. Rarely do I ever use black, but I like to keep it on my palette for reference. The chart shows the colors I use and if the pigments are transparent, opaque, or staining. A few colors and combinations can be considered "granulating," but this depends mostly on the particular manufacturer.

Transparent colors allow the white of the paper to show through their thin film. *Opaque* colors cover the paper or any color beneath them. *Staining* colors saturate the paper and are difficult to lift. *Granulating* colors are ones whose pigment often settles in the valleys of the paper, leaving tiny spots of color.

It is important that you are able to recognize different characteristics of pigments, as this knowledge will have a definite impact on your results. For instance, painting the delicate quality of a child's skin might require transparent colors, while her dress and a nearby tree might require more opaque colors. Transparent colors are the easiest to work with, as they mix well with other colors and almost always appear fresh, as long as the white paper still shows through. Opaque colors allow little paper to show through and are best used by themselves or with a transparent color. The result is often a "chalky" look, which may be ideal in certain cases but not others. By experimenting, you will gain more confidence as to when certain colors may be preferred.

Masking Fluid

When you wish to preserve specific areas of white in your painting, one way is to use masking fluid or liquid frisket over those parts. Made of opaque latex, masking fluid enables you to paint freely over those areas before the mask is removed. Be sure to use an old brush when you apply the fluid, as it can be very difficult to remove dried frisket from the brush hair. To protect the brush hairs, I find it helpful to wet my brush and rub it against a bar of soap before dipping it in the frisket.

Masking fluid does have a few drawbacks. My main reason for rarely using it is because after the mask is removed the remaining white shapes all have the same, mechanical hard edge, which can sometimes look unnatural. To get around this, I sometimes use torn bits of masking tape to mask out white areas. The resulting shapes will all have a softer, more irregular and pleasing edge.

Once you are familiar with the possibilities and limitations of your materials, you open the door to painting with greater confidence and freedom.

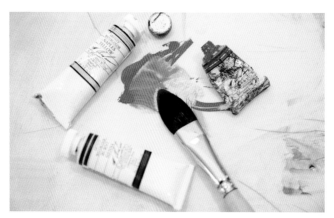

Watercolor paint is made of finely ground pigments that share their color effects when mixed with a binder and water to form a film of color on the paper. Gouache is the same as watercolor paint except that it contains opaque pigments. Gouache colors are designed to be applied opaquely, but they will crack or peel if applied too thickly or when too many thick layers are superimposed. When using gouache, lay it in thin applications.

Not all watercolor hues are transparent. Though most colors are transparent, other colors are semitransparent or even opaque. A transparent color like quinacridone rose or ultramarine blue seems to disappear when painted across a black stripe, while more opaque colors like cadmium red and cobalt teal remain visible.

To preserve white areas of the paper from subsequent washes, masking fluid can be used. Similar to rubber cement, masking fluid dries rapidly and can be removed easily once the painting is completely dry.

PAPER

There are many different makes, textures, sizes, and weights of paper for the watercolor artist to choose from. Each paper has its own specific characteristics as to how it accepts paint, and each will add a unique look to the final painting. Certain papers are more agreeable than others to specific techniques, thus allowing or inhibiting the artist's intentions. Good watercolor papers are either handmade, mold-made, or machine-made, and they are composed of either pure cotton or pure rag. Less expensive papers, made of wood pulp or blends, do not have the same durability as cotton or linen rag. The difference between papers is their whiteness, texture, or sizing. *Sizing* is generally the last step in the papermaking process and refers to adding a glutinous substance to the paper pulp to fill up pores as a protective agent. The sizing allows the watercolor washes to adhere to the fibrous surface properly without "feathering" or spreading out. Most sizings also include a fungicide to inhibit mold.

Watercolor paper surfaces fall into three categories: rough, cold pressed, and hot pressed. Surfaces vary from company to company. Rough paper has the most texture, with pronounced peaks and valleys that produce white sparkles when a heavily loaded brush skips over the surface. Hot-pressed paper is the smoothest, as it is "pressed" one final time in the manufacturing process. Because of its slick surface, colors can appear more brilliant, as there are no tiny valleys to produce optical grays. Hot-pressed paper is not agreeable to successive glazes, since its tooth doesn't hold pigment as well but will allow dried washes to be lifted, creating unique passages with soft edges and luminous lights. Cold-pressed paper is very versatile, as it allows for more controlled washes, successive glazes, and an even flow of color.

Watercolor paper is most commonly sold in individual sheets of standard sizes and weights. Traditional sizes are often called *imperial* (22 x 30 in.), *elephant* (29½ x 40 in.), and *double elephant* (40 x 60 in.). The thickness of paper is described by weight, based on what a ream of 500 sheets weighs. For instance, a ream of 140-lb. paper weighs 140 pounds. Other common weights are 90 lb., 200 lb., 260 lb., 300 lb., and 555 lb.

There are many manufacturers who make excellent watercolor paper for beginning and professional artists. My personal favorites are 300-lb. cold-pressed papers produced by Arches, Fabriano, and Winsor & Newton. I like their

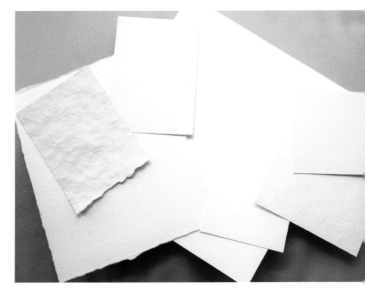

TOP Watercolor papers come in a variety of textures and degrees of whiteness. Some papers are extremely smooth, while others can be very rough. Handmade papers have uneven surfaces, which can add a lovely quality to watercolor. I prefer a cold-pressed paper, which is halfway between rough and smooth.

ABOVE Sketchbooks made for watercolor are handy for travel. I carry a spiral sketchbook made by Artxpress with me most of the time. Shown is a quick watercolor sketch I made while sitting on the beach in Mexico. Sketches like this are a good way to study the figure and can be useful later in the studio for doing more finished works.

papers' forgiving and durable surfaces, especially when painting the figure. Since I add many layers of paint and also scrub, sponge, and lift out, I find these papers to be the most compatible with my work habits. The best advice I can give the beginning and intermediate artist is to try them all. Many companies offer small sample packs of their papers, allowing artists to experiment. Eventually you will discover a paper that is meant for your temperament and style.

There are also several handmade papers available that have a unique, natural beauty with small imperfections that are appealing. Companies such as Twin Rocker and Nujabi make exquisite papers in a variety of colors and textures. Though handmade papers are much more expensive than their machine-made counterparts, the unique surface can add an additional richness to the painting.

Watercolor paper is also available in rolls, blocks, and pads. For smaller works I tend to use scraps of individual sheets. I tend to shy away from blocks. Even though the pages are attached to each other at the edges, forming a "block," the paper tends to buckle more. I use a spiral-bound sketchbook with 140-lb. paper that lends itself well to quick, portable sketches. The sizing on the paper keeps the pages from buckling beneath layers of wet washes, and the finished sketch is easy to remove from the book.

As far as which side is the correct one to paint on, most papers have a watermark showing their logo in the corner, which signifies the front. Since most of my paintings are done on Arches paper and both sides are similar, I just grab a sheet and start painting. If the painting fails, I don't think I can blame it on which side of the paper I painted!

Stretching Paper

Watercolor paper needs to be supported on a flat, stable surface during the painting process. The best support I have found for working in watercolor is called Gatorboard, which is a lightweight, acid-free board available through many suppliers. Gatorboard is similar in appearance to foam core, which framers use for backing pictures, though it is preferable for a painting support since it won't bend or warp if it gets wet. Other supports such as plywood or Homasote also aren't as suitable, since they can be heavy and cumbersome. Also, the acid content of the wood pulp can leach through to the paper and leave a permanent brown or yellow stain.

The purpose of stretching paper is to ensure that it

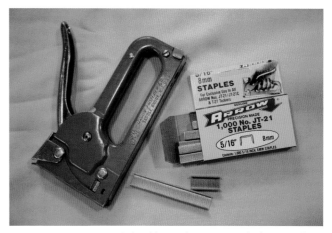

A durable staple gun is needed to stretch paper properly.

remains flat during the painting process. When the paper has been properly stretched, it can no longer expand and buckle with wet washes creating bumps and valleys. The undulations collecting puddles of washes can frustrate even the most skilled artists. Stretching paper (if done correctly) also breaks up the sizing, making the paper surface slightly more conducive to accepting pigmented washes. Very small paper sizes (under 10 inches) and heavy paper do not need to be stretched, since they are not apt to buckle. To break up sizing on these papers before painting, a quick swish of water over the surface will suffice. Allow the paper to completely dry before drawing or painting.

Stretching paper requires a good hand-held staple gun and an ample supply of staples. I use an old Swingline staple gun that I have had for forty years, which uses Arrow JT-21 $\frac{5}{16}$ in. staples. Other staple guns work as well, as long as the staples are ample in width and depth to secure the paper.

There are several ways to stretch paper. I have tried them all and consider the method described below to be the fastest and easiest. I usually stretch my paper at the end of the day, so that it will be completely dry for me the next morning. If I am in a hurry, I can place the wet and stapled paper beneath the ceiling fan or speed up the drying time even more with a hand-held hair dryer set on a low temperature setting.

I use $\frac{5}{16}$ in. (8mm) staples, or a similar size, and place them about a quarter inch or half inch from the paper's edge and two inches apart on all four sides. Bulldog clips and push-pins are best suited only for anchoring paper that does not need to be stretched, such as papers that are 300-lb. weight or are less than 10 x 10 inches in size. To avoid having to carry

heavy staples and a staple gun with me when painting on location, I stretch my paper in advance. Doing so guarantees that my paper is flat and dry before I start. Staple the corners last and leave your board in a horizontal position until the paper is dry.

Using cool or lukewarm water, rinse the paper on both sides, making sure the entire surface has been wetted. You can rinse paper in the sink or bathtub or by holding it under a shower. A word of caution here—do not over-soak the paper. If too much of the sizing is rinsed out, paint will not properly adhere to the paper and the color will "feather," or spread out when applied.

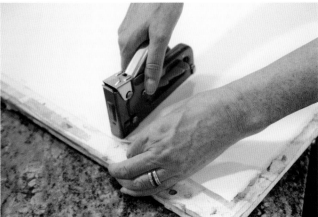

To allow your paper to absorb water, lay it down on the Gatorboard. Gatorboard is a lightweight, waterproof surface carried by many art supply stores and catalogs. Allow the paper to expand. When the paper has lost its shine, it means that the water has been absorbed into the fibers. That is your signal that the paper can be gently smoothed out, and it is time to staple it to the Gatorboard. Begin by stapling at the middle of the edge and work your way to the corners last.

Lay the board and paper on a horizontal surface until it is dry. As the paper is drying, you will see some undulations on the surface. As the paper dries, it will shrink. Once the paper is completely dry, it will be tight as a drum and should stay flat during the painting process.

PALETTES

The best watercolor palettes are made of durable white plastic and have at least sixteen wells along the outer edge for holding colors, as well as an adequate area for mixing washes. Washes tend to "bead up" on a new palette, but with use, the washes will spread out evenly. The accompanying palette lid can be used upside down as an additional large mixing area. Smaller plastic and metal palettes are manufactured for travel. The compact size allows the palette to fit into a coat pocket or handbag.

I arrange my colors in a rainbow fashion, with yellows and reds on one side; blues, violets, and greens on another side; and the earth colors on the third side. Don't worry if your paints dry out on the palette. With a little water dribbled over the dry pigment, the paint can be rejuvenated. I sometimes will add water into the paint wells at the end of the day, knowing that the paint will be adequately hydrated and soft again by the next morning.

The palette I use is an old John Pike white plastic palette that I have used for thirty years. The colors can be squeezed into the wells along the edge, and there is ample area for mixing colored washes.

EASELS

Although working on an easel isn't mandatory, it does make life easier by keeping the board propped at a consistent angle. Working upright will allow you to work on larger formats and enable you to step back from your work and see it in proper proportion. The extreme tilt of the paper will produce cleaner, more pristine washes, since the water can only flow downward.

I have three different kinds of easels that I use for watercolor. I keep a small table easel on my level drawing table. With this easel I can place my palette and painting supplies right on the table next to my painting. I generally use the table easel for smaller works (22 x 30 in. or less). For medium-sized works or for travel I use a collapsible, aluminum tripod-style easel that is easy to carry and fits into a narrow bag. For large studio works I use a heavy, large wooden easel that can support any size board.

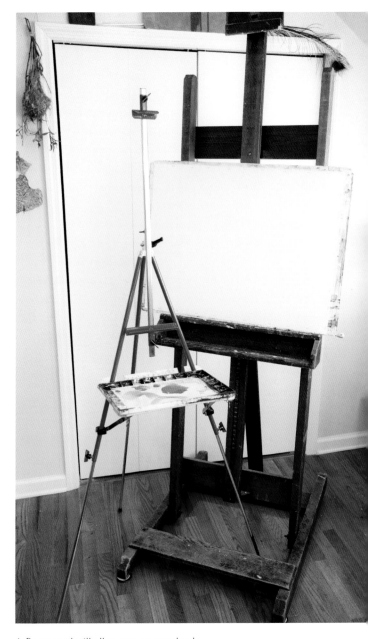

A floor easel will allow you to step back from your work and view the entire painting at once from a distance. The large wooden easel can support works up to eight feet high. The red metal easel is lightweight and useful for medium-sized works or for working outside. A plastic tray that clamps onto two of the easel's legs supports my palette.

PURCHASING SUPPLIES

Most art supplies can be purchased from your local art supply retailer or ordered from online catalog companies. The advantage of going to retail stores is that it allows you to handle the supplies and select them firsthand. For the beginning watercolorist, having the assistance of a knowledgeable salesperson can be most helpful. I have discovered that most people who work in art supply stores are artists themselves and can provide a wealth of information about products that are tried and true as well as brand new.

Online catalog companies can save you time as well as money. By having an idea of what you want, you can order it from home and have it delivered to your door in a couple of days. There are several great catalog companies, including Cheap Joe's, Art Supply Warehouse, and Dick Blick. My personal favorite is Artxpress.com. The staff is very helpful by phone, and my supplies are delivered to my doorstep in no time.

Basic Supplies

Brushes

#8 round kolinsky high-quality brush

½–1 in. petit gris (squirrel hair) cat's-tongue brush

1–3 in. flat wash brush

#4 synthetic round brush for lifting

Toothbrush for spattering

Inexpensive small brush for masking fluid

Paper and Support Board

Several full sheets of high-quality paper, 140 lb. or heavier

Support board, such as Gatorboard

Minimum Selection of Paints

Quinacridone rose

Cadmium red light

Cadmium yellow light

Cadmium yellow

Ultramarine blue

Cobalt blue

Cerulean blue

Cobalt teal

Hookers green

Sap green permanent

Yellow ochre

Raw sienna

Burnt sienna

Maroon perylene

Chinese white

Lamp black

Additional Supplies

Palette

Easel

Masking fluid

Staple gun and staples

#2 pencil

Kneaded eraser

Paper towels

Water container

Masking tape

Sketch book

Brush carrier

Easel tray or side table to hold palette and water container

THE BASIC STUDIO

A large and glamorous studio filled with expensive furnishings might impress a few friends and patrons, but a modest space can be just as effective for making paintings. While most of us do not have the luxury or the means to create the ideal studio, there are several considerations you can make when deciding where to set up your easel that will make a significant difference in the quality of your work. Anywhere you paint can ultimately be considered your studio, whether it is in the woods or in the corner of your dining room. Wherever you choose to paint, it must be a place *conducive* to creativity. It must be a place where you can *work*, *see*, and *think*.

A Place to Work

Watercolor does not require a large work area, just a space big enough to set up your painting and lay out your supplies. I've had tiny studios (small enough to touch both walls) and huge studios (big enough to hold a square dance), and I much prefer a smaller studio. When I had studios in factory-sized rooms, I still ended up painting in one corner. Currently, my studio is over a two-car garage. There is an adjoining bathroom, which is handy for wetting and stretching paper, as well as a large walk-in closet to store all the necessary supplies and clutter out of sight. Since my bookkeeping, framing, photographing, promoting, and exhibiting are all handled at another location, a modest-sized painting space suits me well.

For the watercolor artist, a studio needn't be big unless you plan to work on exceptionally large paintings. A spare bedroom will do. An organized floor plan with consideration for storage is the first step. Tripping over papers, brushes, props, and other supplies can be distracting, if not dangerous, so careful thought about placement and storage of supplies is important. I have a large drawing table, a long work surface, flat file cabinets, bookshelves, and a storage area in my studio. I also keep a large metal cabinet for storing more volatile materials such as turpentine and mediums.

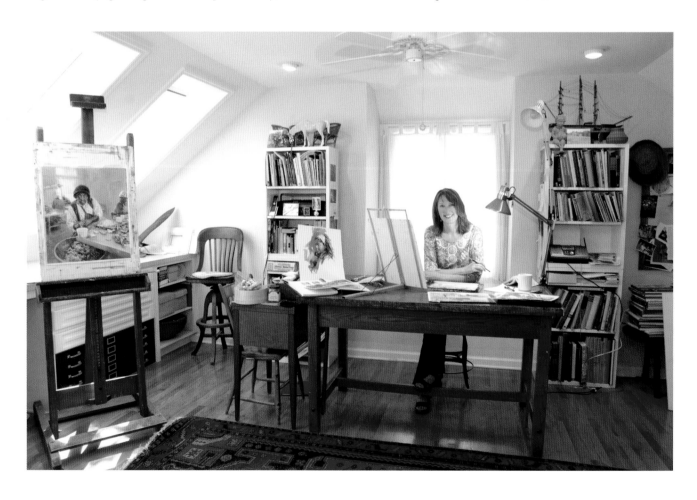

A Place to See

I believe the most important ingredient for a functional working area is proper lighting. Many artists over the centuries have preferred a north light source. The north light stays consistent longer than light coming from the south, east, or west and produces cool highlights with warm shadows.

Since not all work areas come equipped with a steady north light, there are ways to augment lighting that simulates natural daylight. A spare bedroom or adjacent porch can be augmented with extra lighting at minimal cost. A few manufacturers make light bulbs that have a temperature, rendering, and brightness that are close to the effect of north light. Color temperature is measured in Kelvin units, with 3,000 being warm, 7,000 being cool, and 5,500 being most like north light. The color rendering index (CRI) ranges from 1 to 100 and measures a light's true color capability (how true the colors of objects are) in comparison to optimal conditions. Having a CRI rating of 90 or above is considered very good. The brightness is measured in lumens. Artists generally increase the amount of lumens by adding more lights. Full-spectrum incandescent lamps and standard true light bulbs (60 to 150 watts) are available at most lighting supply stores.

A Place to Think

Painting is largely a solitary endeavor that requires enormous concentration. I know artists who say they work while talking on the phone or listening to rock music, but I can't. I need a quiet place where I know I can have several hours of uninterrupted work time. Having your studio set up in an area of the house away from the hubbub can be the first step to keeping your train of thought when painting. Find a corner of the basement or an unused bedroom, or perhaps think about converting a part of the attic or garage.

OPPOSITE My studio is equipped with a large drawing table as well as a long work space. Beneath the counter are wide, flat drawers for storing paintings and paper. There are several light sources, including three low skylights, as well as full-spectrum spotlights that shine over my left shoulder when I am working at the drawing table. A floor easel supports large watercolors.

Photo by Adina Preston

Not all creative time is spent separating paint from the brush. A good amount of effort is spent in contemplation or study. Having a place to read and peruse art books can be an important part of studio planning. In my studio I have a comfortable couch, which I use to view paintings from a distance, as well as for times when I need to study books on art for inspiration and learning.

SUGGESTED EXERCISES

1 Go through and examine all of your painting supplies. Make a list of what supplies you need to purchase. Pass your unwanted supplies on to your local school or art center.

2 Make a paint transparency/opacity chart for future reference. On a sheet of watercolor paper, paint a long one-inch-wide band using India ink or black acrylic paint. After the black strip dries, using a wash of one color of watercolor, paint a strip of color across the dark band. Next to the color, repeat the cross strips with each color on your palette, then label each color. You will discover that transparent colors like quinacridone rose or ultramarine blue seem to disappear when painted across the darker black. Opaque colors such as cerulean blue and yellow ochre show up on top of black.

3 Plan and draw a floor plan for your studio, or see if you can improve the layout of the space you already have.

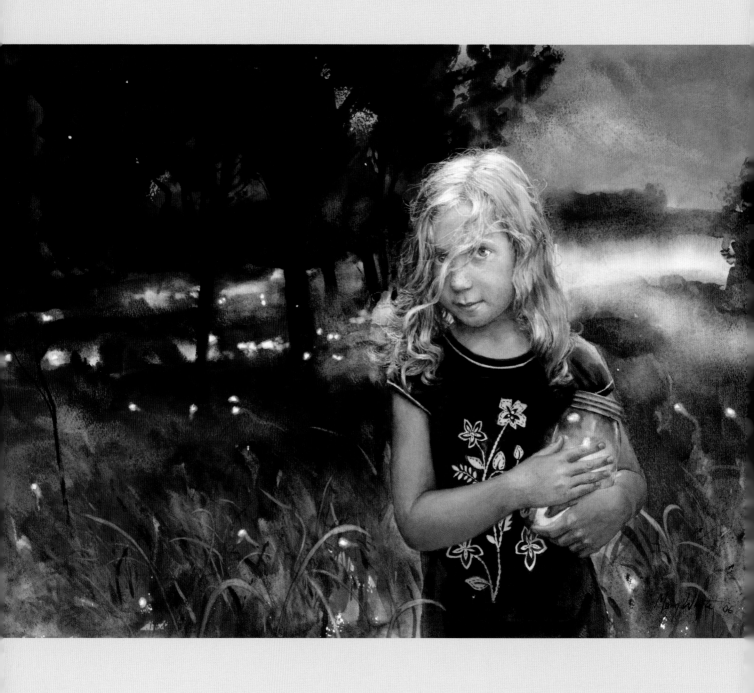

techniques

"*One can have no smaller or greater mastery
than mastery of oneself.*"
—LEONARDO DA VINCI

OPPOSITE *Firefly Girl*
2006, watercolor on paper, 20½ x 28¼ in.

The details of the skin and damp hair stand out because they are painted against the smooth foil of the background. I didn't paint all of the hair in detail, but the final effect is that I did.

People have often asked if it is possible to teach non-artists how to paint. If the question is, Can anyone learn painting *technique*?, then I would have to answer yes. Anyone can learn the procedure of putting paint on paper or canvas, but good technique is only a small part of becoming a good painter. The real question is, *Can one learn to produce art that speaks to the soul and appeals to the senses?* I believe having the creative "idea" and passion to express it is the one component of art that can't be taught. It must be an intrinsic part of the student's personality. The techniques in this chapter should be treated as guidelines. They are the beginning of artistic expression—they are the means and never to be considered as the ends.

HOW IMPORTANT IS TECHNIQUE?

Technique is simply vocabulary. It is the necessary toolbox from which you select the perfect tool for the job at hand. Knowing how to create any illusion with paint and having the tools to do so will allow you the luxury of being able to express almost anything you desire. If you only know how to paint hard edges, then you will never be able to paint the soft curls of a toddler's hair or the fur collar of a woman's coat. If you don't know how to mix neutral colors, you will be handicapped in your attempts to paint a scene of a muted landscape at dusk or the interior of a dimly lit room. Too many artists become a "one-act show," limited to a small range of paintable subject matter as a result of a deficiency in technical knowledge. Your ideas as an artist should dictate the techniques you employ, and not the other way around. There is no method, school, or style through which you will become a fine painter. Your technique and style will evolve along with your discovery of what you wish to express.

Technique is the means *to artistic expression and not the end.*

Night Light
2009, watercolor on paper, 28½ x 28½ in.

A painting will be more interesting if there are a variety of edges, textures, and shapes. Knowing how to achieve these different looks in watercolor requires an understanding of technique. In this painting, I employed washes, glazes, and wet-into-wet methods of painting to render a combination of visual effects.

LEARNING THE BASICS

I once met a man who showed me a watercolor he did on the first try. The painting was of a simple still life, and it was by all accounts a successful piece; the composition was good, and the colors were fresh. He was quite pleased with himself and bragged that he had done the painting without ever having taken an art lesson. When I asked to see other paintings, he said he didn't have any. After the success of his first painting he had attempted a few more paintings, but the results were horrendous, and he gave up. He was baffled as to why his stunning ability had suddenly evaporated.

Unfortunately, the man had confused ability with luck. By sheer chance, on his very first effort at painting he made a good composition with a harmonious combination of fresh colors. Because he had no knowledge behind his efforts, he had no idea how he came to make the painting, nor was he ever likely of making another good painting without further serious study and practice.

Watercolor, as any of the serious arts, takes considerable patience, fortitude, and practice. If mastering the medium were easy, everyone would be an adept watercolorist and the medium would lose its magical appeal. Becoming an accomplished artist requires years of earnest effort to master drawing, composition, color mixing, and technique. The good news is that if you love the look and feel of watercolor, chances are you will get up the learning curve more quickly. And even if mastery doesn't happen overnight, the process of developing your skills will be endlessly engaging. When you have a passion about what it is you are learning, acquiring the necessary skills to become proficient is never a chore.

Unlike other mediums, everything about watercolor technique is *timing*. The second the watercolor wash is applied to the paper it is a constantly moving entity and is in a different state of dryness. The colored pigment that is suspended in water is constantly changing its character as it dries. For the savvy watercolorist, it is necessary to understand this unique characteristic of the medium. You will need to know when it is appropriate to choose a wet wash, a damp wash, or a dry brush, as well as all the other fundamentals, such as the exact moment to charge in a complementary color or perhaps to lift out a hazy light. All of these decisions about technique will be guided by the exact look you are going for in your painting. If you know the quality and look you want, and have an adequate arsenal of knowledge behind you, you will have the ability to express your most heartfelt feelings.

Keeping this all in mind, the first course of the serious artist is to learn the fundamentals of his or her craft. Basics must be learned and practiced first. I am sure that no artist ever picked up a brush and made a masterful watercolor on the first try. I know I didn't. I am equally convinced that for beginners each attempt will bring you much closer to an understanding of the medium. It just takes time and practice.

As tricky as watercolor may seem to the beginner, there are really only three basic methods of application that you need to know. Numerous special textural effects can be employed, but the entire basis of watercolor boils down to washes, glazes, and wet-into-wet techniques. That's it. These three methods of application make up the foundation of watercolor painting.

THE WASH

The first component to all pure watercolor painting is the wash. A wash is a color laid into an area too big to be accomplished by a single brushstroke. A wash can be done on either wet or dry paper with different outcomes. If the paper is wet, the wash will flow faster and more smoothly, without the look of many small brushstrokes. If applied in one quick stroke, the result can look pristine and fresh and can be advantageous when painting smooth textures such as sky and the translucent quality of skin.

A wash can change values, meaning it can go from light to dark or dark to light. It can be made to appear to float behind something in the foreground and have a look of atmosphere. A wash can change color—for example, graduate from blue to green. All of these applications will have a different look and character by the choice of paper beneath the wash.

Wash Techniques

Laying a *wash on wet paper* will leave no visible brushstrokes. If the paper is wet, the flat wash will have an airiness and smoothness to it. If the paper is barely damp, the wash will have more density and be darker in value. Too much water puddling on top of the paper will cause the wash to wander unevenly.

Using paper that has been stretched and dried on a support board, cover the surface with clean water using a large brush. Tilt the board so the water is pulled downward by gravity. Next, mix a large puddle of color on your palette. Always mix more color than you think you need, since stopping halfway through the wash to remix more color may cause patches or backwashes. Starting at the top, using a large flat or oval mop brush, apply the wash with even horizontal brush strokes.

A *wash that is laid on dry paper* will have controlled edges. If you want your wash to maintain a specific shape, apply it on paper that is completely dry. If you are working on paper that is affixed to a board, make sure that the board is always on a tilt and that you always start the wash at the top.

A *graduated wash* is one that changes value (light and dark). It can be painted on either wet or dry paper, though you will have more control if you paint it on dry paper. Graduated washes are an effective way in watercolor to paint forms that have a light side and a dark side.

Migrant Worker
2010, watercolor on board, 9 x 6 in.

Small head studies can be accomplished quickly with simple washes of one color. In this painting, I mixed a sepia color using ultramarine blue and burnt sienna. Laying a wash first in the background enabled me to judge other subsequent wash values. Color isn't always necessary to impart a feeling with your paintings.

A *variegated wash* combines two washes of different colors within the same area or shape. In watercolor, variegated washes contribute greatly to the luminosity of a painting, since there are more color changes within a specific shape. In the central area where the two colors mix is often where you will achieve beautiful neutrals.

When the paper is very wet, the wash will flow quickly. Using a large brush will leave fewer brush strokes.

Maintain the same tilt of the board while applying the wash. Continue moving your brush evenly across the paper, reloading the brush with the same amount of water and paint after each pass.

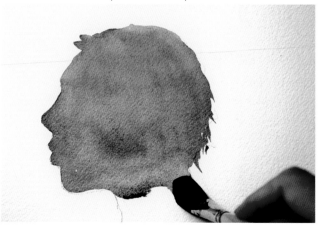

ABOVE LEFT When making a large, flat wash shape, paint a stroke, then attach another stroke beneath it. Before the first brushstroke has time to dry, quickly reload the brush and paint the next horizontal stroke, touching the bead edge of the previous stroke. It is important to work quickly and with the same speed, always reloading the brush with the same amount of paint and water.

ABOVE RIGHT When making a shape on dry paper, always start the wash at the top and quickly fill in the area using horizontal brushstrokes. Keep the board on a tilt and use a large brush, making sure to put enough paint on the brush so that it leaves a slight bead edge at the bottom of the brushstroke.

LEFT Using a brush that is too small when laying in a wash area will result in streaks. Always use the biggest brush possible and work quickly.

When painting *background washes*, carefully wet the area around the foreground object(s) before adding the wash. The water will help pull the pigment next to the contour edge. For smooth, *pristine washes*, use the biggest brush possible. A large brush covers more area and leaves fewer streaks, patches, and lines.

Painting Rich Darks

Sometimes watercolor washes can look weak and lackluster. A common mistake for beginning painters is to use too much water mixed in with the pigment, giving a thin, wimpy appearance to the picture. Unfortunately, this pastel look associated with watercolor has helped to perpetuate its reputation as being a "lightweight" when compared to other mediums, such as oil or acrylic. The inability for many painters to get the full range of values in their work (from white to black) limits the powerful potential of the medium.

Your whites and lighter values will have more punch in your paintings if you can contrast them against rich darks. Of course, there will be many occasions when you want to capture your subject in diffused or limited lighting, which will require using predominantly middle values with little or no contrast.

For rich darks, I rarely use black but instead prefer to mix my own darkest value using burnt sienna and ultramarine blue or maroon perylene and Hookers green. By combining two dark complementary colors, I can achieve a warmth or coolness to the color based on the percentage of the color used. I do know some artists who employ the use of lampblack or acrylic black to their mixture to get the value as dark as possible with good results.

Really dark darks can look chalky if applied too thickly or with too many glazes. To achieve darks (or, for that matter, any value in watercolor), it is best to apply the wash once, if possible. Remember that the wash will dry much lighter, so you have to mix your wash a little darker than you think you want.

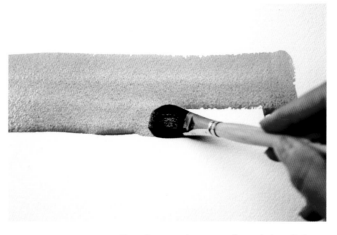

To make a wash area go from dark to light, first make sure your board is on a tilt. The more the board is tilted, the more the paint will flow downward evenly. Mix a puddle of wash color on your palette and load your brush. Beginning at the top, apply the paint in even, horizontal passes.

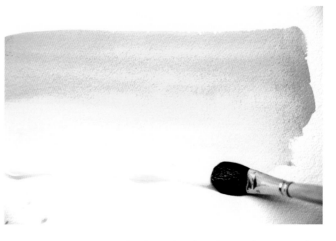

Reload your brush and paint the next stroke, touching the bead edge of the first stroke before it dries. With every other brushstroke, add more water to the wash on your palette so the wash gets progressively lighter.

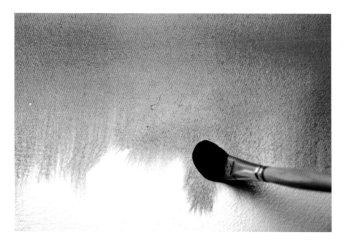

The angle and duration of the board's tilt will affect the character of the end result. Touching or trying to manipulate the wash will only muddy it. If you want the two washes to bleed together more, increase the tilt of the board. If you want to slow the blending, lay the board flat. Start by wetting the paper, then tilt the board and apply a colored wash to the top half of the paper, allowing the paint to flow downward.

To change the hue of a wash area, while the paper is still very wet, turn your paper upside down and apply the second colored wash to what is now the upper half of the paper. Let the two washes mingle on their own.

When mixing deep darks, you need to use very little water in the mix so that the consistency of the paint is similar to honey. Be careful not to mix the paint too thick or it may crack after it has dried.

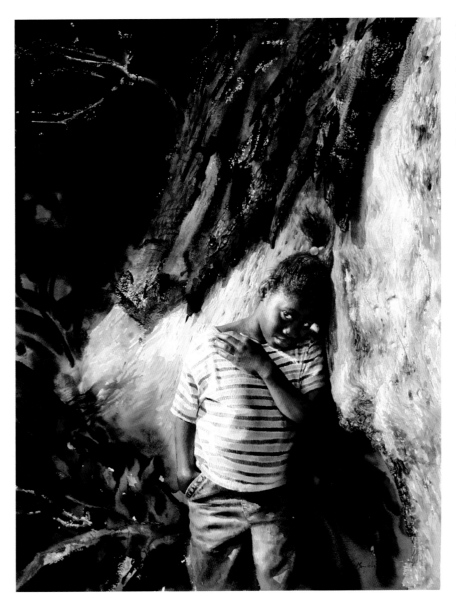

Acorn
2004, watercolor on paper, 37½ x 29 in.

Achieving rich darks can increase the impact of your work. In this painting, the dark sky and areas of the tree were painted using a barely wet mixture of ultramarine blue and burnt sienna. The texture of the tree was enhanced by using spattering and dry techniques.

GLAZES

A glaze is a wash that is applied on top of another wash. The general purpose of a glaze is to darken an area. By adding several glazes of the same color, the original hue will stay the same but eventually become darker in value.

The second reason for utilizing a glaze is to create a new color. By painting one color (such as blue) and glazing over it with a second color (yellow), you will achieve the optical sensation of a third color (green). Applying two complementary colors (opposite on the color wheel) will give you a neutral. This can be useful in toning down a color that is too bright while still keeping it luminous.

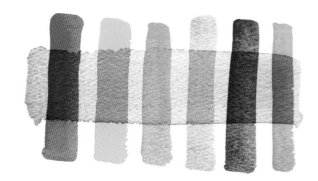

A glaze of color over a different hue will give the appearance of a very different color. When glazing, be sure the first wash is completely dry.

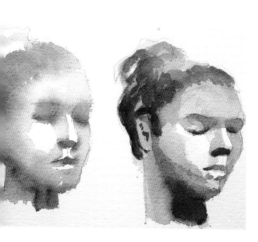

A glaze can be useful in correcting or neutralizing a color. The face was too red, so I toned it down by glazing over it with a Hookers green.

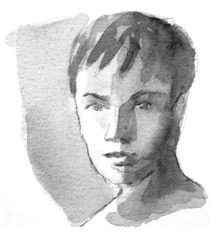

A glaze will darken a color or give the sensation of a third color. Here I have painted the face using burnt sienna, and I then glazed over the shadow areas using ultramarine blue.

A succession of glazes can darken the value of an area. Both faces were painted using burnt sienna. Glazes of the same color were added to the face on the right to darken the value in areas.

The trick to a successful glaze is that the first wash must be bone dry, and the second wash must be floated over the top without disturbing the bottom layer of color. Avoid doing too many strokes and dabs without a clear purpose—no noodling!

Wet-into-Wet

Painting wet-into-wet is the most dramatic and challenging of the basic watercolor techniques. This wonderful technique is impressive because the colors mix themselves on the paper, giving more lively and luminous results. With the wet-into-wet technique, the paint will sometimes seem to be more in control of your work than you are—however, the results will be unlike any you could possibly contrive yourself. With experience, you will be able to anticipate pretty much how your wet-into-wet washes will look when they are dry, yet there will always be surprises along the way. These unexpected occurrences are what make watercolor the unique and delightful medium that it is.

I find painting wet-into-wet to be one of the best ways to depict areas that fall into shadow. When an object is not seen in the light, it will have less brilliance, contrast, and texture. The colors will be more neutral, which is one of the watercolorist's biggest dilemmas. How do you paint a shadowy gray without making mud? To solve this challenge, I often resort to using two opposite colors and painting them together wet-into-wet. By letting the colors make the neutral, I can achieve a much more luminous result than if I resorted to mixing a gray color.

Having a dominant light source on the model helps to determine where the shadows are and make painting values easier.

When painting wet-into-wet, it is imperative that both washes of color be wet enough so that the pigments will mix together. Two complementary colors charged together while wet produce a luminous neutral that has not been over-mixed and made dull.

A "blossom" occurs when a wet wash is dropped into a damp area. The increased amount of water causes a "backwash," or bloom, that pushes the pigment into the damp area. A blossom can also happen when a wash beads along the bottom edge of a fresh wash, so be quick to soak up any beads of paint with the tip of a thirsty brush.

Watercolor washes establish the background and lightest areas of the painting. Because so much of the face is in shadow, I used a wet-into-wet technique to paint the neutral color of where the face is not in the light. Here I started with ultramarine blue and charged in quinacridone rose and raw sienna.

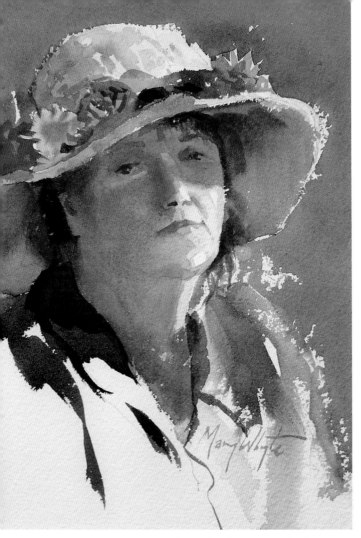

Here I have glazed over areas that have dried using a succession of darker values to establish the details of the face and hat.

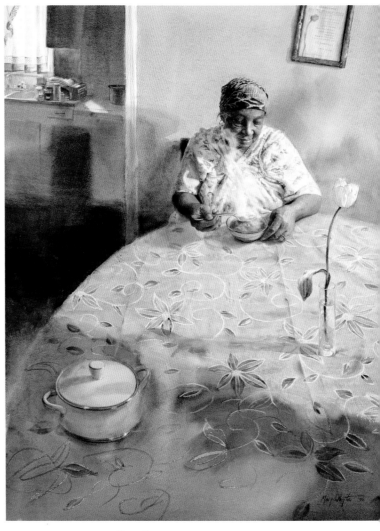

Bean Soup
2006, watercolor on paper, 38½ x 28 in.

Watercolor paintings can be made more interesting by incorporating several techniques. Here, the washes, glazes, and wet-into-wet areas all combine to make a painting that is full of different textures. Areas that are in shadow, in the background, or less important are best indicated with loose washes and wet-into-wet passages.

TEXTURES

Every object has a unique surface or textural quality, such as rough, grainy, wet, slippery, or smooth. A flower has a different texture than a rock, and a tree has a much different feel than a face. Even seemingly intangible things like fog, shadow, and steam have their own unique textures. It is important that you understand the textures you are painting as opposed to copying them. If you study the edges and the character at the meeting of the masses, it is there that you will find the exact nature of the texture to be found. For instance, the edge of a porcelain cup is much different than the edge of a feather. If you can focus on the significant and not the tiny details, you will get closer to your mark.

Every texture will demand of you a different manner of painting. One surface will be caressed; another will be attacked. It is important that you have the right brush or tool for the job. Knowing how to paint a wide variety of textures will increase your artistic vocabulary and enable you to express almost any subject on paper. If you can "feel" the textures in your mind, you will be better able to portray their important qualities in paint. Understanding the intrinsic nature of textures is especially important in watercolor, as any correction will gray down the color and soften the edges of the area. This "overworking" will produce a different look and texture, but it probably won't be the one you are looking for.

Be careful not to rely on recipes. Although it is fun to create textural effects, they can end up being the downfall of a painting. The viewer should not look at a picture and be overly aware of the technical processes used to create its image. If you keep your work earnest, using special effects with judicious care, they can add richness and depth to your compositions. There are dozens of ways to create such effects, but the four most basic techniques you should know are *dry brush*, *lifting*, *spattering*, and *resists*.

You can create different textures by stamping, scraping, blotting, and lifting. Experiment and you will discover many fun ways to make different textures.

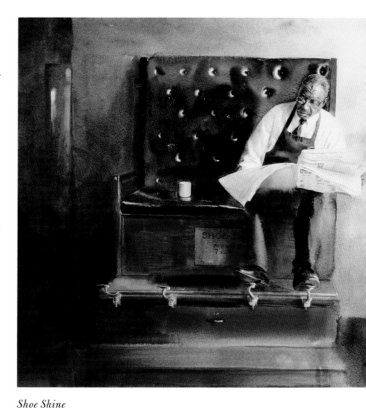

Shoe Shine
2008, watercolor on paper, 25¼ x 23 in.

Images can be made more interesting by incorporating a variety of textures. The texture of the man's skin and hair is contrasted against the texture of the wall, leather bench, and newspaper.

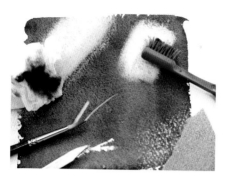

Holding the brush handle low to the paper will better able the barely damp wash to skip over the valleys of the paper.

By splaying the brush hairs apart with your fingers and lightly feathering the damp paint through a damp wash, you will achieve a soft blending of colors.

Lifting techniques are used to lighten an area. Most lifting techniques, such as blotting, rubbing, and sanding, will leave a lighter area with a soft edge. Scraping with a sharp tool will leave a whiter white and a shaper edge or line.

Dry Brush

The term *dry brush* is actually a misnomer, as the paint on the brush is really damp. With dry brush, you use just a small amount of paint on the brush, working on dry or damp textured paper and dragging the brush across it to create broken areas of color or interesting textural brushstrokes. By holding the handle low so that it is almost parallel to the paper, you will achieve the best results. The technique is especially good for painting things like the bark of a tree, the look of a hand-knit sweater, or a course beard.

Dry brush can also refer to a technique where pigment is feathered into a damp wash. By splaying the hairs apart so that they resemble a fan and loading them with damp pigment, the color can then be lightly painted into the damp wash. The resulting effect is a seamless area, with color that is woven together. Painting into the damp area softens the tiny lines so that they blend into the wash better. This technique, too, relies on perfect timing. Dry brushing into an area that has dried completely will produce scratchy-looking lines.

Lifting Out Color

All watercolor effects are not a result of putting down paint. Some wonderful effects are created by pulling paint back up. For partial lifting, you can use a brush, sponge, or paper towel. At other times you may want to remove the paint down to the white paper, and for this you can try sandpaper or a sharp instrument like a razor blade or knife. Sometimes the lifting technique is successfully employed for making a correction; at other times it is used to create a lightened area or to place a highlight.

When using sandpaper or a razor blade, you will actually be removing the top layer of paper, so a light touch is needed. Be careful not to sand or scrape too deeply or you will leave a noticeable scar on the paper. Adding any further paint to the scraped area will cause the pigment to gather in the groove and make the area appear even darker. After the sanded or scraped area has dried, rub it lightly with the smooth, flat area of your fingernail.

Color is also lifted by rubbing it with a damp brush or sponge, which will result in a soft, murky light. If the area is still wet, you can blot it with a paper towel to create light areas. This technique works well for lifting out the lights of a dark coat or the soft highlights in hair.

Spattering

Spattering is produced when paint is flicked from a brush onto paper. The smaller and stiffer the brush, the smaller the dots of that spatter will be produced. An old toothbrush gives an especially fine spatter when you stroke your thumbnail against its bristles. A large, round sable brush gives a larger, less controlled spatter. Another way of employing spatter is with an air brush or mouth atomizer, which gives a fine, even spray of tiny dots but can look a bit manufactured or slick if it is overdone. Spattering first with masking fluid will leave negative areas of white dots so that a dark wash can be painted over, and it could be useful for achieving the effect of lace or a starry night. Be sure to lay a paper towel over areas that you do not want hit with the wayward drops of paint.

Resists

In watercolor, it is often necessary to reserve white areas of the painting. Preserving the areas in a way that keeps the washes looking fluid can be a challenge, so often the solution is to use a masking fluid to block out certain sections. I rarely use masking fluid because every shape it blocks out has a very hard edge, which can look less than artful. As much as I can, I actually enjoy painting around small lights, even areas as small as eyelashes. To block out shapes, I prefer to use masking tape. By tearing the tape and affixing it to the paper in the desired places, the resulting shapes will be more irregular, with diverse edges.

I have a few words of caution if you do decide to use masking fluid. Most masking fluids come off easily by rubbing the area with your finger or using a crepe rubber eraser; however, if left on the paper too long, the fluid will leave a colored stain or be very difficult to remove and possibly tear the paper. When applying the fluid, always use an inexpensive brush that has first been dipped in soapy water, as the fluid tends to dry quickly and is nearly impossible to remove from the hair completely. When I apply masking fluid, I use a very worn brush whose next destination is the trash.

Other forms of resists that can give attractive results are crayons and wax candles. They will repel any washes and create a grainy, calligraphic line.

Stamping and Stenciling

Stamping with a sponge, crumpled paper towel, drywall tape, a wood block, corrugated cardboard, or a leaf can all create interesting textures and patterns. Other methods of transferring a texture, such as pressing crinkled plastic wrap into a wet wash or using a paint roller, can leave unusual results. Potential painting tools are everywhere!

Stenciling is another way to add an intriguing surface quality to your painting. Stenciling can be done by spattering or dabbing paint over paper doilies, screens, lace, or anything that has a pattern of holes. Just be careful to use such techniques judiciously, as too much can make a work look gimmicky.

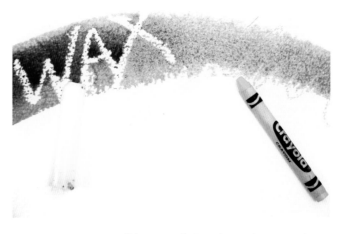

Using a candle is an interesting way to leave behind the whites in a painting. A colored crayon will resist the wash and leave behind its hue.

Objects such as leaves and crumpled plastic can be used as means of stamping and stenciling. With experimentation, you will discover many of your own methods of creating interesting textures.

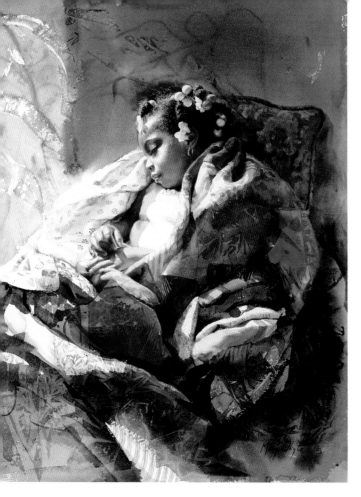

Lily Sleeping
2003, watercolor on paper, 26 x 21 in.

In this painting I used cut-out pieces of paper towel and string to stamp interesting shapes and lines into the background. The pieces of paper towel and string were dropped into the wet watercolor wash and left until the paper had dried before removing them.

USING GOUACHE

I prefer to use transparent watercolor when painting portraits because the nature of the paint mimics the translucent quality of skin; however, I like to incorporate gouache when I want to achieve a milky or more substantial look to an area or when I want to add small details on top of a dark. Mixing Chinese white with other light colors on the palette can be a good way to emphasize light effects, such as the highlight on a silver cup or a few hairs of a man's beard. Titanium white acrylic or gouache paint mixed with a touch of cobalt blue will produce a cool light; while contrastingly, a small amount of yellow or red will produce a warm, glowing light. The extent and way that you use body color or gouache is entirely a matter for your personal judgment and will depend on the type of painting and the sort of effects you wish to produce.

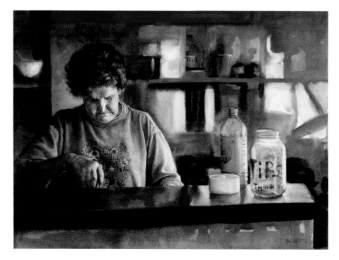

Tips
2007, watercolor on paper, 22½ x 30¾ in.

To achieve the milky light shapes in the background, I used Chinese white mixed with small amounts of color. By keeping the edges soft, the window shapes appear to be filled with light.

COMBINING MEDIUMS

There are many mediums that can be combined with watercolor or that will produce interesting results. For years, artists have experimented by combining watercolor with pastels, pencil, pen and ink, and more opaque mediums like gouache, gesso, and acrylic. Working with new mediums can open the door to invention and lend a variety of intriguing effects to watercolor painting.

Water-soluble pastels blend beautifully with watercolor washes and make for a lively underpainting. By vigorously drawing with the pastels and then blending with clean water or colored washes, the resulting soft lines and mingled colors can set the groundwork for further painting. Caran d'Ache makes water-soluble crayons that melt beautifully with water and colored washes. The crayons can be used under washes for indicating soft lines or used by drawing in to wet washes for stronger lines.

Pen and ink can be incorporated with watercolor with interesting effects. Ink lines can be applied before or after watercolor washes. If the paper is still wet when the ink is applied, the lines will widen and run. Either way, be sure that the lines become a thoughtful, integrated part of the artwork and are not added strictly as outlines, or the work can look cartoonish.

There are many other mediums and tools that can enhance watercolor. Ox gall, charcoal, rubbing alcohol, salt, and gum Arabic can all be added and will affect the transparency, flow, and luster of the painting.

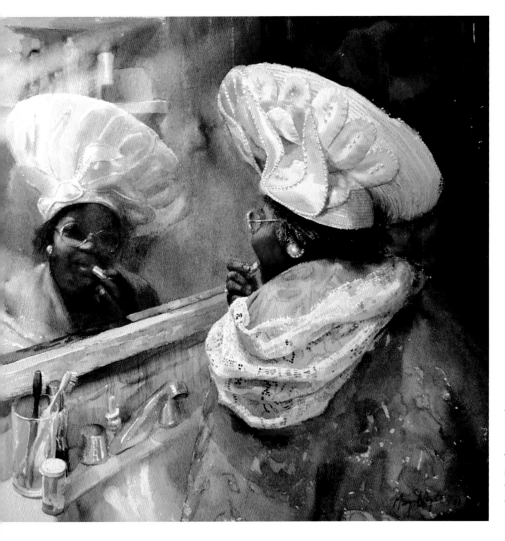

Lipstick
2003, watercolor on paper, 20⅛ x 20⅛ in.

In this painting I added scribbles of lines with water-soluble crayons to indicate the pattern of the woman's dress. Instead of copying the fabric, using the crayon was a more inventive and interesting way to indicate pattern.

PAINTING DETAILS

Almost every beginning artist is enamored of the details in a painting. A woman's earring, a child's eyelashes, an old man's wrinkles—they all beckon to be painted. We can hardly wait! We want to get right to these small gems and worry about the background and those big, nebulous shapes later. Somehow, we convince ourselves, getting into the details first will help those big, unresolved areas work themselves out along the way. In truth, I have yet to meet a serious artist who has found success working this way, as experience has taught them that the big masses and forms *must* be painted first. Understanding the big shapes and establishing them first will help to position and acknowledge the details properly. You will ultimately find that if you can establish the form convincingly, you will need much fewer details to tell the story.

There is no secret to painting details, since they are nothing more than smaller forms. The eye is a sphere, the eyelash is a cylinder, and a tooth is a cube. Painting wrinkles is the same as painting the larger, rounded folds of a gathered skirt. Each wrinkle is a mounded shape that goes from light to middle tone to dark. Keeping in mind that these objects, like everything else we paint, are basic geometric shapes will help you establish them convincingly in your image.

The question that you should be asking yourself is which details to paint. Painting is an invented vocabulary, one that takes careful thought, so you convey not only what you see but, more important, what you feel. Don't try to paint every detail. Instead, indicate the qualities that you want the viewer to see.

By selecting only the details that are intrinsic to the mood and concept of the painting, you will better enable the viewer to feel what you do and not lose him or her in the superficial.

SUGGESTED EXERCISES

1 In a watercolor sketchbook, record twenty different ways to create textures using stamping, lifting, resists, and spattering. Mark the technique used next to each sample. Invent more.

2 In the same sketchbook, using one color and one brush, record as many different brushstrokes as possible. Push, pull, drag, twist, and bear down and pull up on the brush. Try dry brush.

3 Find a photograph of a loved one and paint the same face three ways: using only washes, using only glazes, and using only wet-into-wet. Then paint the face using all three techniques.

demonstration Absolution

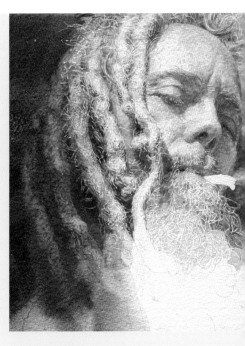

▲ Painting in the large background shape sets the tone, color, and feel for the rest of the painting. Here I used a large 3-inch flat brush to paint the dark areas using a wet-into-wet technique with burnt sienna, ultramarine blue, maroon perylene, and Hookers green. I intentionally painted the lower arm, pants, and brick background at the same time so that the edges would swim together in the shadows.

▲ The bricks were painted loosely, with little detail, so that they would appear to recede. Using a dry brush technique, I dragged Chinese white over the brick area. I also spattered the same opaque, white paint using a round brush.

▲ Here I began painting in the man's face using quinacridone rose, raw sienna, and ultramarine blue. The forms of the dreadlocks were painted first before indicating texture with mostly raw sienna and ultramarine blue. The whites are the bare paper showing through.

◄ The skin of the man's arm was painted using the same combination of colors as in painting the face, except I added more ultramarine blue so that the arm would begin to recede down into the shadows. The highlight on the shoulder was painted using a glaze of Chinese white and ultramarine blue to give it a coolness, and the tattoo was painted following the contour of the arm.

▲ By cutting out a stencil I was better able to control the spatter to indicate spray-painted graffiti. For the spatter, I used Chinese white and an old toothbrush.

▲ With a damp paper towel, I scrubbed away some of the paint to establish the light area of the graffiti and to soften the edges further.

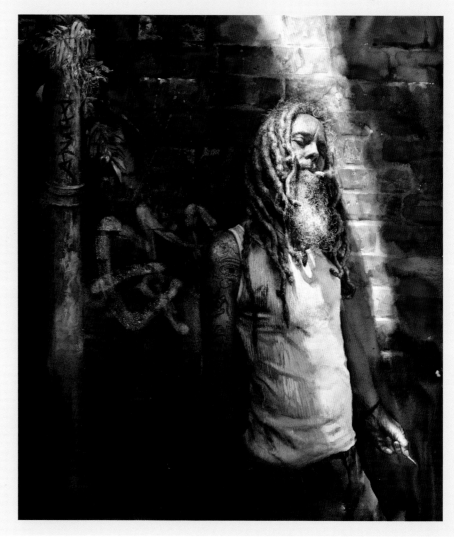

▶ *Absolution*
2010, watercolor on paper, 34 x 29 in.

The details of the beard, hair, and hand are added, as were the texture and color of the man's shirt. The arm on the right was painted at the same time that I painted the background so that it would have a soft, shadowy edge and would play up the hand in the light.

drawing

"It takes a long time for a man to look like his portrait."

—JAMES MCNEILL WHISTLER

OPPOSITE *Mid-Breeze*
2005, watercolor on paper, 21⅜ x 28½ in.

Having good drawing skills is a must for painting portraits, even a self-portrait. I painted this by setting up a mirror next to my easel. The scarf was painted wet-into-wet at the same time that I painted the background so that it would have soft edges and a sense of movement.

Drawing is the foundation of all art. It is how we translate form and space into a recognizable idea, enabling us to communicate with those around us. Whether your style is abstract or representational, drawing is the universal language that makes two-dimensional shapes and lines appear to have volume, structure, and depth in a way the viewer can understand. Of all the painting mediums, it is watercolor that demands the greatest drawing acumen from the artist. A good watercolor requires fresh color and a spontaneous look, so its maker must be absolutely sure where each brush stroke goes.

LEARNING TO DRAW

There is no underestimating the value of knowing how to draw. If you are going to realize your goals as an artist, you will need to have a solid background in drawing. No amount of painting techniques and gimmicks can cover up a deficit in drawing ability. Fortunately, drawing is a skill that can be learned. It is a matter of learning to see shapes and values and translating them into the two-dimensional.

Traditionally, students in formal art training would have to spend a couple of years mastering drawing before being allowed to advance to using color. Through the use of plaster casts and live models, young artists were given rudimentary lessons in line, mass, value, shape, anatomy, and the principles of light. American art schools largely abandoned the approach of formal drawing classes in the 1950s in favor of a seeking a less stringent form of learning. The artists that were painting in styles like cubism and abstract expressionism were paving the way to art that was considered more self-expressive and less about transcribing beauty into recognizable forms. In recent years, several atelier-style art schools in the United States and in Europe have opened their doors, with the emphasis on traditional drawing fundamentals.

I can tell you from my own experience and from studying the work of other artists that learning to draw is worth the effort. Through drawing you will learn to be observant and selective, which will in turn enable you to be more deliberate and concise in your expression of ideas. You will be able to say what you wish, coupling your new drawing strength with greater artistic freedom. Your ideas won't be limited by a weak vocabulary, and you will say more.

Whenever I see a young person crouched somewhere sketching, with his mind deep in his work, I think, "Ah, now there is an artist in the making." I know I'm witnessing one

Crossing Bourbon Street
2008, watercolor on paper, 20 x 17 in.

Understanding the human figure and how it moves is helpful, especially when painting from life. I did this painting in New Orleans, setting up my easel right on the sidewalk. By studying the way people walked, I was able to capture this one man as he stepped into the light and crossed the street.

Slicker
2010, watercolor on paper, 18 x 17½ in.

Learning to draw well will enable you to paint the world around you and to depict the people you know.

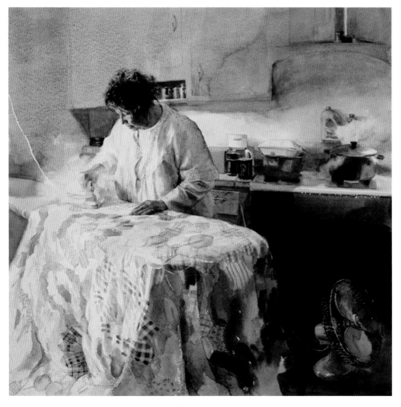

Finishing the Quilt
2008, watercolor on paper, 19 x 17½ in.

Drawing the shapes of the figure is really not much different than depicting the shapes of objects, such as pots and pans. Keep in mind that everything has a core geometric shape, such as a cone, cube, sphere, or cylinder, and goes from light to middle tone to dark. Here, the dominant light is coming from the left, illuminating the figure and certain objects in the painting, while everything else is suggested in shadow.

ABOVE I have several sketchbooks that I use for different purposes. A small sketchbook is convenient for everyday excursions, since it fits easily into my handbag or coat pocket. My sturdy red sketchbook is suitable for pencil drawings or quick watercolors since the paper is well sized, so washes will not cause the surface to buckle. The largest sketchbook often goes with me to portrait sittings, since it allows for more involved drawings and notations.

ABOVE Quick sketches are valuable for capturing the essence of your subject. When the figure is moving, look for general shapes that keep repeating.

LEFT Breaking the subject into distinctive value shapes is a good way to prepare for painting in watercolor. By thinking in terms of shape, you will get a much better sense of light and form. Having your shapes well thought out in advance allows for greater freedom and more confidence with the brush.

OPPOSITE *Venders*
2009, watercolor on paper, 3¼ x 3½ in.

Painting quick sketches from life strengthens your ability to see and remember key shapes.

who wishes to master a valuable means of expression rather than the trick of dashing off something to impress or shock the uneducated public. Even if he decides to pursue another vocation, his life will be that much richer for his thoughtful appreciation of the visual bounty around him.

Every sketchbook you fill will bring you closer to an understanding of how light affects form, how composition is built, and how the shapes of the face and figure relate to one another. So, buy several sketchbooks and get to work. Whether you enroll in a figure drawing class or start drawing on your own, your sincere effort will become the foundation for future paintings. How much time you spend drawing each week is up to you, as is where and how you apply your quest. While studying anatomy can be enormously interesting, learning to recite the names of all the human muscles and bones may only impress a few of your friends at cocktail parties and do nothing to further your ability to draw. Learning to see the way the planes of the muscles and bones are shaped and inter-related is what matters and will help you immensely in your journey to becoming a good painter.

PROPORTION

While all painting is a form of self-expression, painting the face and figure requires a certain amount of restrained accuracy. When painting a landscape, it is possible to lengthen a tree limb or even omit it with no problem. Try doing that when painting a person's arm or nose! Drawing the face and figure accurately requires an understanding of the specific planes of the model and their unique shapes.

With billions of people on this planet, all of whom share the commonality of having two eyes, a nose, and a mouth, it is amazing to me that we can all look so different. Surprisingly, it is not our individual features such as our eyes and mouth that make us identifiable in public. We are able to recognize people we know from as far away as fifty feet, not because of their features but because we recognize the distinctive shapes

We recognize the people we know by the distinctive planes of their heads and faces. Every face has a different arrangement of these shapes.

OPPOSITE *Cotton Man*
2007, watercolor on paper, 40½ x 27½ in.

Understanding proportions of the figure is important if you want to paint people. I was particularly interested in the tall, slender physique of the model. The telephone pole in the background echoes the shape of the figure.

Most adults are equal to eight heads tall. Children, depending on age, might be only five heads tall.

There are three distances of the face that are almost always the same when the model is at eye level and is facing you: the distance from the forehead to the eyebrow, from the eyebrow to the tip of the nose, and from the tip of the nose to the chin. It is where these distances vary that we will find the greatest differences in our individual looks.

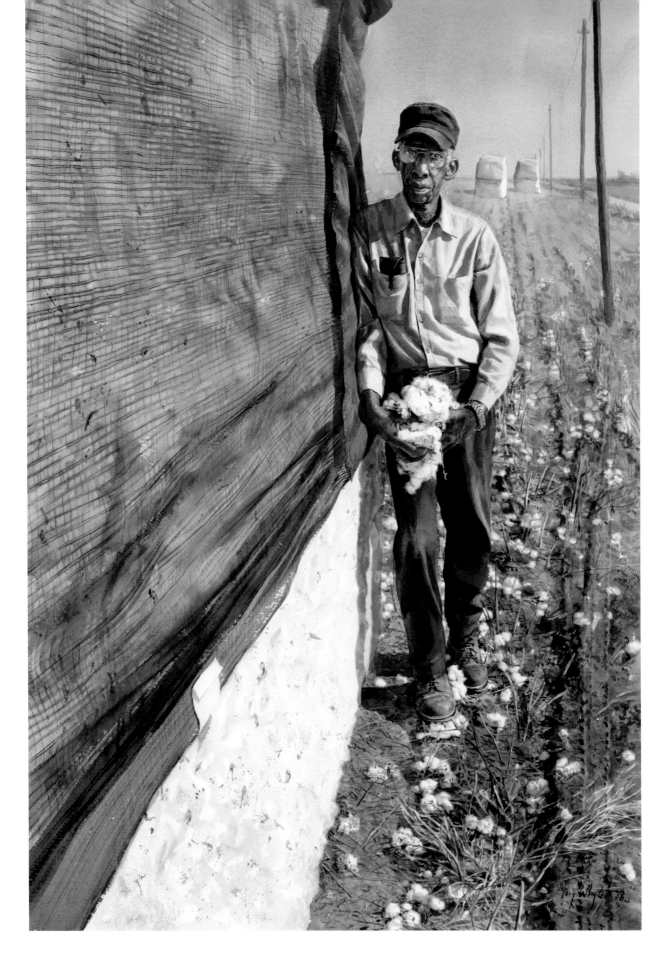

of the planes of their face. One person may have wide, flat cheekbones and a narrow nose, while another may have round cheeks and a wide-planed nose. It is not until we get up close that we are able to see the details of the person's blue eyes and the particular curve of the lips. Seeing your model in the three-dimensional sense of flat planes as shapes is the first step in getting correct proportion, which in turn will give you a likeness. Thinking in this more abstract way will help you see more broadly, without the intrusion of small details. For water-color, this way of seeing planes and shapes is crucial, since it is necessary to get it right with as few corrections as possible.

Since seeing the figure accurately is important to getting a good drawing, it may be helpful to note that there are several proportions of the figure and face that are fairly consistent with most people. Age, heritage, weight, and height play a major role in proportion, but overall, a few basic generalities apply. These observations are not meant to be rules but only a helpful place to start when drawing the face or figure.

Passages
2001, watercolor on paper, 16½ x 25 in.

The profile of an older person can be extremely interesting to paint. I was intrigued by the model's white hair and pale complexion and wanted to play up these features. By placing her head against the dark, rectangular foil of the window, the shape of her face receives more attention.

Where these three common distances vary you will see the greatest differences in a face. For instance, the face on the left has a longer distance from the tip of the nose to the chin, while the other face is shorter from the tip of the nose to the chin. A face will look "off" if one of these proportions is too long or too short.

A child's head and face are shaped differently from an adult's. Younger children's features appear to be set lower on the head, with more of the crown above the eyes.

When a face is not at eye level, or is looking up or down, the three distances of the facial features changes. Because of foreshortening, more or less of certain parts of the head and face will be seen. Notice, too, how the position of the ears to the face changes.

The ears generally line up with the eyebrows and tip of the nose. The parallel lines will follow the tilt of the head. As a person ages, the ears and nose can become longer.

GETTING A LIKENESS

Many artists are fascinated with capturing the likeness of their model. And, of course, it is especially important to get a likeness if you are doing work for hire and you want to please your client. Remember, though, that getting a likeness is not the most important goal in painting a portrait. Your primary goal is to make a good painting.

Getting the visual likeness of a model requires sensitivity to proportions and how they may differ from one person to another. When I am looking at the model, I find it helpful to imagine I am looking through a windowpane. In this way I think in terms of intersecting horizontal and vertical lines and how each shape on the face or figure lines up with another. A grid is an aid that has been employed by artists for centuries to help draw the figure. By holding your pencil or paintbrush horizontally or vertically in front of you as you study the

model, you will easily see how key areas might line up. This method is especially helpful if the model is in a challenging pose that may have unusual angles or foreshortening. Still, the best aid to getting a likeness is to draw lots of figures so that you readily recognize the subtle differences. To a non-horse person, all horses look alike, but to a seasoned equestrian, the differences in proportion and personality from one horse to another are huge.

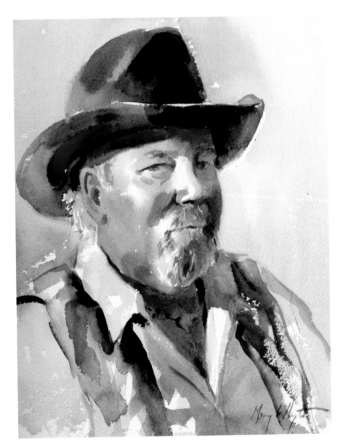

LEFT *Bob*
2008, watercolor on paper, 13 x 11 in.

Quick head studies from life are one of the best ways to get up the learning curve for doing portraits. Here, I wanted to capture the sense of warmth in the model's expression. Because the painting was done in less than an hour, textures such as the beard and vest were kept to a minimum. Though the man's turquoise necklace was a significant part of his heritage, I opted to keep it in soft shadow so it would not distract from the face.

ABOVE Painting from life will be your best teacher. When painting the model, I always work upright, so that I can step back and view the painting and the model at the same time. Painting upright also allows the washes to run downward, giving me more control.

By thinking in terms of a grid with horizontal and vertical lines, you can more easily see what shapes or features line up. For instance, in this diagram of a woman and baby, I can see that the left side of her head lines up vertically with the outside of the arm on the left. If the woman were sitting straight, the outside edge of her arm and head wouldn't line up.

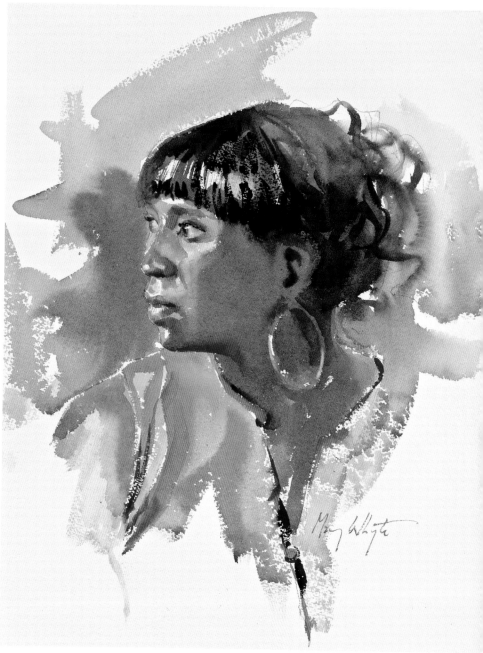

Glance
2009, watercolor on paper, 12 x 9 in.

I like to give the people in my paintings a sense of movement, even if they are sitting still. In this painting, the side view of the model is enhanced by her engaged expression. Employing vigorous brushwork and soft edges, such as in the hair, can help give the impression of action.

HANDS

The hands are a person's résumé and can convey more about a person's character than almost anything else in the painting. Hands can give a narrative about the person's life, work, and age. They can be as descriptive and telling as the face and a person's surroundings.

Hands often seem problematic for many artists because they can be challenging to draw. In truth, hands shouldn't be any more difficult to draw than a tree. Where most students get into trouble is that they try to draw the details first. When drawing the hands, always consider the *gesture* first. Think about what the model and hands are doing.

Begin by drawing the overall shape of the entire hand. Keep in mind how big a hand is in relation to the head: that a hand can fit over an entire face. Fingers are smaller shapes within the larger mass and should be considered later. Imagine that the model is wearing thin mittens and draw the outside contour of the hand, concentrating on the overall shape and its relationship in size to the rest of the body. Then gradually work your way to the smaller shapes within the larger shapes. As you are working, be mindful of the qualities of light and shadow and how they affect the value of the shapes.

Where and how you place the hands in a composition is important. I try to place them at uneven levels and in different gestures so that they do not look like bookends. Whether the hands are actually doing something is your call, but make sure that their action and presence do not overpower the face. Any object that the hands may be holding should be a perfect accompaniment to the model and not look forced or gimmicky. Generally, the gesture of the hands will mirror the mental activity of the model. If the model is asleep, the hands will be limp. If the model is agitated, the hands will be also. If the hand is holding something, the gesture of the fingers will echo the nature of the object. For instance, a hand holding a robin's egg will have a delicacy about it, as compared to a hand gripping a wrench.

When drawing hands, details such as wrinkles, veins, and fingernails should be added at the end and with judicious care.

Draw the overall contour shape of the hand first. Make sure the hand is the right size in relation to the other parts of the figure. Then proceed to drawing the smaller shapes of the fingers and fingernails.

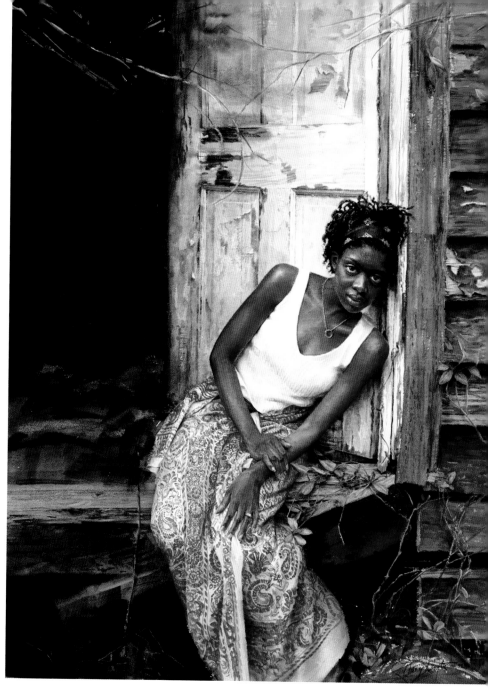

ABOVE *Waiting*
2002, watercolor on paper, 40 x 27 in.

The gesture and placement of hands in your painting can add an important element to the feeling you are trying to project. Here, the gentle way that the hands are draped bespeaks the quiet character of the model.

LEFT Interesting texture details such as veins and fingernails should be addressed only after the overall gesture and shape of the hand are established.

COMPOSITION AND DESIGN

Composition is choosing pieces of the visible world and arranging them in a pleasing manner in your painting. Placing these elements by instinct or reasoning ultimately makes a statement about your point of view. However, bear in mind that composition is not an end in itself. In other words, don't set out just to make a good composition. The composition, or design of your painting, comes after your idea and what you want to say. What matters is your concept, and then finding a way to arrange your subject that projects your idea.

Much has been written about composition. Formulas have been invented and broken by artists for centuries. Of course, there are many "rules" that we have all heard regarding the composition of a painting. *Don't* compose your painting so it is cut in half, *don't* put your focal point dead center, *do* have three or five objects and not two or four, *don't* have lines leading into a corner, etc. In general, these admonitions tend to have sound reasoning, since there is something about certain arrangements of shapes that naturally pleases us. Nonetheless, there are artists who have successfully broken these rules in surprising and delightful ways. Each time the artist broke one of the old rules, it was because the artist found doing so to be a solution to his or her particular problem of arrangement.

Composition is about making choices. It is about including what is significant and eliminating what is distracting. Simplifying your subject matter will strengthen your objective instead of confusing the viewer with nonessential details. To do this you must be clear in your mind of what you are painting. Ask yourself why you want to paint this particular subject and what it is about the subject that attracts you. Once you are able to answer these questions, how to portray the subject will become more obvious to you.

How you arrange your subject on your paper is in some ways like furnishing a room. The pieces need a particular balance to be harmonious together. It probably wouldn't feel right if you were placing furniture in the living room and decided to put the sofa, piano, and huge bookshelf on one side of the room and the small end tables and footstools on the other side. A balance of large and small shapes around the room would feel better. In composition, shapes are balanced in a harmonious way.

As you plan your arrangement, keep asking yourself, "Do I really need to include this or that? Will it help the ultimate purpose and feeling of the painting?"

Daydream
2010, watercolor on paper, 27 x 20 in.

A good painting should have a dominance of either curvilinear or straight lines. In this painting I wanted to convey the idea of a woman daydreaming, so I chose cool, pale colors and curving, irregular shapes. The shape of the head and torso are given more attention by contrasting them against the straight lines of the doorway.

TIPS FOR PLANNING THE COMPOSITION:

1 Give your focal point the greatest color, biggest contrast, sharpest edges, and most interesting texture.

2 Let the *what* and *why* of your painting dictate your composition, not formulas.

3 Have a dominant shape, dominant value, dominant color, and dominant direction in your painting.

4 Avoid cropping your figure at the hands, knees, or other joints, unless you have an artistic reason.

5 Simplify. Only put what is essential to the picture.

6 There is no such thing as an ugly color or bad technique—only one that is used in the wrong place.

7 Avoid placing your focal point right in the middle or at the paper's corner unless you have a good reason.

8 Any subject matter can be made into a beautiful painting if composed and painted well.

Good paintings happen when you have a clear idea and your planning and purpose coincide with your execution.

One of the strongest elements enabling artists to convey an idea in a direct or succinct manner is design: the organization of shapes and values so that the various weights balance one another to form a pleasing whole. Elements that are important aspects of design are shape, line, values, color texture, size, and direction. The eight principles of design that artists often employ in their compositions are as follows:

Alternation (or rhythmical sequence)

Balance

Conflict

Dominance

Gradation

Harmony

Repetition

Unity

A well-placed center of interest in a composition can enhance any painting. Many focal points are engineered by dividing the format into one-third and two-third ratios. Another method for placing the focal point is to draw a diagonal line between two corners, then draw a line from a third corner that meets the diagonal line at a 90-degree angle. The place where these two lines meet can suggest a pleasing location for a focal point.

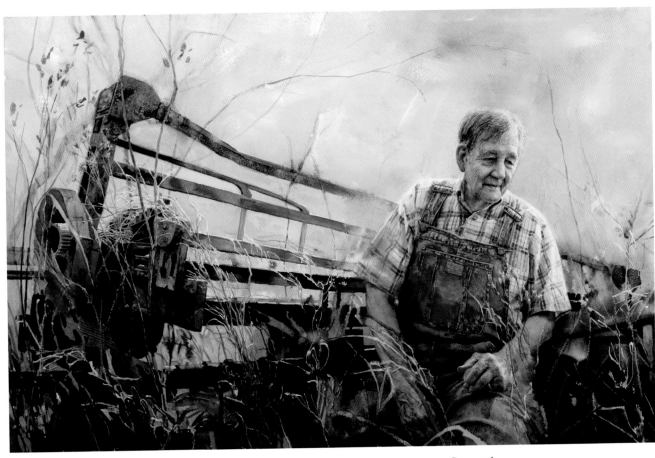

Boneyard
2009, watercolor on paper, 18¾ x 28¾ in.

Where you place your center of interest in a composition can add significant interest to a painting. In this painting of a textile mill worker sitting on a discarded loom, I have placed the figure off center in an L format. I omitted any trees in the background so that the linear quality of the old loom would have more prominence against the cool, atmospheric sky.

Although much has been written about each of these elements of design, in simple terms, they are all devices to control and move the viewer's eye across the painting. I personally think that focusing too much on these principles sometimes serves to confuse students further as to what is most important. What ultimately matters is if the painting works. Most often, if the painting doesn't work, it isn't so much that the principles of design weren't put into play but that the artist did not have a clear idea of what he or she intended.

A key element for every painting is the successful placement and emphasis of the focal point. Presumably, every inch of the painting has merit, but only one area can be where the viewer's eye should be led to and come to rest. The focal area should be strong enough that it holds its place among all the other elements in the painting. It should have a satisfying shape, color, and contrast as compared to what else it shares in the format. The exact placement of your focal point can be almost anywhere, though generally the balance of the painting is more pleasing if this vital area is not square in the middle. There are many books written about composition and focal points, and many are worth reading for reference, but ultimately

you simply place the focal point where it feels best. Again, knowing what you are painting and why will indicate the best way to make your composition. How the eye travels through a composition should be taken into consideration. The viewer needs a pathway designed by the artist to lead him or her around and to the "golden area" of the focal point. The eye can travel via color, edge, line, or contrast. Directional arrows can be mimicked through the use of a T, L, Z, S, cruciform (cross), triangular, arch, or free-form shape.

Viewfinders

One of the simplest ways to establish a composition is by looking through a viewfinder. Particularly helpful in land-scape painting, viewfinders can also be an aid when posing the model. By looking through the opening, you can scan the possibilities while omitting surrounding clutter. Many artists keep a couple of small viewfinders on hand at all times. I must admit I do not use a viewfinder but instead work out all of my compositions with thumbnail sketches.

Thumbnail Sketches

The thumbnail sketch is perhaps the most foolproof way to see in advance if your composition is going to work. Too often artists wait until a painting is nearly finished before realizing that the composition was doomed from the start. All of that effort and frustration could have most likely been avoided had the artist first done and evaluated a thumbnail sketch.

As its name implies, a thumbnail sketch does not need to be large, nor does it need to be detailed. My own are generally no more than three or four inches high. Details are best omit-ted, forcing you to concentrate on the larger shapes and value patterns in the composition. A thumbnail sketch is simply a painting road map, a means of planning the distribution of lights and darks and the important elements in design.

If the thumbnail sketch looks good, chances are the scaled-up finished painting will look good, too. Sometimes, though, the diminutive sketch will end up being more ap-pealing than the finished painting. The sketch may have had a freshness and directness that the more polished version doesn't. If this is the case, analyze the sketch's strong points and incorporate them into the painting.

Be careful, though, that your thumbnail sketch is the same format as your sheet of watercolor paper. A wonderful little

You don't need to buy a fancy viewfinder, since making one yourself is easy. Just use a piece of gray or white cardboard and cut a rectangle in the middle. You can adjust the format size by laying a sheet of paper at one end.

I always do thumbnail sketches before embarking on a painting. The small sketches allow me to see the basic shapes and values of the composition before committing to the final painting. Adding color to the small sketch further enables me to envision my painting.

compositional sketch in a square format will not scale up correctly into a large rectangle and still work.

Working from Photographs

I am frequently asked if I work from photographs. The answer is yes, but with caution. I use photographs as reference, knowing the great limitations they impose on both the visual and emotional aspect of painting. Visually, photographs are limiting because the camera cannot see into shadow as well as our eyes can. When looking at a model in shadow, particularly when the figure is silhouetted against a bright background, the dark values swallow up any lighter color within the shadow. If we were to see the model in the same light with our own eyes, we would be able to see more definition and color in the face and body. Overall, the camera cannot register as many colors as we can. Think how many times you may have photographed a spectacular sunset only to be disappointed later when you viewed the photographs.

More important, the camera records without emotion. Everything is put in and nothing is left out. If we are in awe of a majestic sunset, the camera will still put in the nearby trash can. If you were to paint the sunset from life, you would most likely put in only what is most important to *you*.

Knowing the limitations of the camera, it is still a handy tool to be employed as an aid. It can be helpful in recalling details or proportion and to document the passing nuances of light. Still, nothing will ever surpass the raw quality of experiencing your subject matter from life. It is only when you work from life that all of your senses—sight, sound, taste, touch, and smell—are at work and have meaningful input to your painting.

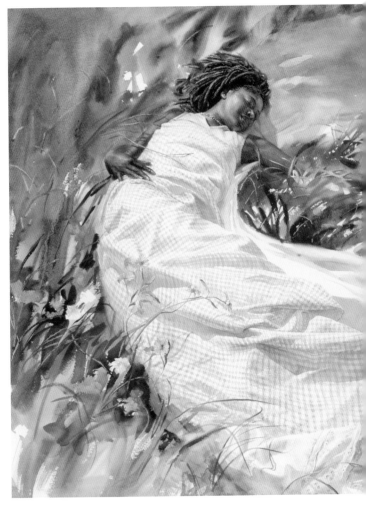

Coreopsis
2006, watercolor on paper, 34½ x 28 in.

In this painting, I wanted to play up the gracefulness of the model by using strong curves in the composition.

COMMON MISTAKES WHEN PAINTING THE FIGURE

Sloppy, inaccurate drawing

Using a brush that is too small

Using too little paint

Making the eyes too high or too close together

Making the hands and feet too small

Making the pose too symmetrical and stiff

Painting the figure with too many sharp edges

Painting inventory (eyes, nose, mouth) and not color shapes

Working too close, not stepping back to view your work

Making skin and shadows too dark and opaque

MAKING CORRECTIONS

Every artist wishes they could get a great painting every time. Even if we get it right once, the same conditions of subject, lighting, emotion, and timing will probably never happen again. Nor should they. Painting is about our immediate response to the world around us, which is an ever-evolving show. Every painting is an invention, and finding the solution is part thoughtful contemplation and part discovery. Unless we are mass-producing copies of our own work, we never know what the next painting will be. If we have never done this painting before, how can we know if it will work?

You must be willing to make mistakes if you are going to grow as an artist. Mistakes give us a starting point for evaluation and serve to remind us that we aren't there yet and need to keep trying. Every time you make a mistake, steer it to your advantage. Learn from it and move forward.

Every time your watercolor did something you didn't want it to do, remember it. What resulted from that unplanned "accident" was simply the evolution of a new technique, one to be employed sometime in the future.

In watercolor, mistakes are particularly unforgiving, so planning is necessary. In oil, anything can be fixed. In watercolor, very little can be fixed. Your best defense for having to correct errors is to plan well enough in advance that mistakes won't happen. By doing a thumbnail sketch, the composition can be planned out ahead of time. Preparation is also important, like having the right colors in adequate amounts ready on your palette. By drawing lightly and painting in light values in the beginning, edges can be modified with little evidence of having done so.

If the hues that need correcting are not harsh staining colors, then these areas can be scrubbed and lifted out for repainting. Using a stiff brush, sponge, toothbrush, or wadded-up paper towel, you can rub out an area. You won't be able to get back to the original pristine white of the paper, but you may achieve a soft glow that is appealing. After the area has completely dried, you can redraw and repaint as needed.

For a more aggressive approach you can use sandpaper. By sanding lightly, the top layer of pigment can be removed, but go gently so that you do not remove too much of the paper. After the area has been sanded, any new washes will have a different saturation and texture, so it is best to experiment first.

The last option for correcting mistakes is my favorite: starting over. Starting afresh always feels the best to me. By then I have worked out all the glitches and can paint in a manner that is confident from the start, knowing the necessary procedure. In real life, I tear up about one out of every four paintings, because I feel the image is composed poorly or the washes have gotten muddy. I never grumble about time or money lost but figure it is all part of being an artist.

SUGGESTED EXERCISES

1 Take a small sketchbook to the park and draw the people. Sketch people walking and sitting, children playing, and dogs running. Spend no more than five minutes on one sketch.

2 Take a sketchbook with you on vacation and make a drawing every day. When you return home, your drawings will be more valuable to you than photographs.

3 By looking in a mirror, draw a self-portrait. Change the pose, setting, and lighting, and do another self-portrait in watercolor.

demonstration Socks

WHITE SOCKS

▲ The idea for the painting came one afternoon as I caught a glimpse of a neighbor hanging socks on a line. Thumbnail sketches are useful for exploring ideas and compositions for paintings. I made several different sketches before deciding on this simple concept. I decided to use a dark background to emphasize the shapes of the girl and the socks.

◄ Making drawings of your model will familiarize you with the shapes of the face and figure before you start painting. When you are very certain of what you are going to paint, there is less chance of having to make corrections and muddying a watercolor.

▶ The image was first drawn in pencil on 300-lb. Arches cold-press paper. To establish the background, I used a 3-inch brush and dark washes of burnt sienna, ultramarine, and Hookers green. A few dark accents of cadmium yellow were added to the left. The shapes of the model, clothesline, and socks were left to be painted in later.

◄ I often set up props in my studio to help me understand better what I am painting. Here I have attached socks to the back of a chair. When you add additional props to a painting, the direction of the light source is very important, so that every object in the painting is lighted consistently.

► *Socks*
2010, watercolor on paper, 13½ x 14¾ in.

Using my #8 round kolinsky brush, I painted in the details of the face and figure. Most of the tiny whites in the face and hair are where I left the paper blank. The skin tone was painted using quinacridone rose, ultramarine blue, and raw sienna. The socks were painted in quickly, with different washes of cobalt teal, cadmium yellow light, raw sienna, and ultramarine blue. On the light side of the socks, I kept a ragged edge to suggest their texture. On the shadow side, I gave the socks a much softer "lost" edge.

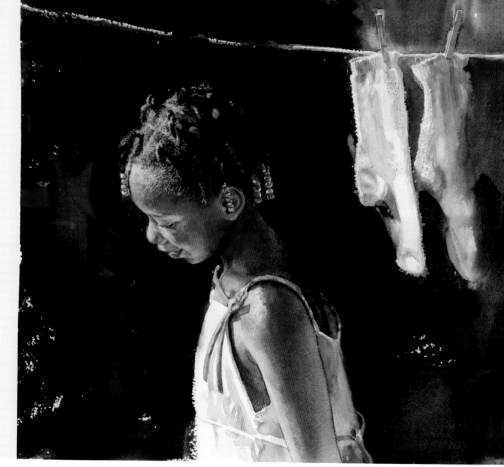

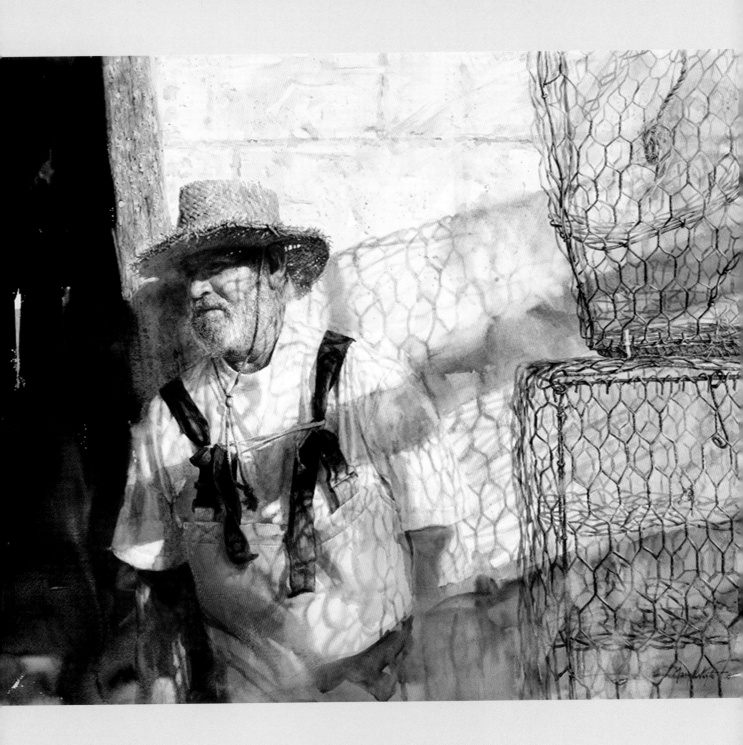

values

"The greatness of art depends absolutely on the greatness of the artist's individuality and on the same source depends the power to acquire a technique sufficient for expression."

—ROBERT HENRI, *THE ART SPIRIT*

Understanding the principles of value is fundamental if you want to depict form, particularly the human figure. Value is the crucial ingredient in painting that allows an object to appear to come forward or retreat. Value also describes the lighting in any given situation, showing its direction and intensity. Understanding the relationships of values is what is most important to the serious artist—how various tones compare to one another, so that each form and shape that is painted stays in the exact spatial plane intended. Value describes much of the world around us and tells us a lot about what we are seeing.

OPPOSITE *Trap*
2008, watercolor on paper, 30¾ x 38⅛ in.

The distribution of lights and darks in a painting will direct the viewer's eye. Here I have added stronger contrast to the values around the model's head to establish the face as the focal point.

WHAT IS VALUE?

Every color we see appears somewhere between black and white in its inherent tonal quality. Value is the relative lightness or darkness assigned to any given color. Red and pink may be the same hue on the color wheel, but pink is lighter in value than red. If you look at the paint on your palette you will see that certain colors are naturally darker than others. For instance, ultramarine blue is darker than cadmium yellow. When mixing watercolor, adjusting the value of any particular hue is easy—simply add more paint to make the color darker, or add more water to the mix to make the color lighter.

The simplest way to understand value is with lights and darks. To give objects in a painting a greater sense of volume, many artists think of the value scale as having nine shades, ranging from white to black. Values one, two, and three are considered *light* values. The next three values are considered *middle* values (with the fifth value being exactly halfway between white and black), and the last three tones are the *darks*. Of course, there are many nuances in between these values, but if you can render these nine degrees of light and dark, you will be able to successfully describe anything with paint.

What Value Does

Value creates three things:

1 A sense of light and shadow

2 A sense of form

3 A sense of depth

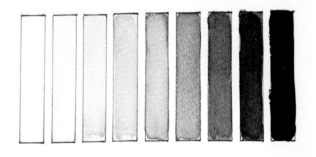

The value scale is broken up into nine steps, from white to black. The fifth tone is considered to be the exact middle value, halfway between the two extremes.

ABOVE Because of light, when looking at the world around us, everything we see comprises light, middle tone, and dark values. Even objects that are completely black or completely white have a full tonal range that falls within a particular section of the value scale.

RIGHT Lightening a value is easily done by adding water to the puddle of color on the palette or by adding water to the wash on the paper while it is still wet.

CREATING SHAPE AND DEPTH WITH VALUE

If we wanted to make a painting of eggs on a white tablecloth using only white paint and white paper, the eggs would appear flat and seem to disappear against the light background. We won't be able to tell which eggs are closest to us, unless some are overlapping or are noticeably larger. To give the eggs volume and make them stand out against the background, we will have to add some deeper values into the mix. Darker tones on the shadow side of the eggs as well as behind them will describe the eggs' forms as well as their particular texture. Adding a cast shadow will seat the eggs on the table and indicate the direction and quality of the light. If the values are correctly seen and painted, the eggs will look as they should and sit in their proper place in space. Whether you are painting eggs or noses, you must give each shape in your painting its proportional degree of value. The lightest lights and darkest darks always come forward. This principle will come into play in every single painting you do.

New Book
2003, watercolor on paper, 13½ x 13½ in.

Values tell the viewer where each shape sits in space and from which direction the light is coming. In this painting, the placement of contrasting values directs the viewer's attention to the two figures. To make the pillows more interesting, I varied the values and widths of the pink stripes.

Depicting objects that are on a background of the same value can be a challenge since the objects will seem to disappear.

Without the use of values, all shapes will appear to be on the same spatial plane.

To make the eggs that are closest come forward, it is necessary to give them more value contrast. The closest egg will appear the whitest in the light areas, and its shadow will appear slightly darker than the shadows of the eggs behind it. The eggs that are slightly farther away will not be as white, nor their shadows as dark.

Another way to look at value is to imagine telephone poles along a straight country road. The closest poles will appear darkest, while the receding poles will become increasingly lighter in value. This phenomenon of spatially decreasing value contrasts is caused by our atmosphere. The more distance between us and the objects we are looking at, the more of a hazy curtain of dust and water particles there is to dull the values we see and give them less contrast.

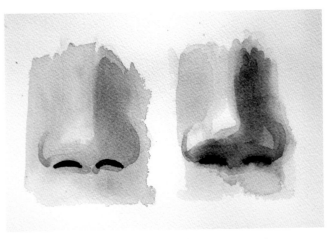

Without the use of values, any object, even a nose, will appear flat. The tip of the nose on the right comes forward because it is painted with lighter highlights and darker shadows.

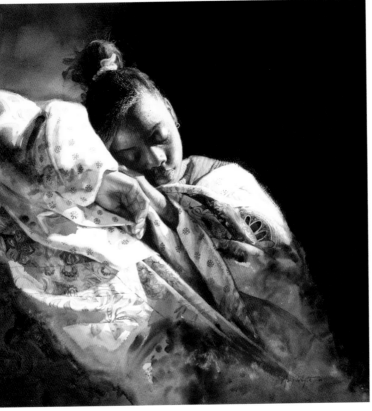

ABOVE *Dream of the Ancestors*
2001, watercolor on paper, 21 x 21 in.

The light coming from the right serves to describe the model's form. If there was not a strong light source to lighten and define her face, the young girl would disappear against the dark background.

RIGHT *Fifteen-Minute Break*
2008, watercolor on paper, 58 x 38¾ in.

Here I have made the model with the yellow suspenders come forward by placing him in front of the dark shape of the interior and by giving him lighter lights and darker darks than anything behind him. The other two figures recede into the shadows by giving them less contrast and softer edges.

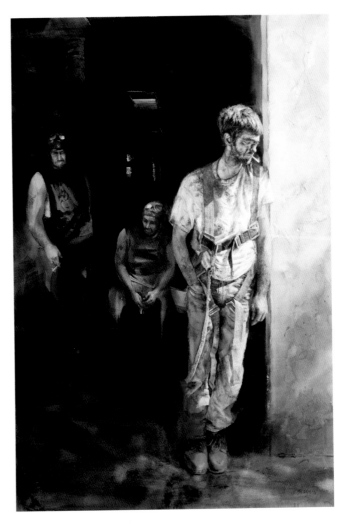

SEEING VALUES CORRECTLY

A value's relative degree of lightness or darkness can only be evaluated correctly when it is compared to other tones around it. If all you have are very pale washes on your painting, they will seem darker than they actually are because you are evaluating them on white paper and there are no true darks to gauge the light values against. To truly access the correct tonal degree of any color you are looking at, you must compare all of the values. It may be helpful to start by first identifying the darkest dark and lightest light in the subject or scene you wish to paint. Then, keep in mind that all of the remaining values will fall somewhere in between the two extremes but will be closer to either the lights or the darks.

The best way to most accurately see values is by squinting. By lowering your eyelids halfway and looking through your eyelashes, you will see that all of the values become simplified, and the confusion of detail is diffused. Squinting pushes together values that are close in tone, grouping them into bigger, more easily understood shapes. This method of "half seeing" is an advisable habit to adopt, especially since I don't know one serious painter who doesn't squint at least part of the time. It is a way of seeing and painting that takes getting used to, and at times you may not be sure of the values you are seeing. Always believe what you see, and avoid painting something that isn't there.

Learning to see values is a skill. With time you will get better at understanding and trusting what you see. Because watercolor is generally painted light to dark, the darker values can be added at the end before committing too early to what may turn out to be a mistake. If you are unsure about the tones while you are painting, keep your values light, and darken them as the painting progresses.

THE FIVE DEGREES OF LIGHT

For centuries, beginning art students were required by their instructors to draw and paint with one color only for several years. These rudimentary classes of drawing from life or from sculptural casts were part of the training artists went through to gain the necessary foundation in working with values and understanding the unique qualities of light. Only after students had demonstrated an understanding of light, form, and the human anatomy were they permitted to advance to the theories and practices of using color.

Light is the means by which we are able to discern form. Without light we would not be able to see and identify shapes and masses. It is the way light falls on things that enables us to recognize objects as hard, soft, near, far, textured, etc. The way light strikes any given object also tells us about the quality of the light itself, such as if it is harsh, soft, dim, etc.

In every situation where there is light, you will see these five aspects:

1 The *light* areas of any shape are those planes that are angled toward the light source and receive the most direct light. Highlights always point toward the light source.

2 The *mid tones* are the planes that are angled halfway away from light source, so they are receiving a glancing strike of the light. It is this type of lighting that best displays texture.

3 Any plane that is angled completely away from the light or is blocked from the light will be a *dark*.

4 A *cast shadow* occurs when something blocks a portion of the light cast onto another surface.

5 *Reflected light* will be seen when light bouncing off a nearby surface illuminates the shadow side of an object. Reflected lights are never as light in value as the areas actually struck by the light.

Seeing the Value Pattern

Seeing the lights and darks and the pattern-like shape they make is helpful if you want to describe form. By grouping all the lights together into one shape, and all the darks together into another shape, you can achieve a stronger pattern that will give them a sense of volume. By making these overall shapes as simple as possible, you will end up with a more dynamic painting because it will be easier for the viewer to "read."

ABOVE LEFT It is important to discern the different shapes of value when painting anything, particularly the face. I always draw in all the shapes I see, including the light, middle tone, and dark shapes, before I start painting. I also indicate the shapes of any highlight so I don't accidentally paint over them later and lose the white of the paper.

ABOVE In watercolor, the light values are generally painted first. Here I have painted the lightest areas as well as some of the middle values using raw umber.

LEFT Details and darks are best saved for last. In this study of a young girl's face, the five degrees of light are all accounted for, including the bounced light on the shadow side of the model's cheek and jaw area.

OPPOSITE *Sixteen*
2009, watercolor on paper, 18 x 14 in.

Seeing the lights and darks, or value pattern, in what you are painting will help you decipher form. It is always better to think in terms of shape, light, and shadow and not specific anatomic features.

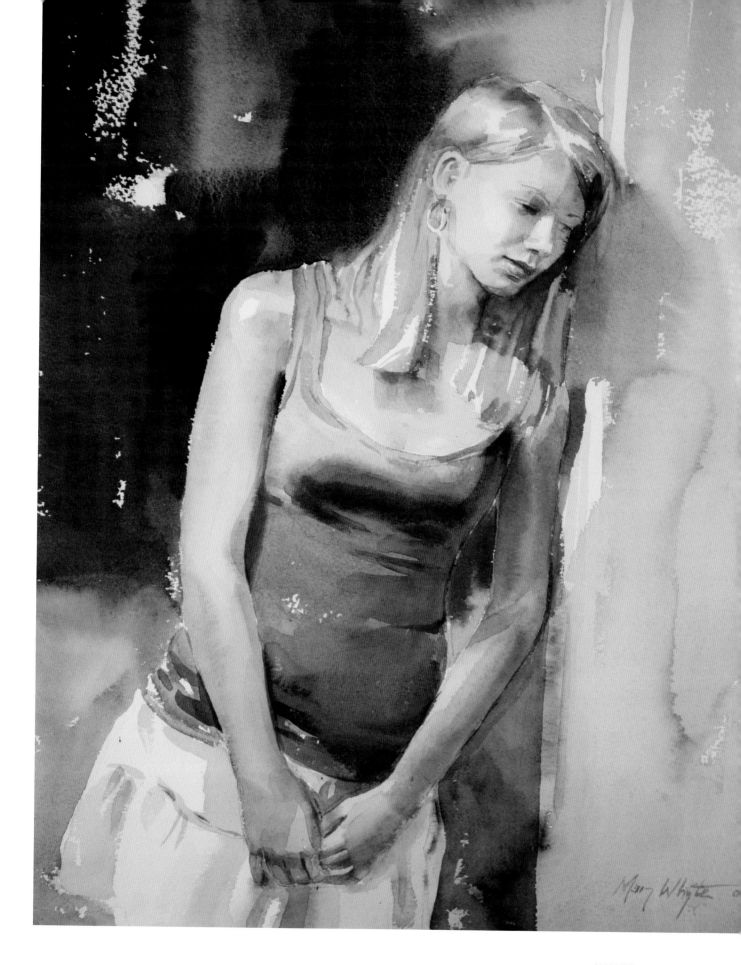

USING VALUES IN COMPOSITION

The way you use values in your painting will determine the painting's composition and ultimate mood. Predominately using values with low contrast will give a painting a more serene feeling. A painting that utilizes both extreme ends of the value scale will have a more dynamic feeling. Decide first what feeling you want your painting to have, and then orchestrate your values accordingly.

Every painting can have only one focal point or center of interest. How you place your values will guide the viewer's eye to this area, or not. Too many value changes will only serve to confuse the viewer. Make every effort to group as many closely related values together as possible, and save the highest contrast area for your focal point. Since the eye is always attracted to contrast, your painting's ultimate area of focus should be reserved for where the lightest lights and darkest darks collide. Fewer value changes and more color changes generally lead to more cohesive work.

Almost every successful painting has value dominance. One value must rule, or the painting can become spotty looking and fall apart as a unit. I like to think of value dominance in terms gallons, quarts, and pints. A painting can be designed to have a gallon of darks, a quart of lights, and a pint of middle values. Or perhaps a painting can be a gallon of middle tones, a quart of darks, and a pint of lights. It doesn't matter which value you have the most of, only that one tone is greater in proportion to the others.

Look at your subject and ask yourself where the dominant light source is coming from. Where is the lightest light and darkest dark? Where is the focal point, and how will I achieve that with value?

TOP Too many different values can confuse the eye and ruin the best idea for a painting. The viewer doesn't know where to look with so many busy, contrasting shapes.

ABOVE Grouping values and simplifying shapes makes a painting easier to read. The area of greatest contrast should be reserved for the focal area, and all other areas should be subordinate.

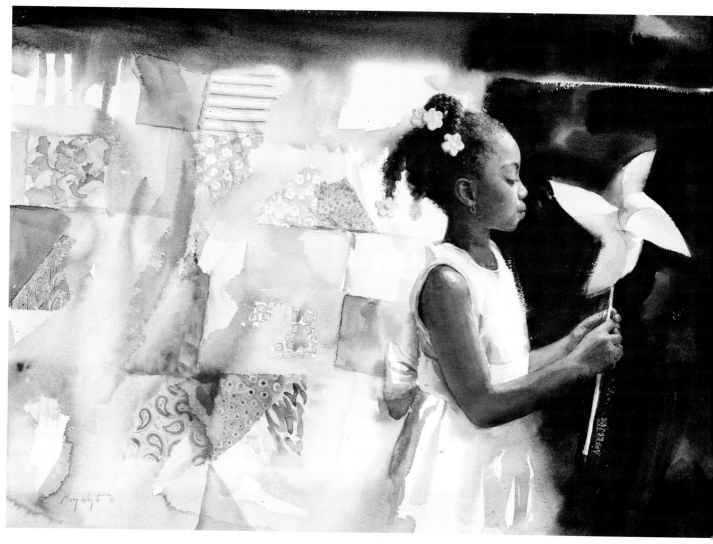

Pinwheel
2007, watercolor on paper, 21¼ x 28½ in.

In real life, my model was standing in front of a quilt with bright red and white patches. The contrasting, busy patterns would have taken away from the little girl's face, so I reinvented the quilt and made it softer and lighter in value. By placing the model's face against the dark background, and her dark hair against the light quilt, I was able to establish the little girl's head as the unchallenged focal point.

SUGGESTED EXERCISES

1 Using a photograph of a head as reference, show the light and shadow pattern in two values using only one color. Then do the same painting again with one color showing the five degrees of light.

2 Do a self-portrait looking in the mirror using one color.

3 Fill an entire sketchbook with black-and-white pencil studies of the people around you (at home, the park, diner, medical office, airport, etc.).

demonstration Corn Stalks

▲ The model was posed in the garden in the early evening, so that the light would be low.

Photo by Patrick Cavan Brown

▲ I drew the shapes of the young woman and corn stalks using a #2 pencil. Using masking fluid, I blocked out several areas where the light would hit the corn stalks so that these areas would be preserved for later.

▲ I like to paint my biggest area first to "set the stage." Using a 1½-inch cat's-tongue brush, I laid several washes into the background wet-into-wet using Hookers green, ultramarine blue, and maroon perylene. I wanted to have the dark background established so that the strong sunlight on the corn stalks would stand out.

▲ More of the shapes of the figure and corn stalks are placed. To give the figure a sense of motion, I painted her skirt at the same time that I painted the background next to it to create soft, moving edges.

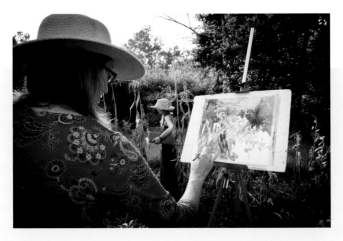

◀ Painting outside requires planning. When I set up outside, I turn my easel so that my paper is not receiving direct sunlight. Looking at the painting in shadow gives me a truer evaluation of the colors and values on the paper.

Photo by Patrick Cavan Brown

▼ *Corn Stalks*
2010, watercolor on paper, 11½ x 13 in.

The masking fluid is removed and the final touches are added to the painting. The watercolor was drawn and painted in less than three hours.

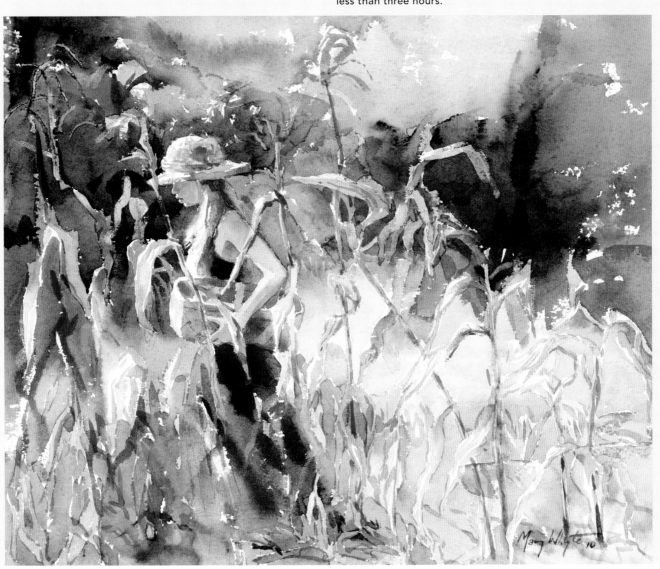

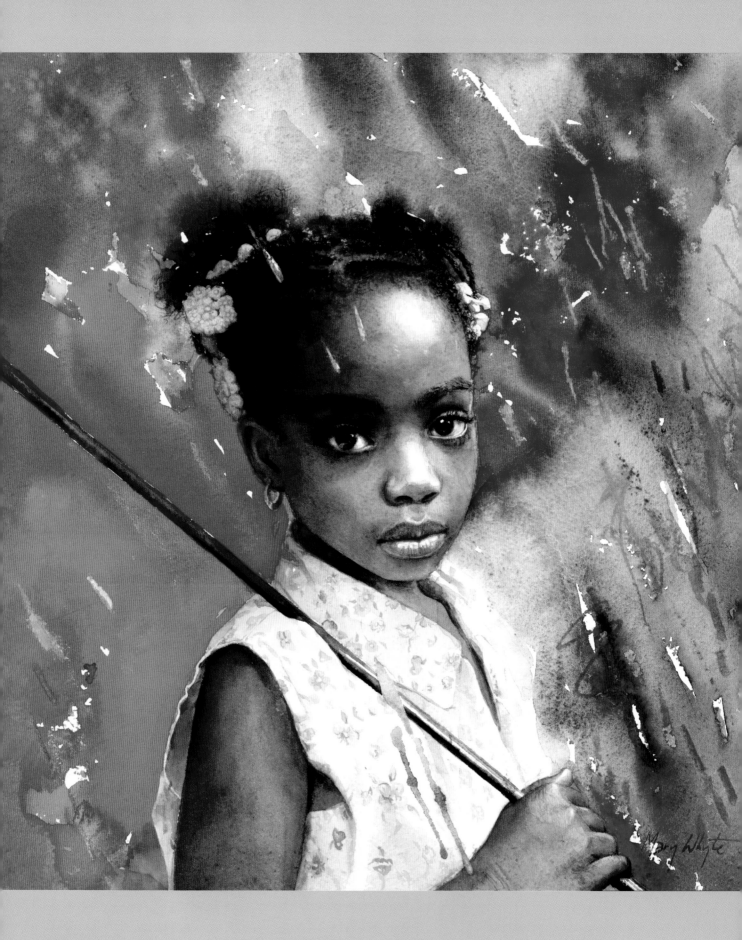

CHAPTER SIX

edges

"No great artist ever sees things as they really are. If he did, he would cease to be an artist."

—OSCAR WILDE

The quality of the edge we paint tells the viewer about the nature of the object we are looking at, where it sits in space, and what kind of light is falling on it. A hard edge indicates a stiff, solid surface or a quick turning edge. A soft edge indicates a yielding, fluffy, or supple surface or a rounded edge. A hard edge also can indicate that what we are looking at may be close to us. Be aware of the full potential of edges, since the manner in which you treat an edge can direct the viewer to specific areas of the painting.

OPPOSITE *Red Umbrella*
2005, watercolor on paper, 14½ x 14½ in.

Edges can give us a sense of distance, texture, and motion. In this painting, I softened the edges of the umbrella by painting them at the same time that I painted the background and suggestion of rain. The edges of the young girl's face were made more defined so that the viewer's eye would linger in that area longer.

HOW EDGES OCCUR

Every time you touch the brush to the paper, you create an edge. That edge can be hard, soft, ragged, or something in between. The edge you make can also have a poetic quality to it, such as soft, forceful, whispering, majestic, lively, or harsh. Edges are the magical components in painting that help us to create sensuous works, and having a variety of edges in our paintings helps us to keep from making overly flat works that have limited expression.

Where you place your hard and soft edges within your composition will have enormous impact on not only the feeling of the painting but on what you are telling the viewer is important. Reserve your most powerful edges for your focal area, and give all other edges a varying but less conspicuous quality. You only need to remember that a hard edge will invite attention and project interest, while a soft edge will play a more neutral role in the composition. The edge is a primary way of directing the eye and holding its attention.

Sometimes edges are imperceptible because the values of the two adjoining shapes are extremely close in tone, so they are referred to as *lost* edges. Edges that are more readily seen are referred to as *found* edges. Because almost every object we look at has varying values at and near its edges, there will be places on an object where the edges are both *visible* and *invisible*. Most edges will appear somewhere between hard and soft, lost and found.

When we look around us, we will see a mixture of hard and soft edges, as very little of any scene we are looking at is in sharp focus all at once. Where we focus our gaze on one object, its edges will appear more distinct, partly because we are giving this one small area our full attention. If you hold out your hand and focus on it, everything in your peripheral vision will go out of focus. Switch your attention just past your hand to an object in the background, and now your hand will go out of focus.

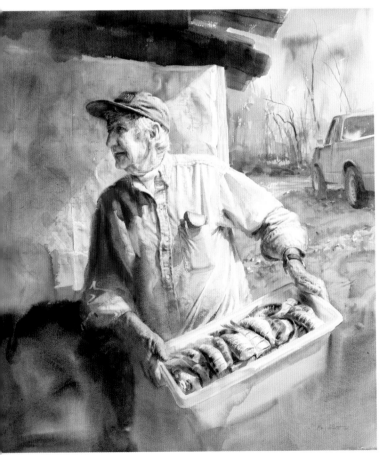

Giving something a hard edge or outline all the way around will only make it look flatter.

ABOVE An edge can be hard, soft, ragged, or something in between.

LEFT *Roanoke*
2007, watercolor on paper, 28¾ x 26¼ in.

Most of the edges in this painting are kept soft, to give the painting a thin, watery feel. The hardest edges and greatest contrast are at or near the man's head, which helps to lead the viewer's eye there. The soft edges were painted mostly with a wet-into-wet technique. Areas that have a hard edge were painted when the paper was dry.

MAKING SOFT EDGES

In watercolor, the physical working surface of the paper is constantly changing due to absorption and evaporation, so making different types of edges with the brush will take some practice. In watercolor, the quality of the edge depends on the *wetness* of the area and the *speed* of your brush manipulat-ing the wash. The more water you have on the brush and the faster you come back to soften an edge, the more the boundary between the two particular color shapes will soften or disap-pear. If you paint an edge slowly on dry or damp paper, the shape or edge of the area will have a more defined quality.

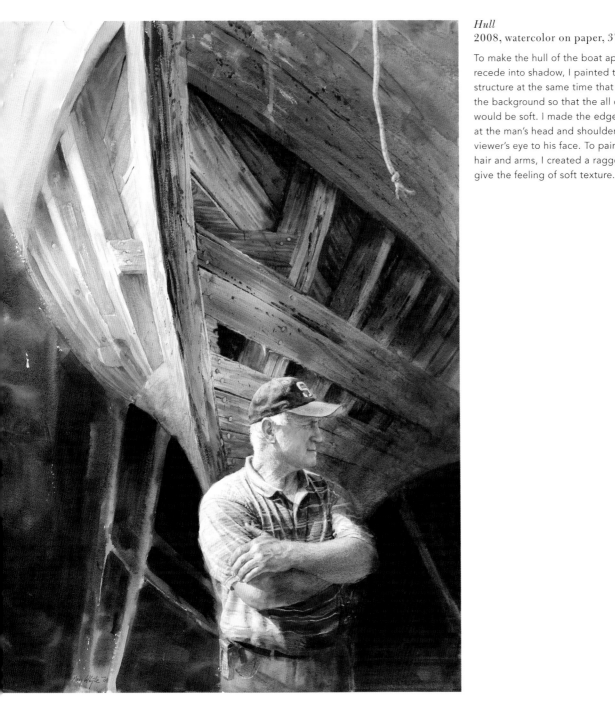

Hull
2008, watercolor on paper, 37 x 29 in.

To make the hull of the boat appear to recede into shadow, I painted the wooden structure at the same time that I painted the background so that the all of the edges would be soft. I made the edges the hardest at the man's head and shoulder to bring the viewer's eye to his face. To paint the man's hair and arms, I created a ragged edge to give the feeling of soft texture.

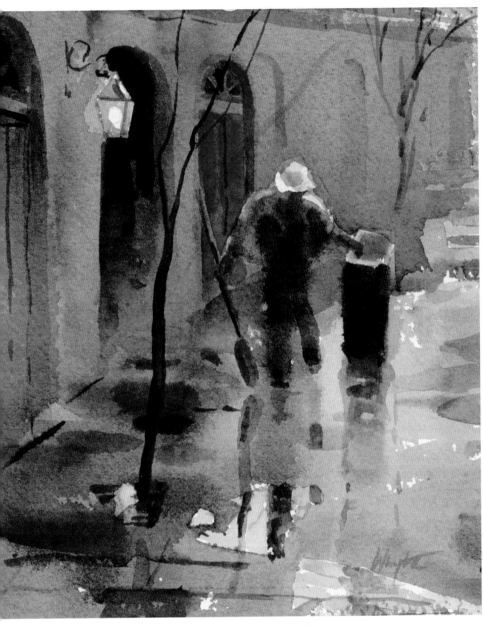

If an edge that needs to be softened has already dried, use a damp, round brush and lightly scrub the edge. If the color is a staining color or just plain stubborn, then work on it with a small, damp bristle brush—the kind generally used for oil painting.

Street Sweeper
2004, watercolor on paper, 7⅛ x 6 in.

Painting wet-into-wet will automatically give you soft edges. Here, I wanted to give the feeling of a figure in motion, so I painted most of the shapes of the figure at the same time that I painted the shapes next to and behind the figure.

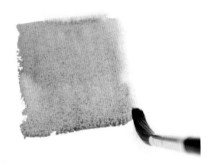

You can soften an edge in two different ways: the first, while the wash is still wet. After you have applied a wash shape or brushstroke, immediately rinse your brush and lightly blot it once on a paper towel. Then quickly trace around the outside edge of the area, just touching the wash with your damp brush. This "halo" of dampness will soften and slightly extend the first shape. This is an especially effective technique for painting the different color shapes of the face. The second way to soften an edge is to wait until the wash has dried, then lightly scrub the area with the tip of a stiff, damp brush.

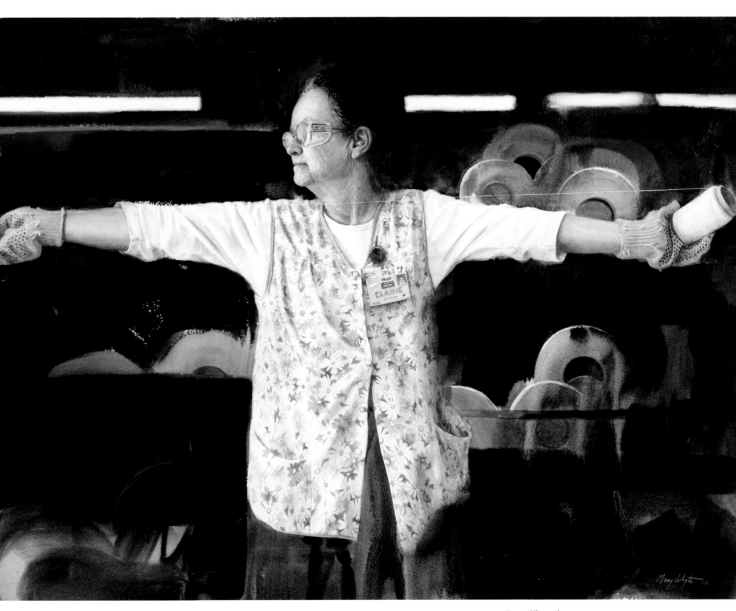

ABOVE *By a Thread*
2006, watercolor on paper, 27¾ x 39¾ in.

Since the face comprises many small color shapes with soft edges, I soften the contours of each shape as I paint them. Because I had previously drawn the facial shapes first with pencil on dry paper, I was able to paint the various glazes of color shapes with more confidence.

LEFT Anytime you paint two shapes or wash areas together at the same time you will get a soft edge. The wetter you make the washes, the more blending of the boundary will occur.

WHAT AFFECTS EDGES

Understanding what affects the quality of edges is important for every artist. Following are the elements to look for:

Distance: All edges tend to get softer as they get farther away. Because of atmosphere, perspective, dust, and humidity, everything becomes diffused as it recedes.

Quality of light: A strong light will produce much harder edges than a murky or north light. A single powerful light striking an object at right angles will produce sharp edges, while softer illumination like twilight will make edges appear hazy.

Shape: Rounded objects like a cheek, an arm, or the fold of a dress will have a softer edge than objects that are sharp or angular, like a knife or the edge of a collar. Smaller objects will have the illusion of being lighter in value and have softer edges because more light spills around the outside contours.

Color: When two adjoining objects are close in value (such as a dark blue belt on a dark green dress), the transitional edge between them will be more difficult to see and will appear soft. If the belt is a light yellow, the boundary and edge will appear stronger.

Nature: If the inherent nature of the object is soft, such as a kitten or curly hair against a fur coat, the edges will appear much softer than if you were painting a tree trunk or rock.

Motion: Anything in motion will appear to have a soft edge, such as a child running, a flag flapping, a bird flying, or a hand waving.

When looking at the model, squinting is your best tool for determining the quality of edges. By squinting you will more clearly see which edges are hard and which are soft.

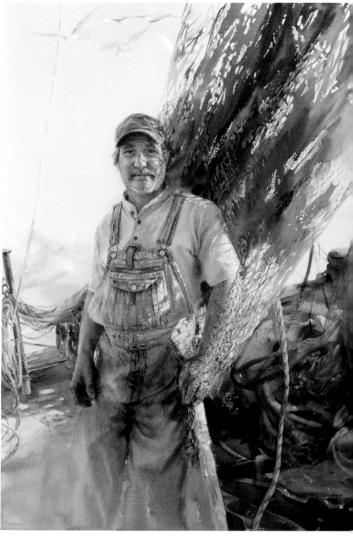

Trawler
2009, watercolor on paper, 37 x 28¾ in.

When painting an object and texture that repeats often, such as the small shapes of a shrimper's net, it is best to suggest the net in places and focus on details in only a few spots. In this painting, most of the net was painted with a large brush on damp paper with combinations of blues and greens. Objects that fall into shadow are given soft, swimming edges.

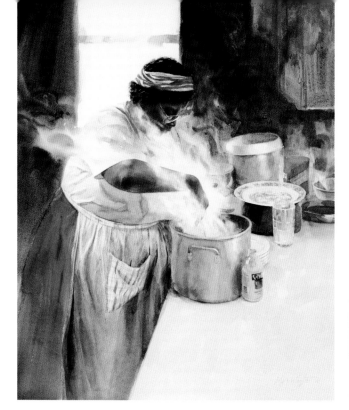

ABOVE *Sunday Dinner*
2001, watercolor on paper, 22 x 19 in.

Having a variety of textures in a painting can add visual interest. In this watercolor, the soft edge of the steam and clothing are contrasted against the hard edge of the woman's face. Although the soft edge of the steam is appealing, the eye will always be more attracted to a hard edge.

RIGHT *Mr. Okra*
2008, watercolor on paper, 28½ x 38½ in.

When a painting has many shapes, such as this one, I am careful to make the edges of the objects near the corners of the painting softer and with less contrast. My sharpest edges are in the areas of the figure's face and torso.

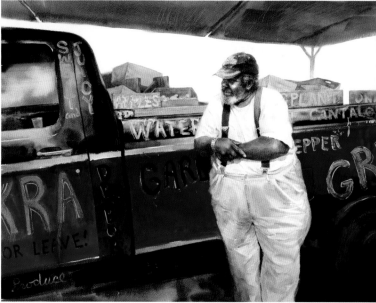

SUGGESTED EXERCISES

1 On a piece of watercolor paper, list eight words that describe music, such as *soft, majestic, powerful, lively,* and *sweet.* Then paint a series of brushstrokes with edges that depict the words.

2 Make sketches of people at the park. Sketch people at rest and others moving. Evaluate your edges.

3 Paint a figure that is in bright light, and then paint the same figure again in diminished light. Study how your treatment of edges varies in the two paintings.

demonstration Luna

▲ A thumbnail sketch is a sound way to work out in advance where the figure's shape is placed in the compositional format.

▲ The model is posed so that the line of her body creates a diagonal, which will help to give the painting a more serene and relaxed feeling. The cool, natural light coming from the left produces warm shadows.

◄ The success of a painting depends not on how it is finished but on how it is started. By making the big statement of the background first, I will then be able to integrate all of my subsequent colors into it for a harmonious look. To paint the background, I first wet the area with clear water, then I painted into the damp paper using maroon perylene, ultramarine blue, Hookers green, and burnt sienna.

▲ When the background was almost dry, I lightly scraped out small marks with my fingernail to give the impression of a few wisps of hair along the edge of the model's head.

▲ To simulate skin in shadow, I often paint two washes wet-into-wet. By painting a wash of ultramarine blue and then charging in a second wash of raw sienna and quinacridone rose, I was able to get the neutral color of the skin in shadow.

▲ If you have a good brush, you can paint a one-inch-wide stroke or an eyelash. Here I am using my #8 round kolinsky brush for my smallest details.

▲ To suggest the texture of the model's hair in the light, I used a dry-brush technique. By holding the handle low to the paper, I was able to scumble or drag damp paint over the surface of the painting. Here I used a mixture of burnt sienna and ultramarine blue to paint most of the darker areas of hair. Be sure not to use too much water in your wash when you use a dry-brush technique.

◄ The quilt is painted partially in shadow, so the edges needed to be soft where there is less light. I didn't want the pattern of the quilt to distract from the model's face, so I kept the various shapes of the quilt elements low contrast with softer edges.

◄ To give the hand the feeling of having a light side and a shadow side, I gave a harder edge and more contrast to the illuminated side of the hand and arm. Also, by keeping the edges of the hand sharp near the face, I was sure to draw the eye to the model's expression and features.

▶ *Luna*
2010, watercolor on paper, 26 x 20 in.

To finish the painting, I completed the other hand and remainder of the quilt. Other areas of the painting are refined, but I kept my greatest contrast, details, and sharpest edges near the model's face, the focal point.

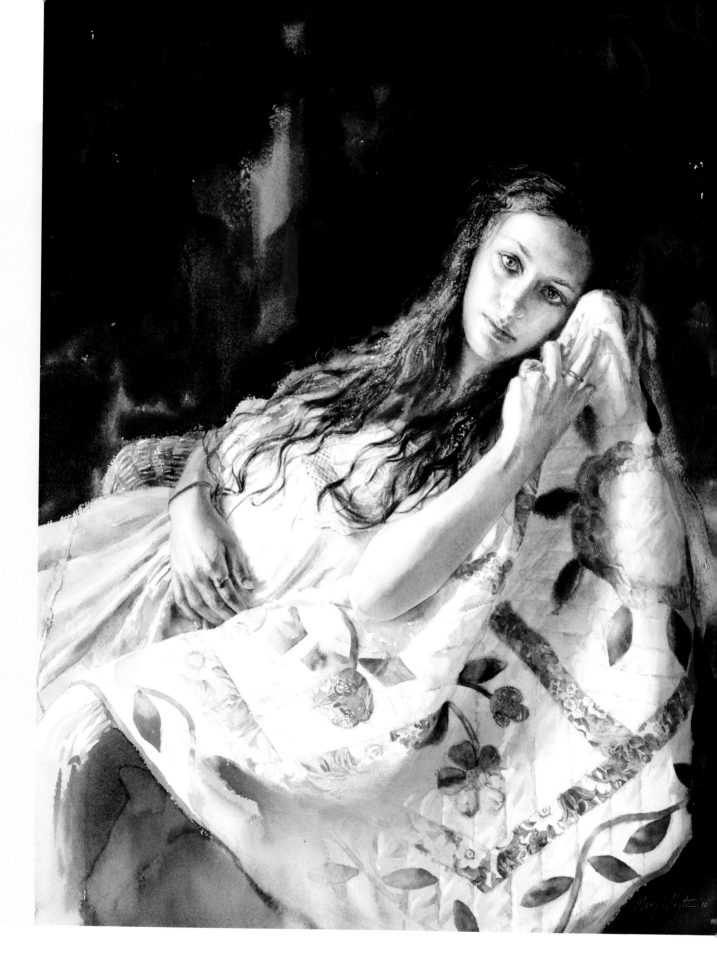

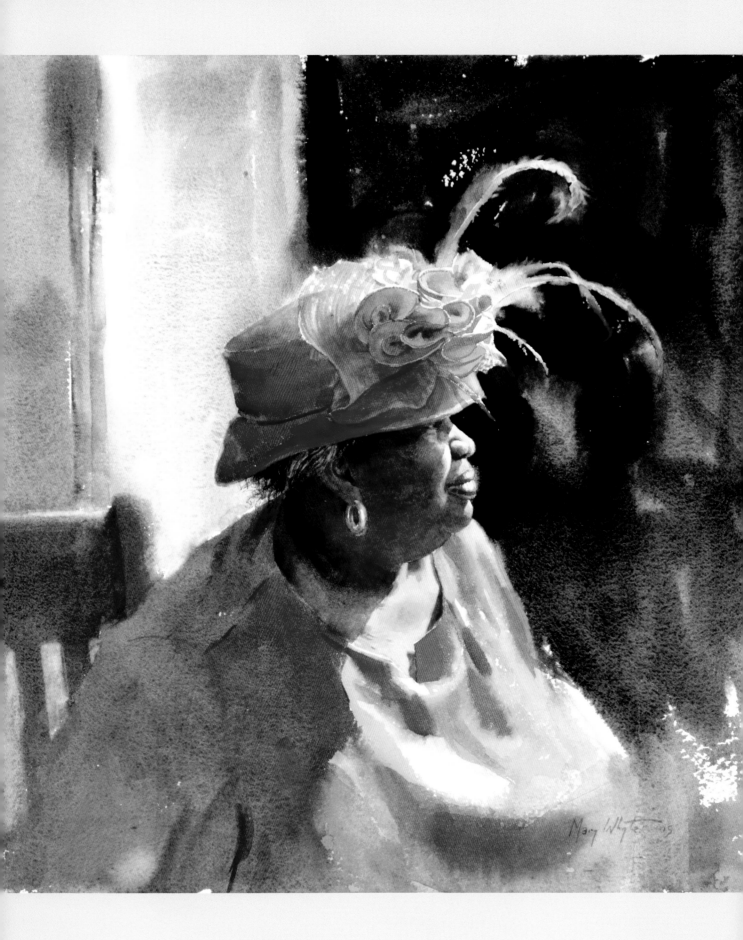

color & light

> *"The aim of art is to represent not the outward appearance of things, but their inward significance."*
>
> —ARISTOTLE

Color helps to create the illusion of form and the space around form. It also has the ability to shape our mood and influence our senses. The feeling we get when we look at a portrait made with cool neutrals can be very different than when we view a portrait comprising oranges and yellows. One painting may signify a person with a somber or serene temperament, while another color palette may suggest a robust, vibrant personality.

◀ *Red*
2009, watercolor on paper, 22 x 18 in.

Color creates form, but with the addition of emotion. In this painting of my friend Alfreda, I wanted the image to make a statement about the model's strong and confident personality. With this in mind, there was no other color choice but to make the hat and dress red.

THE MAGIC OF COLOR

Painting with color is part knowledge of theory and part instinct. Many of your color decisions will be made intuitively and will become a part of your personal signature. As an artist you may find that you gravitate toward certain hues. This aesthetic disposition is most likely programmed at birth, but it may well also be a product of your education, geographic location, and current tastes. Some artists respond to "hot" intense colors, while others are more comfortable with softer, more neutral combinations. The painters of the Italian Renaissance preferred dark, warm colors, while the French Impressionists chose pinks, greens, and blues from the opposite side of the color wheel.

Artists do not see color differently or better than other people. Our eyes function in exactly the same way as do the eyes of roofers, office workers, and computer programmers. The difference is that we have learned to observe color and then translate what we see and feel into a work of art. So, you can't say you don't have any color sense or that you don't know what colors work together. There are no groups of colors that are better than others, in the same way that there are no formulas for painting skin, hair, trees, clouds, or barns. It all depends on what you *see at that moment* and how you *feel* about it. And while we are debunking myths here, let me also add that there is no such thing as a beautiful or ugly color.

In the right composition of hues the color gray can appear just as lovely as your favorite blue. It is where that particular color sits in relation to other colors that makes it compatible or not; in other words, it is simply how you feel about a certain color in a particular place.

Spending earnest effort in learning how color and light work together will only improve your paintings. The undisciplined use of color will result in a fragmented composition or a work that seems contrived.

Color and value are inseparable, so as you gain experience in mixing color you will automatically begin to consider the value of each hue and know whether you want it to be light, dark, or somewhere in between. Learning about color and its powerful capabilities will widen your vocabulary and open up a range of expression in your work that you may not have thought possible. Instead of just painting a face with an exact likeness, through the sensitive use of color you will be able to add a degree of emotion to the painting that otherwise was not there. Your portraits will have more humanity, say something meaningful about the model, and will endure as works of art.

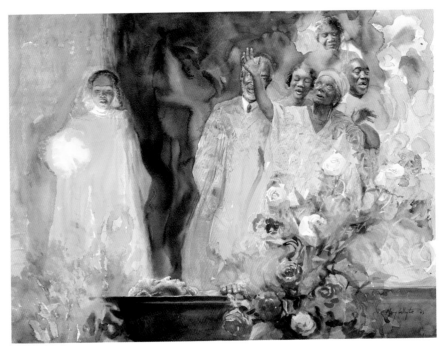

Soul Rising
2003, watercolor on paper, 22¼ x 29¼ in.

The colors you choose will greatly impact the mood of the painting. This was a painting I did from memory after attending a funeral of a friend. By using predominantly warm colors such as yellow and gold, I was able to give the painting a sense of mystery and spiritual light.

THE COLOR WHEEL

As artists we have a full palette of colors from which we can choose to create our paintings. The seven colors of the spectrum are red, orange, yellow, green, blue, indigo, and violet. These colors, and all of the nuances of hues in between, make up our range of vision.

The *primary* colors are red, yellow, and blue. *Secondary* colors are the mixture of any two primaries, such as orange, made from red and yellow, and green, made from blue and yellow. *Tertiary* colors are the combinations of any two secondary colors. With watercolor, to make any color lighter we simply add increasing amounts of water to the hue.

The colors I use (as listed on page 34) incorporate the full range of the spectrum. I employ the primary colors in warm and cool, and from them I can mix an endless number of washes in varying nuances of value, intensity, and temperature. Over the years I've honed my color choices to suit my own personal taste and have selected pigments that better enable me to capture the subtle characteristics of painting the figure. After you have been painting for a while and have had the opportunity to experiment with different hues, you'll find that you will have preferences for particular hues and brands.

Complementary Colors

Complementary colors are hues that are opposite each other on the color wheel—for instance, red and green or orange and blue. Knowing how complementary colors can enhance your painting will be beneficial no matter what the medium or subject matter is that you choose. Combining opposite colors can add a visual liveliness to paintings because of the inherent tension between the two colors. Also, the perceived intensity of any color can be enhanced by placing its complement around or near it.

Several Impressionist painters, such as Degas, underpainted skin tones in blue-greens and then crosshatched over the existing color with rosy tones. The optical sensation of the two colors together produced a shimmering effect not possible with one color alone. A similar effect is achieved in watercolor by glazing or painting wet-into-wet. When glazing, the second wash is applied lightly, allowing the lower complement to shine through the top layer. With wet-into-wet, the two complements are applied simultaneously, and if not over-manipulated, they will produce a wash with luminosity.

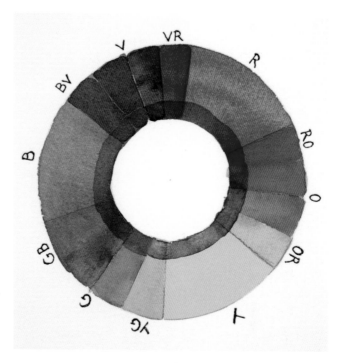

You can make your own color wheel and hang it in your studio for reference. By making your own chart you will become more familiar with color mixes and how primary, secondary, and tertiary colors are made. The colors on the inside band have been glazed with the color across from them on the color wheel, which is their complementary color.

When predominantly using two complementary colors in a painting, it is advisable to consider the proportions of the two hues being used. Employing equal percentages of two colors will produce a composition that appears disjointed. Using more of one complement and less of another creates an aesthetic balance.

Neutrals

Many beginning artists shun neutrals because they think of these less-colorful hues as dull grays. This notion that neutrals are detrimental and will make a painting lose its appeal is totally false. Neutrals can be instrumental in a painting because they can give the eye a resting place and create a visual "bridge" between the dominant colors. Neutrals can also be beneficial because they are a suitable foil for the vibrant, eye-catching areas of your work. If you want your viewer to notice the intensity of a certain shape, place it against the quiet neighbor of a neutral.

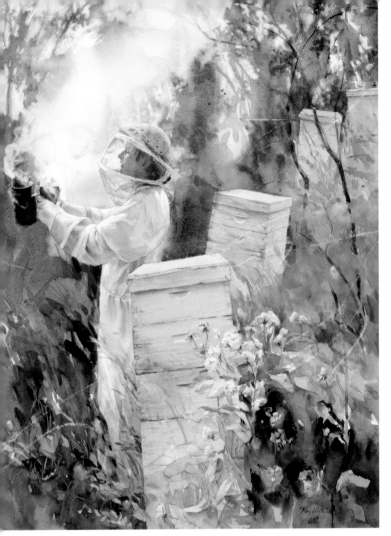

Your most lively neutrals will be created by mixing two complementary colors together. For example, a mix of burnt sienna and ultramarine blue will produce a handsome gray, but the exact tone and temperature of the gray will depend on the proportion of burnt sienna to ultramarine blue. If you add more of the blue you will get a cool gray, as opposed to adding more brown, which will produce a warmer neutral. By not over-mixing your two complements, the color will have more luminosity, with subtle nuances of the two original colors. Experimenting with different mixtures will lead you to new discoveries.

Beekeeper's Daughter
2008, watercolor on paper, 28¾ x 21¾ in.

In this painting, I used mostly cool blues, violets, and greens and then added just a note of the opposite yellow in the model's clothing. If you put your hand over the yellow, you will see that the painting loses its liveliness. The little bit of complementary yellow plays a strong part in the composition.

In the first square, I mixed quinacridone rose and Hookers green on the palette before applying the wash. For the second square, I painted a wash of cobalt violet and then when the wash had dried glazed over with raw sienna. In the third square, I painted ultramarine blue and burnt sienna wet-into-wet. Each combination of colors produces a different neutral, and each method of application gives a different look.

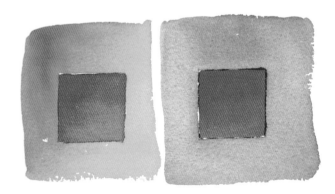

Here I have painted two squares using cadmium red. One square is surrounded by an intense orange. The other red is surrounded by a neutral gray. The red stands out more against the neutral.

THE DECISION OF COLOR

For many students, one of the most difficult parts of constructing a painting is making color decisions. Determining which color to place in an area can be a difficult choice to make. The reason color selection can be so daunting is because you are not making just one decision; you are making four: *hue, value, intensity,* and *temperature.*

Hue

Many beginning artists falsely believe that the only decision they need to make is hue, or which of the twelve colors on the color wheel they will select. Hue is simply the color's common name, such as blue-violet or orange. It is probably the easiest decision to make, as most artists have an idea of the basic color they want to incorporate. If you are still indecisive, sometimes it can be helpful to paint the proposed color on another piece of paper, cut it into the shape of the area in question on the painting, and then gently tack the colored cutout to the painting. This way you can evaluate if you like the color or not and then decide if it needs adjustment in value, intensity, or temperature.

Value

Most watercolorists work from the lightest to darkest values, decreasing the amount of water in their color mixtures as they go along, hence making gradually darker washes. Value is relatively easy to adjust and correct in watercolor. If the wash you have put down is too light in value, simply glaze over it with another wash until you have the desired value. If the wash is too dark, you can correct it by immediately adding water to it or by blotting it with a paper towel, which lightens the value. If the wash area has already dried, you can lightly scrub and lift the area with a sponge or brush, providing it is not a staining color.

Intensity

Intensity, also referred to as chroma or saturation, relates to the purity of color. The purer the color, the more intense the hue will be. Students often confuse value with intensity, thinking that if they add white to the color, it will make it more intense. The opposite is true. The instant you add anything to

Paint squeezed from the tube will be its most pure and intense color. However, it is still possible to make the color seem even brighter by placing it near its complement and making all other colors around it less intense.

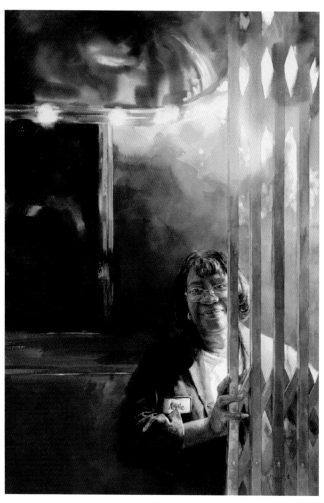

Fourth Floor
2009, watercolor on paper, 32½ x 22½ in.

In this painting, the paper is left white in places to indicate lights and reflections and then darkened in value in other areas to enhance the effect of golden illumination. The light and dark values of colors are given more contrast near the model's face and to the light source.

a color—white, black, or another color—you are diluting that hue and making it less pure. Watercolor is actually a subtractive process. The more outside elements you add to a color, the less intense it becomes.

In nature, the intensity of an object's color is determined by its proximity to the viewer and by the degree and quality of light falling on the object. The closer an object is to you, the more intense the color will be. In the distance, objects will become less intense in color and actually move toward their complement, producing a gray. Lighting also has a profound effect on intensity. The more light on an object, the more intense its color will be. Sunlight will produce more vibrant colors than you will see on an overcast day or at night.

Temperature

We often refer to certain colors as warm or cool. Colors with blue in them are considered cool, while colors that contain yellow, such as some reds and oranges, are called warm. Green can actually be either because of where it sits on the color wheel. By adding yellow or blue into a color, its temperature can be adjusted, making it warmer or cooler.

In my classes, to illustrate color temperature I will often hold up something that is red (say a can of Coke) and ask the students, "Is this a warm red or a cool red?" Then I'll hold up a violet-red object next to the can and ask the question again. The cool violet-red will make the can of soda look warm. Finally, I'll hold up something that is a warmer red next to the Coke, making the color on the can look comparatively cool. The point of the visual exercise is that any color's perceived temperature can be altered by the color next to it. It is simply how the color looks compared to its surrounding hues. Each time a new color is introduced into an arrangement, all of the previous colors shift in temperature.

In nature, we see warm and cool colors around us all the time. A good example of how color temperature can change is when we observe a mountainous landscape in autumn. The trees close to us might appear bright orange, while in the distance the same type of tree will appear to be a cooler color such as violet. This shift in color temperature is caused by distance.

In painting, structure and depth can be visually created by manipulating color temperature. Objects in the foreground can be made to look closer by giving them warmer colors. Objects can be made to recede by utilizing cool colors.

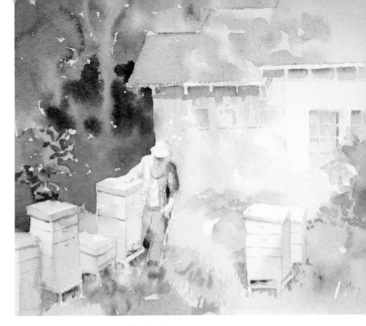

Worker Bee
2010, watercolor on paper, 9 x 11 in.

I did this painting as I watched my neighbor tend his bees. By adding warm washes to the areas of the house in sunlight, and cool colors to shadow areas, I was able to get the feeling of late afternoon light. Objects in the background, such as the trees, were made to recede by using slightly cooler colors and softer edges.

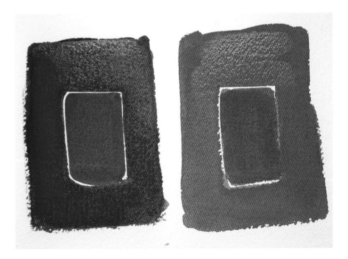

Is this a warm red or a cool red? The two red rectangles are the exact same hue. The red rectangle on the left appears warmer because it is surrounded by a cooler red with blue in it. The red rectangle on the right appears cooler because it is surrounded by a warmer red with yellow in it.

MIXING COLOR

If you set up your palette in a similar fashion to the color wheel, your hues will appear more logical and be easier to mix. I like to put my yellows and reds on one side of my palette; my greens, blues and violets on another side; and my earth colors on the third side. Arranging your colors in an orderly fashion will free you from having to search for a color on your palette and risk losing the quick timing needed that ensures the freshness of watercolor.

In watercolor, if you combine too many hues, the resulting color can become muddy or opaque. Selecting from fewer colors helps with the control and harmony of colors, especially in watercolor, which demands freshness. Although I have eighteen colors set out on my palette, I generally use no more than six in a painting. The other colors are still helpful as visual comparisons when I am determining color and value.

When combining two or more colors, try not to over-mix the pigments. Your paintings will appear brighter and livelier if you let the colors partially blend themselves optically on the paper rather than over-mixing them on the palette or paper. This is the same approach the Impressionists used, by letting the broken areas of color be optically mixed by the viewer. It is important to place the wash and leave it alone. Adjusting color too much after you have put in on the paper can lead to disappointing results. Keep in mind that watercolor always dries lighter and a little duller, so you will need to be brave and mix up your washes darker and with more color saturation.

When putting down glazes, remember that less is more. The fewer times you pass over one color with another color, the fresher the result will be. Too many washes of different colors will produce a dull, opaque look, making it impossible to get back the pristine color without having to start over. Glazing with a complementary color can really only be done once without risking mud.

In watercolor, less is more. Less colors in mixes.
Less glazing. Less noodling.

Surprisingly, using too much water can ruin a watercolor. Having too much water on your brush or in your mixes can produce color that lacks richness, has uncontrolled edges, and causes you to have to keep going over the area to achieve the

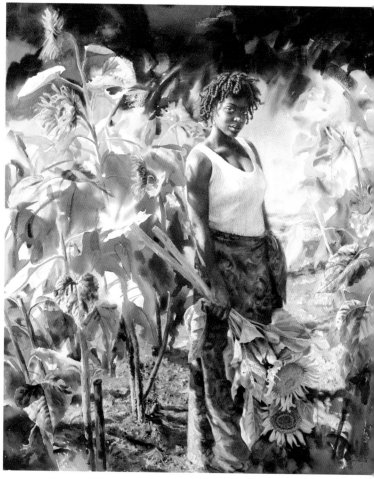

September
2003, watercolor on paper, 47 x 39½ in.

Putting down clean color largely depends on applying the color as few times as possible. Shadow areas should have a transparent airiness to them, not heavy opaque color, so I generally paint these areas wet-into-wet using two colors and then leave it alone. By keeping the shadow colors cool, I was able to give the painting a sense of warm sunlight.

desired value and intensity of color. To avoid this, whenever I rinse my brush I lightly touch the tip of the hairs to a paper towel before going back into the color on the palette.

The size of the brush you use will also play a big part in the ultimate quality of your colors. If you watch experienced watercolorists at work, you will see that many of them use a large brush for a variety of brushstrokes, washes, and effects. Using the largest brush you can for as much of the painting as possible will keep you from overworking. You will use

broader, richer washes, and because you will be able to cover more area quickly, your washes will appear cleaner.

Adopting good working habits will help you in your quest for clean color. Keep your water clean and your palette mixing area frequently wiped off. Good lighting also makes a difference. Use a natural, consistent light source, such as north light, or augment your working area with full-spectrum light bulbs. Avoid working in direct sunshine, as the glare on your white paper will confuse your sense of values. If you paint in direct sunshine, your watercolor may look all right at the time, but when you bring the painting inside, your values will be considerably too dark.

Mixing Skin Color

Regardless of your model's heritage, there is no recipe for mixing skin color. There is no one tube of paint or combination of colors that equals the universal effect of skin or the skin of a particular ethnic group. It all depends on the individual, the quality of light, and what the model is wearing.

Light is one of the single greatest factors that will determine the appearance of skin color. When a face is in warm light, the shadows will appear to be cool in temperature. The opposite is true when a face is in a cool north light, when the shadows turn warm.

Everyone's skin color has a predominance of red, yellow, or blue, which explains why we all tend to look better in certain colors. Some people look better in yellow, others may look better in blue. It all depends on the coloration of a person's skin. Some folks have more blue tones in their skin, while others may have more rose or yellow tones. Even siblings in the same family can have similar features but different skin tones.

I generally select from three or four hues when mixing skin colors. The colors I most often use are quinacridone rose, raw sienna, and ultramarine blue. These three colors are a more neutral, less intense version of the primary colors and will enable you to mix unlimited hues. These colors are also transparent in nature and better mimic the translucent quality of skin. Depending on the model and the situation, I will also sometimes use burnt sienna, cerulean blue, or maroon perylene.

Within the face's overall coloration there are always a myriad of interesting, nuanced colors. Many people have more ruddiness to the fleshier cheek and nose area and more violet tones in the areas of thinner skin, such as around the brow and eye area. Generally there is a cooler color beneath the nose around the mouth, particularly for men, who have a shadow of a beard.

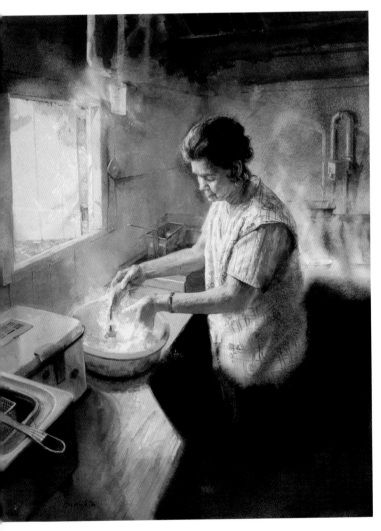

Look for areas of warm and cool within your model's skin colors. Having a range of temperature in skin tones will keep the model from looking like a mannequin in your painting.

Fried Herring
2007, watercolor on paper, 27 x 21¾ in.

Skin color is largely determined by heritage, lighting, surrounding color, and what the person is wearing.

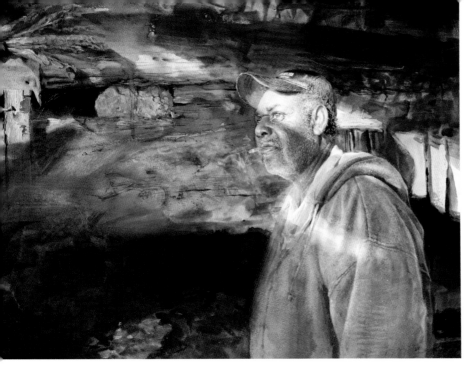

Eclipse
2009, watercolor on paper, 22¼ x 30¾ in.

Painting darker skin is the same as painting light skin, except that the watercolor washes are darker in value. I use the same basic colors to start and then add specific color emphasis where I feel it is needed.

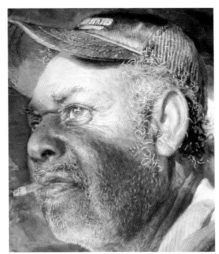

LEFT The colors I most commonly combine to paint skin are quinacridone rose, ultramarine blue, and raw sienna. When mixed in varying proportions, these primary colors can reproduce most colors found in the skin. When mixing skin color, you first need to determine what is the predominant hue, intensity, value, and temperature of the particular skin you are painting.

RIGHT It is important when painting skin to find the different color temperatures. Look for places in the face and figure where the skin appears cool (bluer) or appears more warm (reds and yellows). By adding this range of sensitive color, your model's skin will look more natural and be less apt to appear lifeless.

Highlights

Places where you leave the white of the paper showing will give the appearance of being light-struck. Highlights will always point toward the light source, with the whitest highlights reserved for areas that are shiny, close to the viewer, or near the focal point. Be careful not to have too many highlights, as it can make an image look like it has little substance.

Remember, too, that not all highlights are white. Since everything we see goes from light to middle tone to black, even dark objects like a black French poodle will have highlights. The highlights on the soft fur of the dog will be lighter in value than black but not a pure white.

Keep your shadows transparent, or veil-like, allowing the shapes in shadow to "swim" together. Be careful to make each shadow different, noting any bounced color or light that might affect its quality.

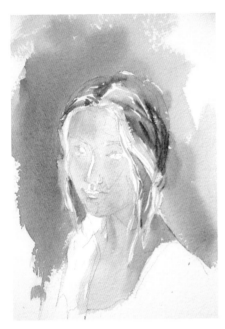

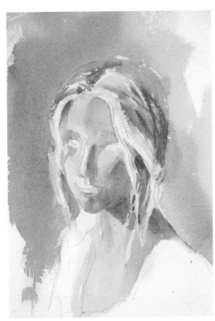

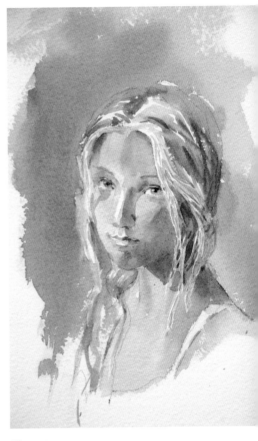

After lightly drawing the shapes with pencil, the first washes are put in. Here I used a combination of quinacridone rose and raw sienna for the skin. In some places there is more of the rose color, and in other places more raw sienna is evident.

The shadow side of the model was painted wet-into-wet using ultramarine blue first. While the wash was still wet, I charged in a combination of raw sienna and quinacridone rose, letting the colors mix together on the paper.

Figment
2010, watercolor on paper, 10 x 7 in.

The details are applied last. The eyes and mouth are added, as are more details to the hair. Only three colors were used for the entire painting.

COLOR HARMONY

A picture can embody almost any color scheme as long as the colors are harmonious. There are no rules for what colors can be used—you can use any of the local colors (the color already there), or you can select a color or a combinations of colors that best conveys your idea and the mood you are trying to portray. You must make a choice and select your color instead of just thoughtlessly taking what is there. A little of each color won't work either. You must have an idea about what it is you are painting and a pictorial or emotional reason for choosing your colors.

Select from the myriad facts and colors before you and choose what is essential to the mood you are trying to create. Be a poet, not a journalist.

Be selective with how many colors you use in a painting. When you paint with too many different colors, there is nothing to bind your painting together in a cohesive way. Using fewer colors can help unify the image's composition. Instead of being restricted, mixing from a smaller range of colors will enable you to achieve subtle nuances of beautiful color.

The harmony of colors you select has everything to do with how much of each hue you use. Color beauty is achieved through sensitive juxtaposition of color masses in varying proportions. For example, if you wish to use three colors of equal proportion (each is 33 percent), you get a repetition of color that will have the monotonous effect of wallpaper. Instead, if you give one color 60 percent of the space, another 30 percent, and one 10 percent of spatial quantity, you will end up with a more pleasing balance of colors.

One way to achieve color harmony is by using predominantly analogous colors. Analogous colors are those that are contiguous to one another on the color wheel and have one primary hue in common. A nice harmony can be achieved by using mostly analogous colors with a touch of their central complement.

If you study the works of master painters, you will notice most of their paintings have a predominant color feel or identity to them. Imagine a landscape painting by one of the English masters—filled with green foliage and then placed perfectly off center is one small figure with a red hat. The tiny

dot of red complements and activates the green and becomes the agreeable focal point. These artists understood that certain color relationships and proportions were harmonious, while other color combinations created discord.

In watercolor, making the wrong color choice generally means having to start over. If you are unsure about the colors you think you want to use for your painting, there are two ways you can "try out" your proposed color scheme beforehand. The first way is by doing a small color sketch before you commit to your final painting. Your sketch does not need to be

Using three colors in the same proportion makes for a painting that can seem monotonous. The rectangle on the bottom shows each color as having a third of the painting. The rectangle on the top shows the green as the dominant color, with red as the accent and focal point. Having a dominance of one color makes a composition more interesting.

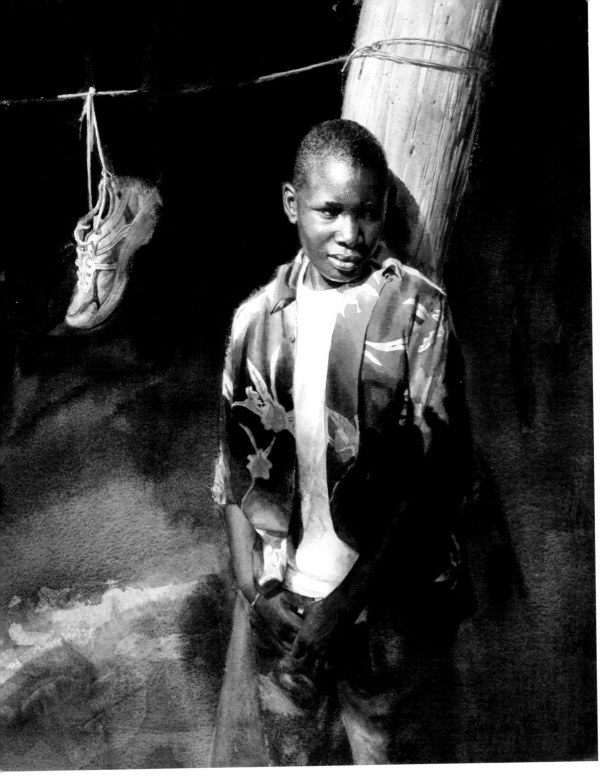

any bigger than a few inches, and in this diminutive scale you can see if your color choices will work. The other way to test your color is by starting your painting with an all-over "ghost wash." By making your initial washes barely visible, you can assess if the colors will be harmonious before committing to darker pigments.

Sneaker
2005, watercolor on paper, 28 x 21 in.

Using a narrow range of color will almost guarantee that you have color harmony in your painting. In this painting of the boy, the warm colors unify the painting. Balance is achieved in the painting by placing the large shape of the boy in contrast to the smaller shape of the sneaker. The narrow clothesline visually connects the two elements.

LIGHT

Light is not separate from color. It is the cause of color. For this reason, as an artist you must forget what you know about the color of objects and learn to see what is really there. If your model has blond hair and is wearing a blue skirt, on a cloudy day the hair may look blue-green, and the skirt will look more violet, as everything will take on the cool hue of the light. On a sunny day, the model's hair will look more yellow and her skirt may look turquoise. This is the difference between local color and how we see color as it exists in space. Aside from its own given local color, the color of any object depends on the play of light on it. The same face can look pink in a late afternoon glow or violet at dusk. A north light will make a face look much cooler than the warm incandescent light of a table lamp. Objects and faces take on the color of the light as well as the colors of objects near them.

If you can identify the color of the light falling on your subject matter, you will have a better understanding of what overall color is being infused into your subject matter and know how to mix your pigments. If you are unsure about the light's relative temperature, place a sheet of white paper in a cast shadow and note its color. If the shadow is cool or bluish, then it means the light is warm. Every color gets its identity because of the color next to it, so the only way you can truly assess color is by comparing one color to another.

Most important, try not to paint things. Instead paint light on things. Don't just paint by copying everything that is there. It is essential to translate what you see, not copy. For example, instead of copying the exact features of a young child's face, strive to find the essential characteristics of the model, as well as the light on the model, and paint *that*.

Dog House
2004, watercolor on paper, 28 x 35½ in.

Mood can be directed by color and light. In this painting, the somber yellow color of the sky is more effective for the intended feeling of the painting than if I had selected a bright blue. The slumping poses of the girl and the dog facing in opposite directions were orchestrated to add to the sentiment of loneliness.

SUGGESTED EXERCISES

1 Make a color wheel and label each color. If more than one color was used to mix a color (such as yellow-orange), write the name of the colors employed in the mixture.

2 Make a thumbnail sketch for a painting you would like to do. Then make three colors studies for your painting using very different dominances of color.

3 Plan a portrait of someone you know. Instead of using local colors, select hues that reveal the *character* of your model.

demonstration Summertime

◄◄ Working out the composition beforehand is a must. Here I have two thumbnail sketches showing the distribution of darks and lights. I chose the composition on top because the dark area of the background connected with the shape of the head, giving more unity to the painting.

◄ To prepare the paper for the first initial wash of color, I blocked out a few areas of the hair and flowers with masking tape so that I could paint without fear of losing those whites. The drawing was done with a #2 pencil on Arches 300-lb. cold-pressed paper.

▲ The very first washes establish the color and tonality of the painting. Almost all of the background edges are kept soft, so that they recede and the model will have more prominence. The colors I used in the background were Hookers green, ultramarine blue, cobalt teal, and quinacridone rose. Toward the foreground I introduced raw sienna and cadmium yellow.

▲ You will find that you will get better results if you use a large brush to paint with. Working with a big brush forces you to paint more generally, use stronger color, and avoid weak, picky brushstrokes. Here I used the large, flat brush to paint the entire background and most of the foreground.

► *Summertime*
2010, watercolor on paper, 21 x 26 in.

The painting gets a few more indications of trees and flowers and is finished.

▲ The girl was painted in using quina-cridone rose, ultramarine blue, and raw sienna for the skin tones. The texture of the hair and lights on the face were established by leaving those areas almost the white of the paper.

▲ Areas of detail in the quilt were painted in using a round kolinsky brush. The negative dark spaces between the blades of grass were suggested using dark browns, greens, and blues. With a small, stiff synthetic hairbrush, I lifted out a few blades of grass.

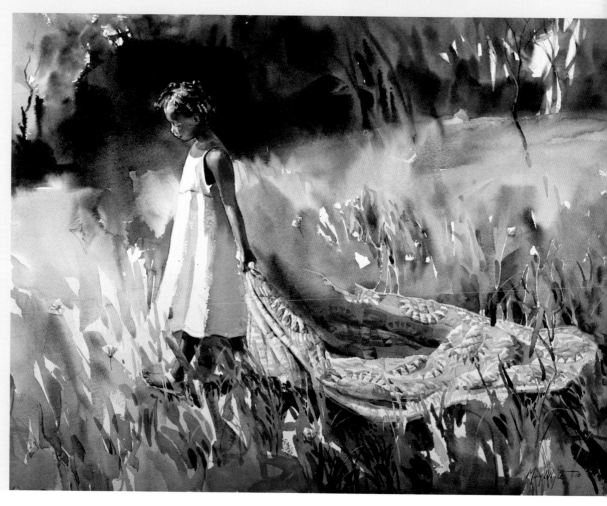

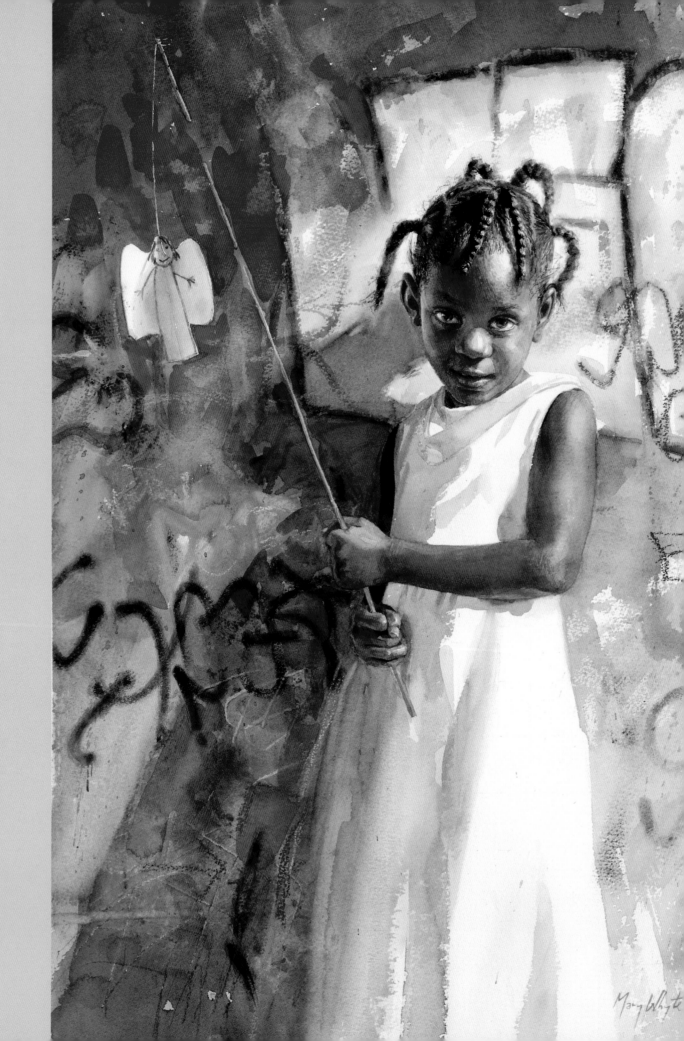

backgrounds

"The true work of art is but a shadow of the divine perfection."

—MICHELANGELO

Many artists think of backgrounds as the least interesting aspect of
a painting. They sometimes ignore the area altogether, or at the very
least give it a half-hearted treatment. Yet the background is one of the
single most important elements of a composition and can make or break
a painting. Hardly inessential, backgrounds are what can unify and
set the tone for the rest of the painting in ways that the viewer would
seldom notice but subconsciously. The color, value, shape, and lines
you place behind or near your focal area can dramatically change the
outcome and temperament of the painting.

OPPOSITE *Paper Angel*
2009, watercolor on paper, 23½ x 15½ in.

Backgrounds can add narrative to a painting as well as enhance the
focal point. In this painting, I placed the model in front of a wall of
graffiti to act as a contrast to the young girl's innocence. The lines of
the words were orchestrated to balance the main shape of her torso,
with careful attention to add stronger emphasis near her head.

PLANNING A BACKGROUND

Backgrounds can be made to look near or far, colorful, neutral, empty, or filled with a million details. Backgrounds can in fact be anything, as long as they enhance the focal area. The job of the background is to complement the rest of the painting and help drive home the emotional message without being distracting to the central idea of the image. Nothing in the background should be more important than the focal point.

When you are pondering what color to make the background, ask yourself what you want the painting to say. What colors will enhance the focal point? What do you want viewers to feel when they look at the painting? Too often, students will select a color that hasn't been used yet in the painting or a color they think is pretty by itself. Unfortunately, the result is often disappointing.

The background, like the rest of the painting, cannot be firmly established unless you have a clear idea of the painting's concept. Before you touch the brush to the paper you must know what you are painting and why you are painting it. If you don't know your painting's point of view or how you feel about it, then you won't know the most appropriate way to paint the background. It would be like going on a trip to an unknown destination and having to guess what to pack. Having a clear idea about what you are painting will better enable you to decide on what colors and mood you want to give every element in your composition, including the background. Your clarity of purpose will help you pull together a cohesive and memorable creation.

The background is the secret mood-making element to a painting, and if crafted well it can set the stage for the overall feeling of the image. A background, like the rest of your painting, needs to be planned.

I have found the most effective way to plot the design of a painting is by first doing a thumbnail sketch. This small pencil drawing, which needn't be bigger than the palm of your hand, is simply a road map of your intentions for the painting. The thumbnail sketch is a diagram of the main shapes, including the shape, size, and value of the background. If you work out the distribution of lights and darks in your composition at this stage, you will save yourself from having to make major corrections later and possibly having to start over.

In your thumbnail sketch, be sure to work out the approximate value of your proposed background. Depending on the value of your focal point, a dark, middle value, or

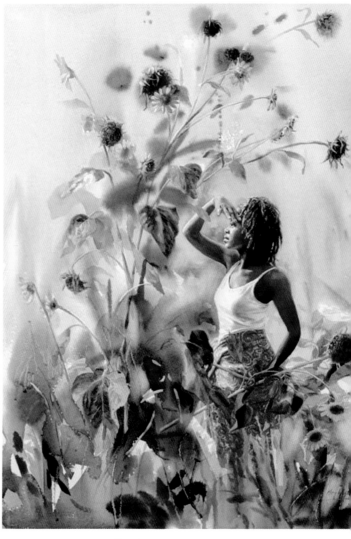

Far Away
2004, watercolor on paper, 28½ x 22¼ in.

The colors you choose for your backgrounds will dramatically affect the emotional feeling of the painting. In this painting, the mood is largely created by the colors and soft edges of the background. The neutral sky surrounding the model creates a sense of hazy atmosphere, while the spent sunflowers add to the pensive, expectant feeling.

light background will enhance your subject in very different ways. For instance, a Rembrandt self-portrait with his head emerging from the dark shadows of the background gives the work a brooding quality. Other paintings benefit from pale backgrounds, such as Renoir's sensuous women set against a bower of pastel light.

I keep a sketch book with me most of the time to work out ideas and compositions for paintings. With these small, quick sketches I am able to imagine conceptual ideas and then gradually hone them through increasingly specific drawings. I usually make several non-detailed sketches so I can see which arrangement of objects and background will best convey my feelings. It is always amazing to me how the size, shape, value, and color of the background can strongly push the feeling of the painting in one direction or another.

Do your homework. Very often the background takes up a significant part of the painting. With so much riding on the background, making preliminary sketches is time well spent.

LEFT *Watching the Chess Game*
2008, watercolor on paper, 7¼ x 6½ in.

A background does not have to be busy to be effective. Value and color are most important. I was sitting on a street corner in New Orleans watching a chess game with a group of men when I did this painting. A red wall behind the model had the perfect value and color to complement the green tones in the man's skin. The simple background wash was painted in one quick sweep.

ABOVE Many of my sketchbooks are filled with small thumbnail sketches for future paintings. In each sketch, the size and shape of the background is very important to the overall composition. These abstracted "doodles" are the genesis for many of my works.

BACKGROUND COLOR

Unless you have a convincing artistic reason, the colors and shapes in the background should be more neutral and less significant than your area of interest. Deciding on the exact hue for a background can sometimes be daunting for beginning artists. Even with as many years of experience as I have with painting, I must admit that at times I also struggle with the decision of color. One thing I know for sure is that every time I have trouble with the painting's background, it is because I am indecisive about my overall idea for the painting. Whether the background is to be a wall, sky, street scene, or an abstraction of air, its color and value need to be certain. For the background to be well incorporated, you must be sure of what you intend for the whole painting. To help in this process, I often do a small color sketch before I attempt the finished painting. If the image is pleasing in the small sketch version, chances are good it will be a sound work when it is enlarged.

One approach to finding a background color is to make use of the colors that already exist in your painting's foreground. For instance, if your model is wearing a yellow blouse and a violet skirt, a neutral background mixed from the existing yellow and violet will be guaranteed harmonious, as the colors already exist in the composition. Another tactic might be to choose a color that is complementary to your model's unique features, such as putting a green behind a woman with pink skin or a dark hue behind the model's white hair. You must decide where you want the eye to linger. In paintings of people, the viewer's eye will almost always be drawn to the model's face.

If you have already started a painting and are still indecisive about a color, you can enlist the aid of color swatches. I keep a small drawer of paint samples in my studio—the kind of color chips that are readily available at hardware and home supply stores. If you place the color samples on your painting, you will easily eliminate those that don't work and select one that will look right with the overall composition. Another way to decide on an area of color is to paint the proposed color on a white piece of paper, cut it to the right shape, and then lay it over your painting. Some artists use a sheet of clear plastic or Mylar to test colors. You may not know in advance what color you want, but when you see a new, possible color in with your composition, you will know if it feels right.

Mixing a background color with hues that already exist in the foreground is a way to achieve overall harmony. In this small sketch, the background is a mixture of the violet and yellow in the woman's clothing.

Small samples of paint colors are available at most building supply and hardware stores and can be very helpful when deliberating color.

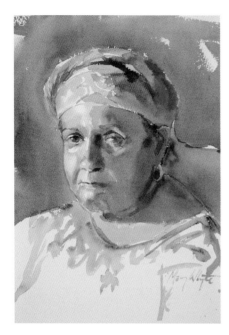

ABOVE In this painting, the warm background steals from the woman's face and does not feel incorporated with the rest of the painting. There are too many different colors in the composition.

RIGHT *Turban*
2010, watercolor on paper, 12 x 10 in.

I glazed over the background with a combination of opaque Chinese white and ultramarine blue, allowing a small bit of the warm color to show through. I also painted more blue into the woman's dress and head scarf to make the overall composition appear cooler. This background works better to unify the composition.

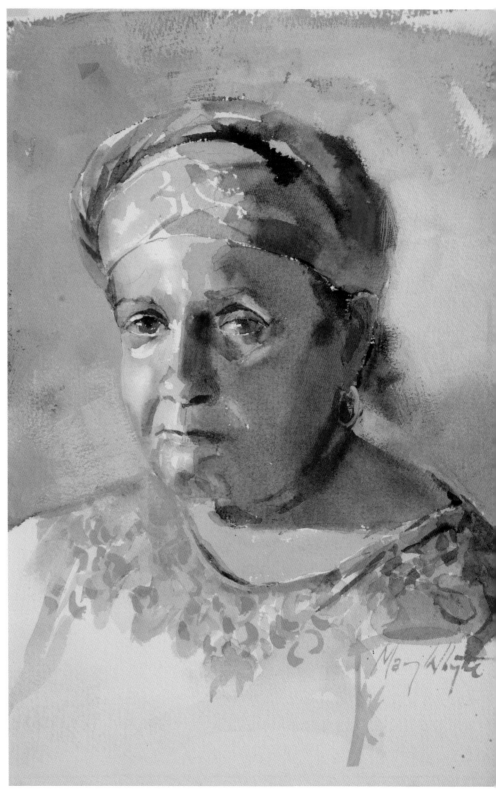

INCORPORATING THE BACKGROUND

The design of the background has to work with the overall composition and be so well incorporated that the viewer is hardly aware that it is there. I find it is best to decide on the right shapes and values for the background and then decide what objects they should be. For instance, if I feel a dark rectangle behind the model would enhance the composition, I might consider making that area a door or the wide trunk of a tree. Of course, what objects you put into the background have to make pictorial sense, but there are generally several options that will work. It should be noted how little is really needed in the background for the viewer to get a sense of place. If the model wants to be painted in front of her family's palatial chateau, the corner of a window or door might be all that is needed behind her to give the architectural feeling of the location. Or, if the model is a small child on the beach, suggesting the pastel colors of the sky and sand in broad, simple washes may be enough to indicate the outdoor setting.

The background should always look like it has a sense of airiness. It should look like it floats behind the model and is not a hard substance that comes crashing up to the side of her head. Since the background is spatially farther away than the foreground, everything in the distance should have less color, contrast, and edge. The air will have its own color and a veil-like quality that permeates and washes over everything. The color of the background air largely depends on the quality of light, whether it is the warm light of a late afternoon sun, the blue light of an overcast day, or the ambient light of an interior.

Everything in the background should have less color, contrast, and edge than the focal area.

Be selective when you paint your background. Don't just arbitrarily pick a color. A drab gray would be no more appropriate to paint behind a rosy-cheeked girl on a swing than a background of pastel pinks and yellows behind a weary coal miner. Every color, edge, texture, and brushstroke you paint behind the model should say something about him or her.

A blank wall might be boring in itself, but as soon as the model stands in front of it the wall becomes something entirely different. It becomes a life force, part of the environment of the model. Every place you position your model will take on the character of that particular person.

Many beginning artists will wait until a painting is nearly finished before putting in the background, only to have less than satisfying results. Remember, every time you add a brushstroke to the painting you consciously or subconsciously weigh that color against the surrounding hues. Establishing the background early allows you to make more accurate and sensitive decisions later.

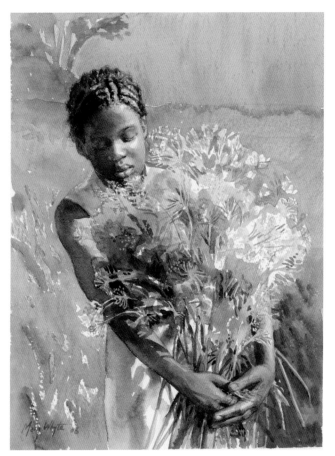

Sweet Dill
2006, watercolor on paper, 10½ x 7½ in.

A background can be useful for suggesting a place without having to add many details. In this small painting, I wanted to suggest an open field, in a color that would enhance the model and add to the mood of the painting.

Paint the background first or early. It is generally one of the largest shapes in the painting and will set the tone for all subsequent colors and shapes.

When you paint the background, try to paint part of the foreground at the same time. This way the edges that meet will soften and the foreground will not look cut out and pasted onto the background. Having lost edges in the foreground objects gives a greater sense of atmosphere and realism. Including small echoes of foreground color in the background will also give a greater sense of oneness between the two entities.

And finally, even though the background may not interest you as much as the focal area, paint it as if you do care about it. Paint the background with the same integrity, mood, and enthusiasm as you do the area of interest.

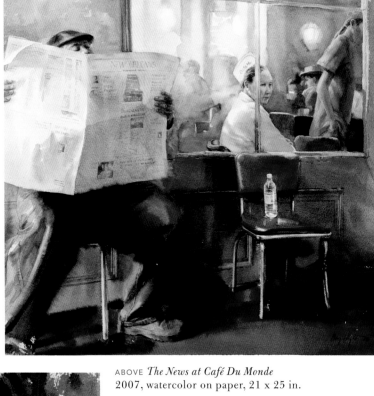

ABOVE *The News at Café Du Monde*
2007, watercolor on paper, 21 x 25 in.

When painting several people in one painting, the challenge is to arrange them in a way that is interesting and still leads the viewer's eye through the composition. In this painting, my goal was to paint several people who were in close proximity but not interacting. The interior of the café becomes the background for the seated server and man reading the newspaper, with the suggested shapes of lights and partial figures behind them adding to the sense of motion.

LEFT *Tending*
2006, watercolor, 19 x 24½ in.

The moment a figure enters a scene, the landscape takes on the character of the person. Usually a graveyard is a place that conjures up thoughts of loss or uneasiness, but with this model the feeling of the location became magical.

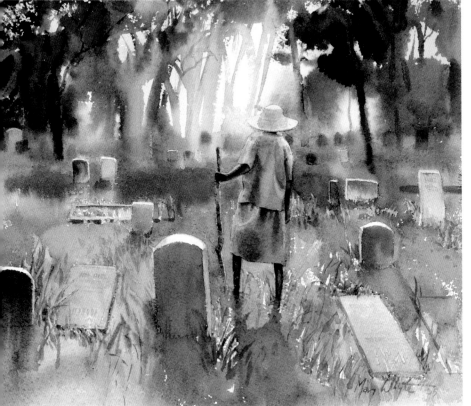
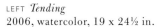

PAINTING PEOPLE IN BACKGROUNDS

When you add figures into the background, it is advisable to suggest their gestures more and their features less. When we look at folks in the distance, we are not generally able to see their expressions or their eyes, but we know what they are doing by their movement and the shape of their silhouette. Avoid trying to paint the small details of fingers or shoelaces, but instead indicate the shape of the arms and legs and the characteristics of the figures' motion. The people in the background may be interesting, as almost all people are, but they are still in the background and therefore must play a subservient role to the focal point.

Painting People in Landscapes

It is rare that we witness a landscape without people in it. Everywhere we travel there are folks going about their daily activities—going to work or to the park, doing errands, jogging, walking the dog, or sitting at an outdoor café. Even if we venture to remote and exotic places, we are apt to meet others.

Painting people in landscapes presents an interesting challenge because so much of the painting is about the scene or location, and the figure seems incidental. Even if the figure is a very small in the overall composition, its weight and importance is great, since the viewer will find it. Some of the potentially best landscape paintings have been ruined by the addition of a poorly drawn figure.

The key to adding a figure into a landscape is to capture the gesture and avoid the details. The fewer brushstrokes used to paint the figure, the better. If a person is walking, omit painting his or her feet; instead simply get the shape of the legs in movement. Omit mouths, buttons, ears, and any other extraneous details and concentrate instead on the overall shape of the head and torso. Watch what shapes repeat with movement and what edges are difficult to see, indicating that they should be painted softly.

Using Screens and Drapes

If you are going to paint the model in your studio, you will most likely need to fashion some kind of device to serve as a background. Many professional artists employ large folding screens, often six to eight feet high, to serve as a foil behind

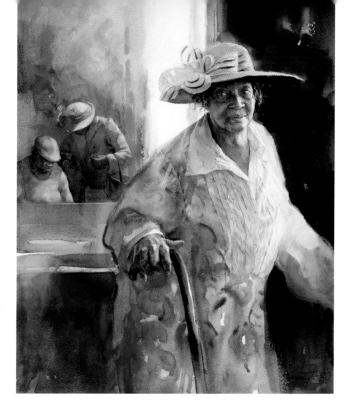

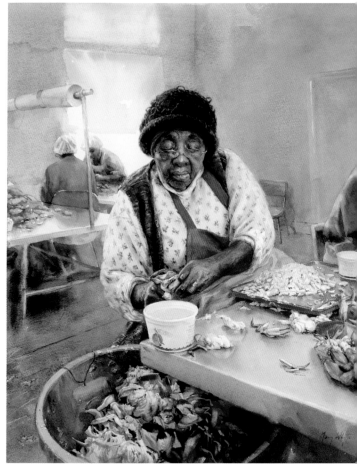

ABOVE *Breezing By*
2010, watercolor on paper, 11 x 9 in.
When I want to add a figure into a landscape, I often spend several minutes just watching who happens by. On this day I was lucky, as a friend came down the street on her bicycle. I asked her to ride by again so I could see how her cape lifted up in the breeze. She then obliged me further by standing on the sidewalk for a few minutes posing with her bike while I painted her into the scene.

OPPOSITE TOP *Coming to Zion*
2008, watercolor on paper, 27 x 22 in.

The figures were added into the background for compositional balance and to create a narrative. By placing the main figure off center, the other two women create a smaller, complementary shape in the background. The two women are intentionally painted with less vibrancy and focus so they will recede and not distract from the main figure.

OPPOSITE BOTTOM *Disciple*
2009, watercolor on paper, 21¾ x 19¾ in.
Think of background figures as shapes behind the focal point. Place each shape so that it becomes an integral part of the composition. In this watercolor of a crab picker from Virginia, the women in the background give a sense of location, while adding to the believable narrative of the painting.

the model. The screen can be positioned so that it catches the light or casts a prominent shadow, or it can be used as a support to drape an assortment of fabrics behind the figure. The color and texture of the fabric can be used to play up distinctive features of the model. For instance, a dark fabric may accentuate white hair, while a pale blue may enhance warm skin tones.

Many artists select a neutral-colored fabric of middle value, so that the model's lightest and darkest tones are easy to see. The head can be lighted so that it is lighter in value than the backdrop on the illuminated side and darker than the background on the shadow side. Fabrics with patterns, such as quilts or tapestries, can be interesting, as long as they make pictorial sense with the model. If you peruse fabric shops and yard sales, you will find an assortment of fabrics to keep on hand.

In my own studio I sometimes string a rope between two easels and hang a backdrop. When I am done with the painting, the fabric is folded up and returned to the closet and the easels moved back into their former positions.

SUGGESTED EXERCISES

1 Imagine how you might paint a portrait of a family member, and make six small thumbnail sketches of him or her with different backgrounds.

2 Paint five postcard-size portraits of the same model but with different backgrounds. Make the background in each painting portray a different weather condition, such as sunny, foggy, stormy, windy, and a heat wave.

3 Make a trip to a museum and select three favorite paintings to study. Analyze the paintings' backgrounds and why they help to make the painting successful.

demonstration Rooster

◄◄ I made several thumbnail sketches from photos I had taken of the model holding a rooster.

◄ On Twinrocker cold-pressed paper, I first drew the major shapes of the figure using a standard pencil. Then, using a 3-inch flat brush, I wet the entire paper except for the areas of model's head and torso, the clothesline, and the dress hanging on the clothesline. Next, I mixed up a dark wash using ultramarine blue and burnt sienna together, as well as maroon perylene and Hookers green. I quickly charged in the color, letting the washes overlap the model and rooster in a few areas. A quick touch of raw sienna and cadmium red were placed into the damp wash to suggest the rooster's body and comb.

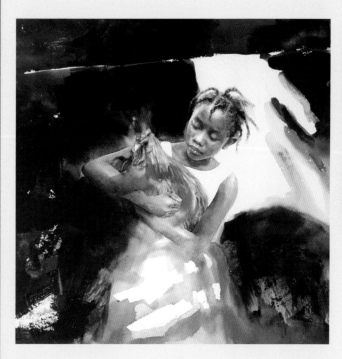

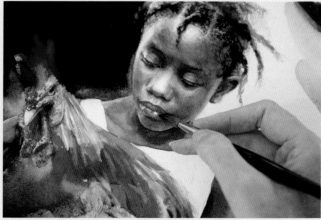

◄ After the biggest areas were established, I painted in the face and head. For the skin I use quinacridone rose, ultramarine blue, raw sienna, and burnt sienna.

▲ The face was painted using quinacridone rose, ultramarine blue, and raw sienna. For the hair I used predominantly ultramarine blue and burnt sienna. Small areas on the face were left the white of the paper, such as the highlight on the lower lip, so they would look light-struck.

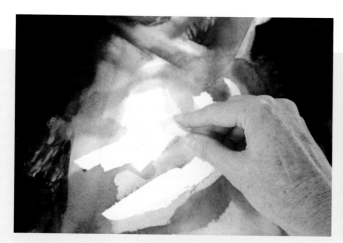

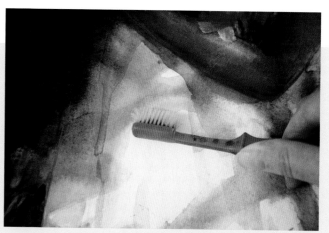

▲ The light areas of the skirt were blocked off from the wash with masking tape. After the wash was dry I removed the tape.

▲ I used a toothbrush to soften several hard edges in the skirt area.

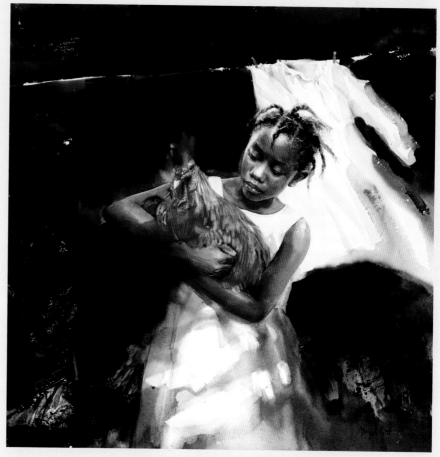

▲ Small edges that need careful softening require a stiff brush with more precision. A small brush with synthetic hair is a good choice. For more stubborn areas that need softening, a bristle brush used for oil painting works well.

▶ *Rooster*
2010, watercolor on paper, 20¾ x 20¾ in.

The feeling of the final painting is driven largely by the way the background was treated. Had I placed the model against a light backgeund, the image would have a very different mood. The sense of flickering light and shadows on the model as well as the diagonal swing of the dress on the clothesline add to the feeling of movement.

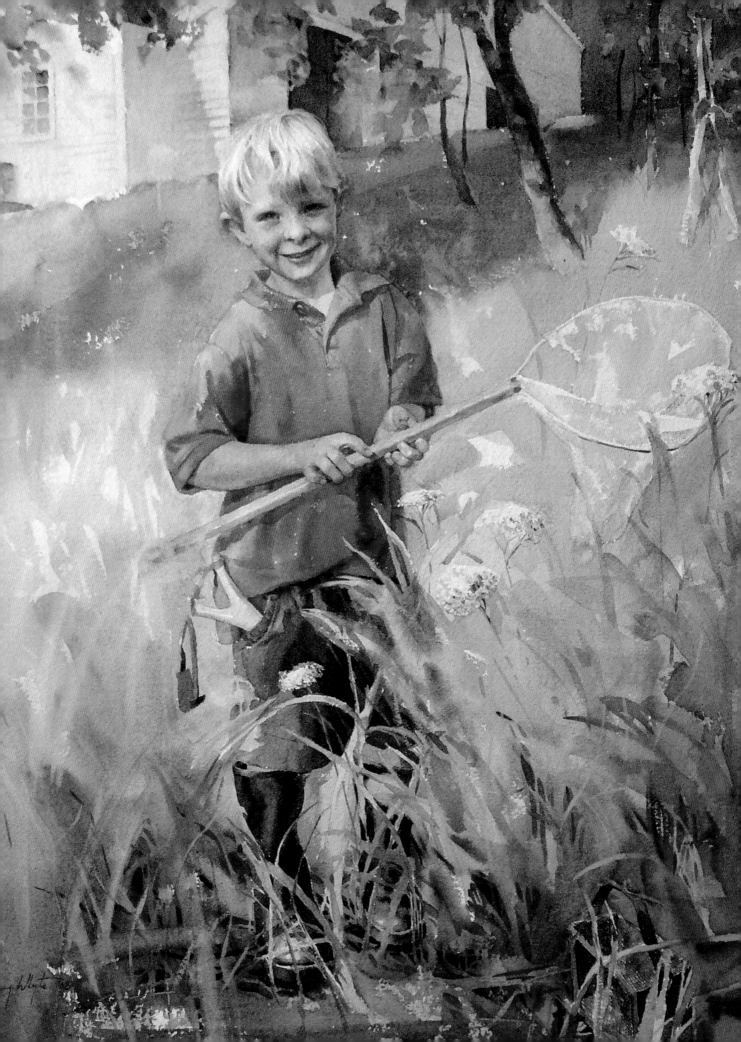

life as
an artist

*"Life is short, art long, opportunity fleeting,
experience treacherous, judgment difficult."*

—HIPPOCRATES

OPPOSITE *Explorer*
2008, watercolor on paper, 27 x 20 in.

As a portrait painter, you will have the opportunity to meet many different people and to visit where they live. This young boy lives in a rural area in South Carolina, where he can fish, hunt insects, and explore all day long. In this painting I used mostly orange and yellow colors to capture a sense of light as well as my model's sunny disposition.

Painting is so much more than learning how to paint a detailed eye or mix a specific color, since technique and expression are two different things. While technique is necessary for communication, it is only a means and not the end. Truly learning how to paint becomes, in large part, a matter of learning how to see. We must become masters at observing and feeling the world around us before we can begin to express it on an easel. Also, we must know ourselves. You have to know how you feel about something to express it.

EXPRESSION

I once had a student come to me lamenting that she never received any recognition for her work. She had studied with several accomplished artists and had perfected many of their techniques and styles, yet few people gave the young woman's work serious consideration. When I looked over the watercolors in the artist's portfolio, the problem was immediately apparent. Almost every painting by the woman contained the feeling, style, and imagery of the teachers and artists she admired. I couldn't find evidence of her anywhere in her paintings.

Expression is the outward portrayal of your inward feelings. It is presenting visual notations to others in a way that will communicate how you feel about a specific idea. True self-expression may be the one aspect of art that cannot be taught, since it is something that has to be felt and transcribed by each individual artist. Almost anyone can learn how to paint, but to create a work of art that appeals to the emotions in the way the artist intended is much more difficult to do.

Artists are probably some of the most emotional people in the world, with strong responses to a multitude of stimuli. Unfortunately, many painters don't know exactly what they feel strongly about. You might recognize that the sunset is pretty, and so you want to duplicate the scene, but why? Is it because everyone else is painting it? Or does the unusual color or the shapes of the silhouetted trees elicit an exciting response in

you that you want to capture on paper? You must identify what is most significant about what you are seeing. If you copy the sunset, you will likely resort to using your standard "sunset technique," and the results will look like everyone else's. But if you feel the beauty of the sunset, and you can recognize and identify the particular nature of your emotions, you will invent the perfect technique to express your response. The resulting image will be wholly original, because it is wholly yours.

Style

Style isn't always readily apparent in the learning years, as we are busy emulating artists who have more experience. As students, our style emerges with our understanding and confidence in ourselves. Your style will be influenced by several outside factors, such as your geographical location, artistic education, and the era in which you are working as an artist. Your style is there; the question you must ask yourself is if you are being true to it. As artists, we learn from the artists who have plowed new ground before us, and our hope is that we in turn make paintings that have never been done before. There can be no finer compliment to you as an artist than to have the viewer recognize that a painting is yours before reading the signature.

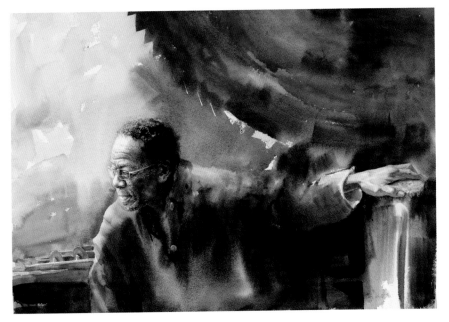

Edger
2007, watercolor on paper, 22 x 30 in.

Knowing what moves you emotionally is the key to having a unique signature as an artist. In this portrait of a lumberman, I wanted to portray the danger of the job with the quiet demeanor of the model. Most of the painting was painted wet-into-wet, particularly the saw blade. To give the large blade a sense of spinning motion, I only painted a few of the serrated teeth.

Summer Solstice
2003, watercolor on paper, 30 x 39¼ in.

This is a model I have been painting for two decades. The old white horse belonged to a neighbor. In the background is the Bohicket Creek, which runs less than a mile from my house. For me, the subject matter is especially meaningful, as it is something with which I am very familiar.

You already possess a unique style. Are you being true to your style?

Originality

Originality takes courage. Many artists paint conventional works because they are afraid of the criticism they might receive if they tried something unexpected. If you are being truly original with your painting, theoretically at least, you will be painting works that have never been seen before. Can you imagine doing a painting that is unlike anything ever done before? If you had enough money to live comfortably the rest of your life and you never had to sell a painting, would you create different work? If you had the technical ability to paint anything you wanted to, what would you paint?

Spinner
2007, watercolor on paper, 28½ x 36½ in.

This is a large painting I did as part of a series of people in vanishing industries. I spent three and a half years traveling the South doing paintings of various workers. The composition is simple, with the smaller shapes of the figure placed off center against the larger, solid shapes of the barrels. What was most important to me was that I capture the fatigue and dignity of my model.

Pilgrimage
2009, watercolor on paper, 39 x 48 in.

I spent an entire afternoon in a cemetery in Miami contemplating the composition for this painting. The next day I hired the funeral band to play for me, making watercolor sketches of individual musicians. The resulting painting is a composite of what I remember, saw, and felt.

KNOWING WHAT TO PAINT

When I was in art school, one of my fellow students painted a series of dead fish. She had seen one of Manet's oil still life paintings of a fish on a platter, and it triggered an explosion of inspiration. My friend went to the market and bought dozens of fish. She painted them frozen, thawed, in piles, on newspaper, in jars, lying on the table, and in frying pans. She reveled in their shimmering scales and slippery textures for weeks on end, and her apartment smelled like the town dump. I was envious beyond description. It wasn't that I wanted to paint fish or flies; I just wanted to find something that I felt that passionate about to paint.

At the time I knew I wanted to paint, but I didn't know what I wanted to express. For several years I painted a shopping list of subject matter: still lifes, landscapes, flowers, nudes, animals, and seascapes. Although most of the paintings found a home on someone's wall, none of them were truly aligned with my most passionate feelings, simply because I didn't know what those emotions were. Since then, I have found what it is that I feel strongly about, and my paintings look more like they are mine. Although I must admit that painting hasn't gotten any easier, it has become even more engaging.

Your best work may be closer than you think. You don't need to go to all the way to Africa or Italy to find subject matter worthy of painting. Your own backyard or neighborhood may be fertile ground for superior paintings. Mary Cassatt spent her career painting friends and family, and almost all of Vermeer's paintings were done in one corner of his studio with the light coming from the window at the left. Forget about what subject matter might win sales. Instead, if you feel strongly enough about what you are painting, your emotions will resonate with the viewer, and that alone will get attention.

Knowing When a Painting Is Finished

Rarely is a painting finished too soon. In most cases, if a painting was ruined it was because the artist finished it too *late*, meaning that he or she overstated too many things that were already obvious. Sometimes we don't recognize when a painting is complete and keep focusing on something in the work that really has little to do with the image's concept or emotion. Often, the last words uttered by an artist before ruining a watercolor are, "It just needs this one more thing …"

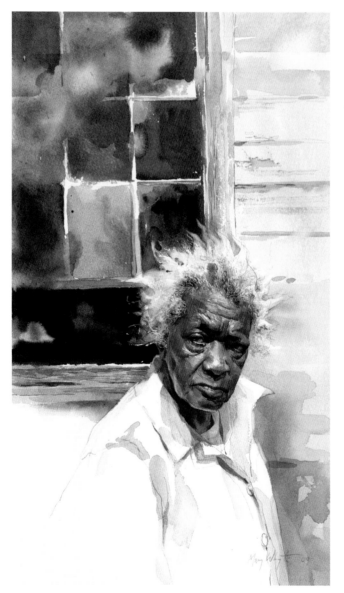

Hurricane Warning
2009, watercolor on paper, 20¼ x 18¼ in.

Sometimes paintings take a long time to come to fruition. This painting is of a woman I had seen more than ten years before but didn't know how to configure into an interesting composition. It wasn't until I heard on the news that there was a hurricane warning that I thought of this woman's demeanor, and that's when I knew how I would paint her.

Never undervalue your emotions. They are the force behind every good work.

Because a painting's success largely depends on the viewer's emotional reaction, we have to leave room for the person's unencumbered response. Too much literal or overstated information in a painting will spoil anything the viewer may bring to the scenario. If the viewer is not allowed to add his own psychological response and dreams to a painting, then why is he bothering to look?

Again, we go back to the importance of knowing exactly what it is you want to say in a painting. When you are certain of the painting's idea, you will know exactly how and where to start. And only then will you will know exactly when a painting is finished. When there is nothing more you can add to a painting that will improve or further its message, the painting is done.

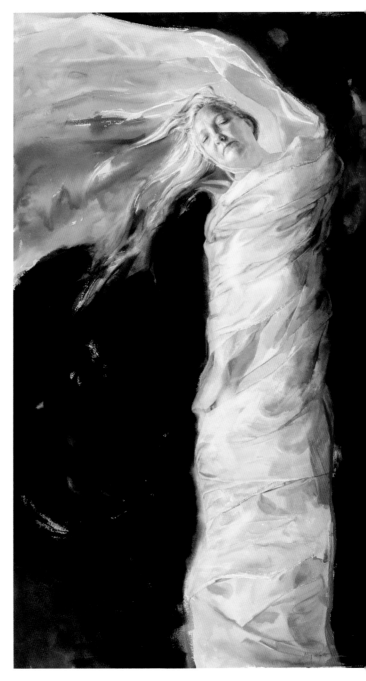

Shroud
2007, watercolor on paper, 58 x 36¼ in.

This was a painting I took a chance on. The model worked in a textile mill, part of an industry that is quickly vanishing in the South. I wanted to make a statement about the demise of the mills and created this painting, which is more about my feelings than reality.

GROWING AS AN ARTIST

Improving your work takes effort and time. It will not happen in a day, but when you are engaged in an endeavor that truly interests you, there won't be enough days in a week to satisfy your appetite to learn more. The journey to making it as an artist isn't an easy road, especially in the early years, when other less-satisfying jobs often have to be pursued to make a living. Learning to do anything well requires sacrifice and perseverance, whether its athletics, music, language, cooking, or engineering.

Desire is its own best teacher. If you want to learn how to do something well, such as painting people in watercolor, you will find the means to do so. You will find the way to make your paintings happen. Never avoid doing a painting that interests you because you think you lack the ability. If the subject intrigues you, you will find the right technique and materials to give rise to your idea.

Schedule time to learn. Allow yourself ways to constantly improve your work. Join a sketching group, hire a model, take a class on anatomy, and go to the library and the museum. Find ways to challenge your drawing, and experiment with different materials. You never know when you will meet up with a creative breakthrough.

Challenges

If you want to get better at doing anything, you must be willing to experience failures. Every seasoned artist I know has done many paintings that were failures. I could wallpaper ten houses with the hundreds of paintings I have torn up (or should have) over the years.

Failures can definitely bruise our ego and self-confidence. When you make mistakes, you have two choices: Give up or try again. When your work is rejected by critics or from shows, or the public seems to be passing it by, instead of seeing it as a reflection of you as a person, use the rejection as a signal to reevaluate your work. When a painting fails, use the

If your painting fails, simply start over and do it again. Consider the first attempt not a failure but a study. Now that you have all the bugs worked out with the study, you know what to do.

opportunity to learn from that mistake and tell yourself you will never make the same mistake again. Regard each failure as being given a new road map to becoming a better artist.

Here's the bad news: No matter how experienced you become, you will continue to experience failures. As artists, we never get to the point where we have learned it all and there are no more mistakes to be made. If you want to continually learn and explore new ideas, techniques, materials, and subject matter, you will most certainly make new mistakes in the process. It is only natural, as no one is an expert on the first try at something different.

Now here's the good news: Each time you overcome a colossal failure, you will find that you have a more educated perspective and you are a better artist. Of course, you can avoid the discomfort of making any mistakes at all by doing what you know works over and over again. However, I wouldn't recommend it, as painting will quickly become very boring and you will eventually give it up.

Painting Plein Air

The best advice I can give any artist wanting to improve is to paint *plein air*. Painting from life outdoors is exhilarating and challenging. It is exciting to see how the colors are more vivid and nuanced when painting outside than the hues in even the best photograph. Where photographs cannot accurately record shadows, the human eye can see the multitude of colors within sunless areas. The result is a painting with generally more saturated color.

Plein air painting has its challenges. One must contend with changing light, moving shadows, inclement weather, annoying insects, inquisitive tourists, and a host of unplanned obstacles that can happen. The painter must be well prepared with adequate supplies, such as an easel, stool, water, paper towels, hat, and sunscreen. It requires preparation, but with a few initial forays, you will know what to take with you and how to set up.

There is a condensed time factor required for plein air painting. Because the light is constantly moving, you will have no more than an hour and a half on a sunny day before the scene changes. After this time, you can finish the painting in your studio or come back at the same time another day. The beauty of painting in a restricted time frame is that it forces

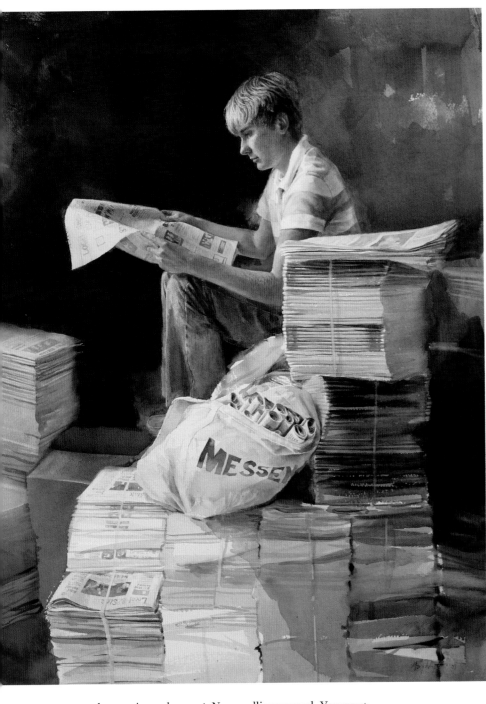

you to be *concise and correct.* No noodling around. You must
decipher what the most important elements of the scene are
and omit what is superfluous. Form must be reduced to gen-
eral shapes of color, and edges must be handled with judicious
care, as there is little time to revise. It is the perfect theater for
watercolor. Believe me, there is nothing like painting from life
plein air.

BEING A PROFESSIONAL ARTIST

If your goal is to be a portrait artist, I hope that first and foremost you are intrigued by people, their unique and diverse characteristics, and that you want to explore the endless and exciting possibilities of capturing humanity on paper. It is a job in which you must be willing to listen to others and make accommodations. There is a balance needed between pleasing the public and knowing how you want to make a painting.

Being an artist requires many things: time, materials, a place to work, ideas, etc. Both the amateur and professional artist must have these ingredients to make a painting. So, what makes a professional artist different from an amateur, and when are you considered a professional?

The answer to this question lies more in attitude than in anything else. An artist's skill does not indicate professional status, since the level of drawing ability a work indicates can be argued as the artist's chosen style. In other words, we cannot assume Rembrandt was more professional or accomplished than Georgia O'Keeffe simply because his work was more representational. Professional status is also not earned by sales volume or awards, as there are many sincere and talented artists who work diligently at their craft but receive little attention and only a moderate income. Creativity certainly helps, but does not promise that the artist will do anything with it. To be a professional you must be *disciplined, consistent, measured,* and *thorough.* These are the four qualities needed if you want to be a professional artist who deals with the public.

Being *disciplined* means not just working when the mood strikes. It is staying the course even when things don't go as planned, when paintings fail, when the studio is too small, the laundry pile is too big, and you seem to be getting nowhere.

Being *consistent* is putting forth an earnest effort on a regular schedule. It means having the integrity to deal with others in a way that is expected. It is delivering the cupcakes to the bake sale or the painting to the senator when you said you would.

Being *measured* means working at a reasonable pace to reach your goals. It also means having a realistic degree of moderation in your efforts as well as your expectations.

Being *thorough* means doing your work completely and fully. It means having the integrity to know what needs to be done, doing only your best work, and never cutting corners.

THE TOP FIVE "MUSTS" FOR PROFESSIONALS:

1 Maintain set working hours.

2 Have consistent pricing and fair business practices.

3 Promote your work to the right audience.

4 Keep thorough records.

5 Present your work in a professional manner.

Being a professional artist is a way of making a life as well as it is a way of making a living.

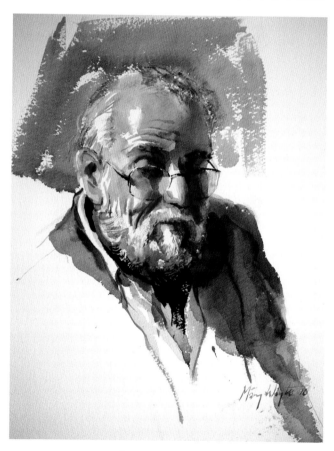

Burton
2010, watercolor on paper, 20 x 27 in.

Painting a portrait is always an honor, and especially so if you have the opportunity to paint an accomplished artist like Burton Silverman. This is a head study I did of Burton at the Portrait Society of America convention in Washington, DC.

WORKING WITH THE MODEL

As a figurative artist, you will most likely paint models that you hire as well as people who commission you to do portraits of them. The advantage to hiring your own models is that you have the great luxury of being selective. You can consider from literally thousands of people before asking the one person who appeals to your vision as a model for your painting. In my own experience, almost everyone I have ever asked to pose for me has been delighted and flattered at the surprising proposition. In fact, the more surprised they are at my request, the more their modesty and lack of vanity appeals to me.

Some artists are fortunate enough to find a model who consistently serves as a muse for many years. I have been fortunate in this, as I have used the same couple of models for more than twenty years and still find them fresh and inspiring with every new painting. With your models it is important to establish a rapport of friendship and trust. When you and the model are completely comfortable with each other, the process of creating a work of art becomes much easier. Exactly which model you choose is something another person cannot direct for you. It is a decision that only you as the artist can make.

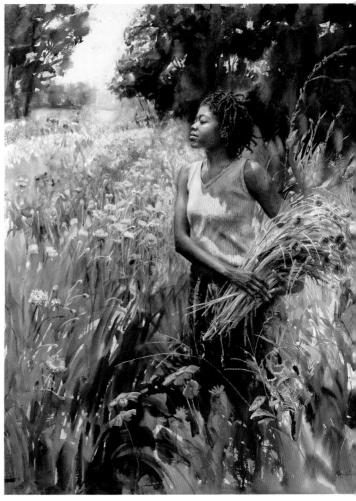

ABOVE *Cool Breeze*
2003, watercolor on paper, 47½ x 39 in.

Having a model that is inspiring as well as a friend is truly a gift for any artist. This is a model that I have painted for twenty years and continues to be the catalyst for many ideas for paintings. The scene is a farm near where we live, which offers ever-changing backdrops with the seasons.

LEFT Avoid posing your model in a static, symmetrical pose with the background the same on both sides of the figure. In the pose on the right, the model is leaning to the left, which cuts into the shape of the background, making it more interesting. Her hands are now at different heights, and the tilt of her torso helps to incorporate some much-needed diagonal lines. The background is broken into more interesting shapes with the addition of the table in the foreground and the picture on the wall behind the figure.

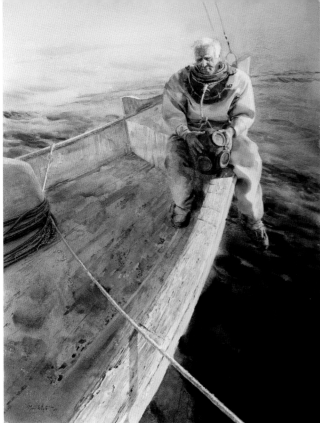

2009, watercolor on paper 30¾ x 23¼ in.

Hiring models shouldn't be limited to just
the studio. This is a painting I did of a
sponge diver from Florida. I was interested
in the endless blue expanses of sky and
water and decided to make the figure com-
paratively small within the composition.

When you already have the concept in mind for your
painting, it is an easy task to pose the model. Show the model
your thumbnail sketch and describe the feeling you are trying
to achieve in the painting. With a little direction, the model
can be placed in the right position. If the model is sitting, it
may be helpful to use a model stand or other means to get the
model up to eye level. Having the model raised will elongate
the model's neck and torso and make it easier for you to evalu-
ate proportion. But regardless of how much planning you
might do for your paintings, you will discover that some of
the best and most original poses will happen when the model
is taking a break. In a relaxed mode, the model will assume
positions that are natural and unplanned. Pay attention during
these unscripted times and watch for ideas for paintings.

When deciding on the model's pose, select stances that
are asymmetrical. In other words, avoid poses where the
model's shoulders are perfectly square or both hands are in
the same gesture and at equal heights. Look for where the
torso might be slightly turned in a different direction from the
hips or where there might be a tilt to the head. Even tiny areas
of asymmetry are better for the composition and show move-
ment, such as one eyebrow slightly lifted or one corner of the
mouth a bit higher than the other. The area of the background
should be asymmetrical and interesting as well. It is generally
more pleasing if the shape behind the model is different on the
left and right.

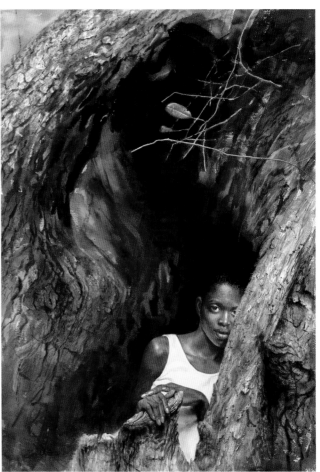

ABOVE *Raccoon*
2001, watercolor on paper, 41 x 29 in.

How and where you pose the model will
establish the mood of the painting. Near
where I live is an old oak tree that is hollow
at the base and wide enough for a person
to stand inside. To give a sense of the tree's
size, I drew the model in the lower quadrant,
off center. The painting was done on Arches
140-lb. cold-pressed paper and was started
on location and completed in my studio.

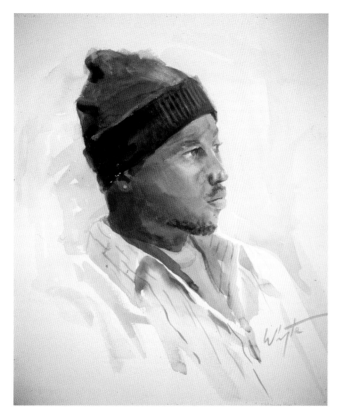

All models need to be compensated, and how you com-
pensate your hired model is up to you. Although modeling
doesn't require a degree, it does require a great deal of pa-
tience, and in many cases stamina, which should be reflected
in the pay. With all models, I recommend that you get written
permission from them before embarking on a painting. For
children it is necessary to have the permission of the parents.

Lighting the Model

The quality of lighting you choose for your model will play a
vital part in the success of the painting. Not only does the light
set the mood for the painting, but it is what most accurately
describes the form of the model's face and body.

Light is a transient thing; effects come and go. The most
magical lighting effects are often the ones that are the brief-
est—the ones that last only a few minutes, such as the shaft of
light across a figure or the rosy glow of the setting sun on a
small child playing. The fact that natural light itself is always
moving presents a particular challenge to the artist. If you are
working outside, you will have to accommodate the mov-
ing light on the model. You will have two options: Paint for
a period of an hour or two and then resume the sitting at the
exact same time the next day, or enlist the aid of the camera to
capture the fleeting light. One note of caution is needed here
if you are going to use a camera to photograph your model:
Avoid using a flash. The harsh, frontal light will diminish the
sculptural effect and nuances of color on the model, making
the photographs difficult to work from.

Indoors, you will have more control over the consistency
of the light. Over the centuries, many artists have preferred
working in a north light, which is the steadiest light available.

PORTRAIT COMMISSIONS

Painting a model in north light will afford you several more hours of working time, as compared to working in western light, which will allow only an hour or so before the shadows change. A northern light source on your model will give softer contours, warm shadows, and cool, violet highlights. If you do not have a working area with a northern light, you can use fluorescent lights that are created to simulate natural daylight by having a balance of blue and yellow.

A stronger light source, such as a 100- or 150-watt bulb, can be used to create more noticeable angles and stronger shadows. It is a dramatic way to light the model. Though not always flattering to women, a strong light can make an ordinary-looking model more interesting. If your light is mounted on a stand, it can be raised or lowered to achieve different effects or moved farther away from your subject to soften the harshness. Standing a light-toned mat board on the shadow side of the model will bounce more light back into the dark areas of the model's face. A background of middle value will highlight both the shadow and light sides of the model.

Accepting portrait commissions is considered by some artists to be too restricting. I've always looked at painting people's portraits not as work for hire but as an honorable and interesting artistic challenge. Every portrait brings a new set of considerations and parameters. And every portrait is an opportunity for a unique way of expression. Commissioned portraits can expand your vision of the world and take you to parts of your town or country that you may never otherwise get to see. More important, the time spent getting to know another person will sometimes bear fruit in a meaningful relationship. I have made some of my most treasured friendships as the result of portrait commissions.

When you accept a portrait commission, it is imperative that you have a complete understanding of what is expected. A commission is a business contract between you and the client, and you should both be in agreement about what will transpire. To start, have a conversation with your client, asking what he or she envisions, where the portrait will hang, how big the painting will be, what the frame will look like, what the subject wants to be wearing, how many sittings are needed, and how long the painting will take you to complete, as well as its price. After you are in agreement about the specifics, send a simple letter of confirmation restating the details. Since some patrons may be a bit concerned about receiving a portrait they are not completely happy with, you may add a line at the end stating that the balance is due upon completion and their satisfaction with the painting. This way your client knows you are willing to work with their concerns and make minor corrections if need be. If you think the client may be impossible to please, it is best to walk away from the commission.

Before the final painting is started, it is often helpful to show the client a drawing of what you have in mind for the portrait. Do a small thumbnail sketch or color study, so that your client can see what the pose will be, if the subject will be smiling in the painting, the content of the background, etc. This way you can discuss any concerns or changes before you start, and there will be no surprises during the unveiling. This is especially important for portraits done in watercolor, as corrections are limited. After the painting is completed, your patron can come to your studio for a final look or touch-up, or an image can be emailed, and you can discuss the finished portrait over the phone.

There are no limits to what you can employ as part of a portrait. The background can be as predictable as a fireplace

mantle or as unusual as an amusement park. I have done portraits in boats, carriages, tree houses, and church steeples. I have dragged heavy upholstered chairs outside and tree limbs inside, all to get the effect or lighting that was right for the painting. Do whatever you need to do to ensure the positive outcome of the painting. Your model will not remember the small inconveniences, only that the painting turned out well.

Deciding on the Pose

There are a million options for positioning the model and just one final portrait, so selecting the best pose for your client should be done carefully. The way you have your model sit or stand will tell the viewer a lot about the person and his or her personality. Remember, though, that your job as an artist is to make a pleasing painting, so the pose should lend itself to the beauty of the entire work. All efforts for getting a likeness of the model and location should be secondary to the abstract and artistic considerations of the work of art. The pose must bespeak the character of the model while at the same time work artfully into the overall composition of the painting.

I prefer going to the client instead of having the client come to me. While my studio is more convenient and suits the way I work, I fear that the location would become repetitious with every client sitting in front of the same backdrop and under the same lighting. The other reason I prefer to go to the client is because I know that the model will be more at ease in familiar surroundings. If the model is relaxed, I know I am more apt to see a truer representation of the person's character.

When I first arrive at the client's home or office, I ask that we sit and talk about the pose. I ask questions about what the model has in mind, while at the same time study the way the person sits or stands. I make mental notes on the way the person tilts his head, gestures with his hands, or looks out the window. Some people look right at you when they are speaking, others may look away. Some folks square their shoulders, cross their arms or legs, or put most of their weight on one leg when standing. All of these small physical nuances are clues to how you might pose the model and will be truer to the model's character than if you try to impose something that is forced. If your model is relaxed and confident, you will be less apt to end up with a pose that looks self-conscious or stiff. Do all that you can to make the portrait session a pleasant experience.

Deciding how much of the figure to include and where to place it in the painting is up to you. In a head-and-shoulders portrait, the head is generally positioned closer to the middle of the paper. In larger compositions, the head and figure are best placed off center. The hands, if you are going to include them, should be in an interesting relationship to the face and should be in a gesture that is appropriate to the model and location. If you must crop the hands or feet, do so with intelligence.

Most important, no matter how interesting your model is, or how beautiful the colors are in her dress, the entire effect can be destroyed by misjudgment in placing the shapes on your paper. A painting is a successful distribution of light and dark shapes, as well as a harmonious grouping of colors. All must be taken into consideration to ensure a successful work. In the end, the model must have all the correctly drawn physical parts, but it is the placement of the overall light and dark shapes in the composition that matters most.

Clothing and Props

Often the model's clothing is dictated by where the portrait will hang. If the portrait is to go in a judicial office, university, or formal living room, the attire of the sitter will tend to be dressier. Robes and uniforms are often required for traditional, honorary portraits, while casual clothing is generally preferred for family portraits. Because the portrait will be on view for many years, the clothing should be on the conservative and classic side, so that in twenty years it won't look dated. Outfits that are simple, tailored, and solid in color tend to endure the test of time.

Most people know what colors and styles they look best in. It may be helpful to ask your client to select three options for attire and then the two of you pick the final outfit together. Look for clothing that has an interesting texture and shape and will enhance the model's face. For women, jewelry should be kept to a minimum, as should makeup and hairstyles. While the enormous beehive hairdos, go-go boots, false eyelashes, and peace sign jewelry were the rage in the '60s, these icons of style might appear a bit superfluous nowadays in a serious portrait.

Roses of Sharon
2005, watercolor on paper, 27 x 21 in.

The pose you choose should describe the demeanor of your model. I liked the graceful quality of this young woman and chose to include the diagonal line of her arm reaching upward. I intentionally placed her slightly tilted head off center and softened the edges and intensity of the shapes in the background.

WORKING WITH CHILDREN

Working with children as models can be great fun. While the little ones can get a bit wiggly at times, I have found that in many ways they are easier to paint than adults. Children are rarely concerned with their hair or attire, and I have yet to have a child ask me to make them look younger or thinner. Most children are delighted to be the center of attention by a complete stranger toting a camera and paints, and if you can get them past the canned "say cheese" smile in front of the camera, you are home free.

When I first arrive at the child's home, I find it helpful to engage first in a bit of play. Ask to see the child's pets, bedroom, favorite hiding place, and art projects. To break the ice with young children, I sometimes bring a stuffed animal of my own to "talk" to and initiate conversations. As soon as children realize that this whole adventure centers on them, they tend to be more willing to share their interests. Consider selecting a meaningful prop for the child to hold, such as a toy or found object. The particular object can add meaning and memories to the painting in years to come.

Sometimes you may want to include a live animal in the painting if it has special significance to the model. Dogs and cats can add an interesting additional texture, but be careful that the animal doesn't command more attention in the painting than the child. Big dogs or horses must be carefully considered so that the child isn't overwhelmed by the large animal's size.

I have found it best to have the mother or father nearby but not in the same room coaching, as sometimes the parents' expectations of the portrait can make a child nervous. There is nothing worse than finally getting a child to relax only to have the parent tell him to sit up straight. Occasionally, I will encounter a child that remains shy, and when this happens I ask the child to tell me a joke. Most children think their own jokes are the funniest on the planet, even if they make no sense. Of course, any drawings or photographs that you are going to take of the child have to be done in a relatively short period of time, since even the most congenial of small children get bored. Take frequent breaks and keep it fun.

ABOVE *Yellow Umbrella*
2010, watercolor on paper, 14 x 12 in.

Props such as an umbrella or flowers can add additional meaning and interest to a portrait.

OPPOSITE *Lily*
2003, watercolor on paper, 29 x 21 ¾ in.

Watercolor lends itself to portraits of children because it is as fast and spontaneous as they are. The transparent quality of the medium is particularly good for painting skin tones and for getting soft, moving edges.

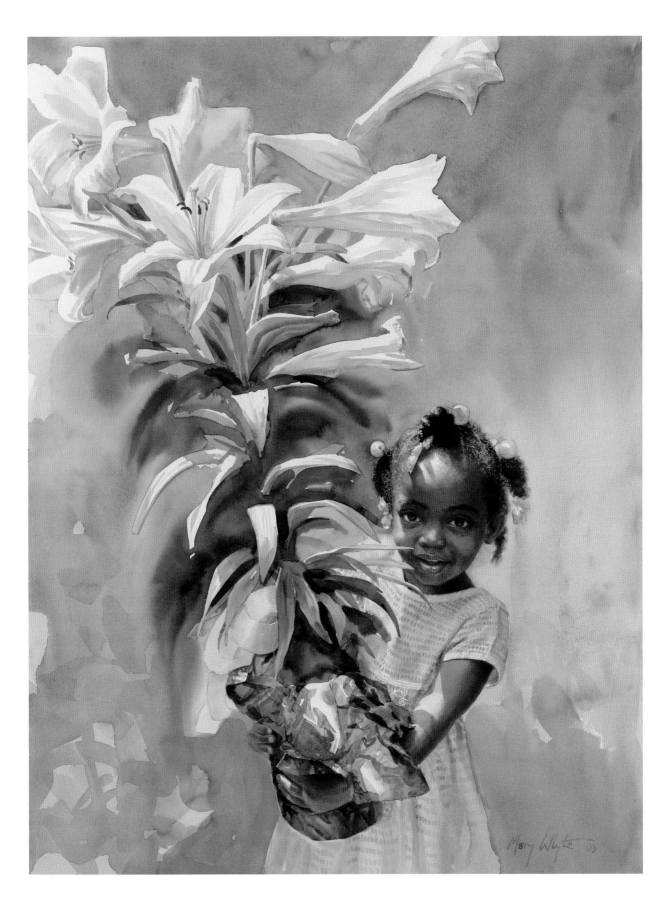

FRAMING YOUR WORK

A painting isn't really done until it is framed. The proper matting and frame can preserve and protect a watercolor and show off the watercolor's best attributes in a professional manner. In the nineteenth century, watercolors were often given ornate and heavy frames, often without mats. Since then, framing has become less obtrusive, with more minimal presentations that better enhance the painting. Every frame should be handsome by itself but remain as a complementary backdrop to the painting.

I have to give full disclosure here and admit that I am married to an extraordinary frame maker. I have the great luxury of having each of my paintings presented in a hand-gilded frame on par with any you might find in a museum.

A good frame maker is worth his weight in gold, especially if you are married to him. This is my husband, Smith Coleman, carving a frame in his studio.

Every frame is labor intensive and very expensive to make. But even if I weren't married to this very gifted craftsman, I would seek out the very best framer I could afford. In my early years, I used metal frames and cheap matting to go on my watercolors. The frames looked as amateurish as my paintings and said very little about my seriousness as an artist.

The mat that goes around your watercolor should be white, off-white, or a very light, neutral color such as beige or gray. Avoid colored mats, as they tend to look gimmicky and rarely enhance the painting. The matting should be acid-free museum grade (100-percent rag), otherwise the painting will be damaged by the mat in years to come. The frame should be simple or non-distracting to the painting, with a complementary color and finish. The width of the frame should be different than the width of the mat and well balanced with the scale of the painting. A tour of almost any major museum's collection of watercolors will be your best tutor for framing guidelines.

As most watercolors are done on paper, they must be framed under glass. Most picture framers offer a UV glass that filters out the majority of ultraviolet sunlight, which can damage paper and fade pigments. At the very high end of the price scale there is museum glass, which hides almost all reflections. Plexiglas is often required for paintings being shipped to exhibitions, as it lessens the risk of breakage and can make extremely large paintings much lighter to lift and transport. Although Plexiglas has its advantages, it can scratch easily and is not generally used in museums since the fumes from the plastic can damage the art over a long period of time. Avoid non-glare glass, as its cloudiness distorts the details and color of a painting.

SUGGESTED EXERCISES

1 Seek out an experienced artist and mentor who will give you professional criticism and advice.

2 Go to the library and take out several books on business and art.

3 Have professional-looking business cards or brochures made that show and tell what you do.

Twirl
2011, watercolor on paper, 19 x 19 in.

Being a portrait artist will give you the limit-
less pleasure of painting the people of your
life and times.

RESOURCES

Tools and Supplies

Artxpress
www.artxpress.com
(800) 535-5908

Cheap Joe's Art Stuff, Inc.
www.cheapjoes.com
374 Industrial Park Drive, Boone, NC 28607
(800) 227-2788

Dick Blick Art Materials
www.dickblick.com
(800) 828-4548

M. Graham & Company
Handcrafted color and mediums
www.mgraham.com
PO Box 215 West Linn, OR 97068

Pearl Paint
www.pearlpaint.com
(800) 451-7327

SunEden Artist's Gear
Equipment for studio and plein air painting
www.sunedenartistsgear.com
(303) 828-4430

Twinrocker
Handmade papers
www.twinrocker.com
(800) 757-8946

Utrecht Art Supplies
www.utrechtart.com
(800) 223-9132

Other Resources

Art in the Mountains
Painting workshops for artists of all levels
www.artinthemountains.com
PO Box 311 Mehama, OR 97384
(503) 930-4572

Coleman Fine Art
Fine art gallery and frame makers
www.colemanfineart.com
79 Church Street, Charleston, SC 29401
(843) 853-7000

Portrait Society of America
National non-profit organization for portrait painters
www.portraitsociety.org
PO Box 11272 Tallahassee, FL 32302
(877) 772-4321

Author's Contact

Mary Whyte
www.marywhyte.com

INDEX

Graffiti
2007, watercolor on paper, 39½ x 48 in.